With Paris in Mind

Talking with artists of this generation

With Paris in Mind

Talking with artists of this generation

Will Mountain Cox

Relegation Books, USA

©2019 by Will Mountain Cox
All rights reserved.

Cover design by Zach Dodson
All photos were taken by and belong to Will Mountain Cox
unless credited otherwise. To contact regarding photos, visit:
www.instagram.com/willmountaincox

This is a work of nonfiction. The ideas and opinions expressed are
those of the artists and have been printed with their permission.

This book features translations from French by Christopher Seder,
Jennifer Ben Brahim, and Madeleine Rothery. They are noted in the
specific interviews where they feature.

ISBN: 978-0-9847648-8-4
Library of Congress Control Number: 2019908703

Relegation Books LLC
Falls Church, Virginia
USA

Our books may be purchased online at www.relegationbooks.com or from our
distributor, Itasca Books: www.itascabooks.com/relegation-books

First published by Relegation Books: November 2019

For Nigel

Table of Contents

Introduction
Why even?
A book like a community

My Paris moment

This whole thing started six years ago, like all good things start I guess, like a good commercial for a bad American beer. I was on top of Parc de Belleville, a park in the northeast of Paris, a place with a distant view of all the pretty tourist attractions of the city. It was summer night. Music was playing loud out a phone shoved into a cup to make it louder. There were people; tons of them. And there were beers being pulled from a glistening, soggy cardboard box. The beers were French and not American, Kronenbourg 1664 specifically, but that hardly matters for this story. What matters is how the beers were acting. They were clinking, clinking and passing between hands, the hands connected to shoulders that were laughing and bumping and clinking themselves. On the faces connected to the shoulders were smiles, huge ones, the kind where the eyes of the smiles could be mistaken for crying.

Those colliding bodies belonged to a group of new friends, French and British, a variety of other European nationals, foreigners from even farther away, and then American me. Those bodies have, in the present, become writers, musicians, painters, filmmakers, and photographers. At the time, however, those bodies just belonged to us, a group of ultra-youngs, sixteen to twenty-five, all dreaming of becoming artists in Paris.

I arrived in Paris as a cliché, writing bad poetry, searching for friends to drink with and chat ideas. I found some and with them we spoke knowingly, knowing nothing of any serious problems. We went to weekly poetry readings where we read our amateur writing and we went to parties where we drank too much. We were young in a place where it is fun to be young. We were immature and we

9

took advantage.

In the first months of knowing each other, we were constantly going to things. Music shows, dirty squat parties, stuffy art gallery openings, and wholesome picnics. There was so much happening in Paris. So much to learn from. And I saw the benefits all that going was having on us. Our writing was developing. We were competitive with one another, but not in any way of inflated importance. We were just competitive in getting better, attempting to impress one another at our weekly poetry readings, hoping that each time we read our work, people would confirm we were improving.

It was with that group that I started the first thing I did in Paris: a literature magazine called the *Belleville Park Pages*, named after a night we all had together at a park. That magazine was born of our self-styled disenchantment. As "editors," we asked for no previous publishing résumé, something none of us had, which was a requirement we believed to be preventing us from getting published in every other art magazine. That wasn't true. Our writing just wasn't good enough yet. But we believed it was.

More importantly, we asked people to pay two euros for the magazine, a price cheaper than a pint of beer, a value that if any higher, we wouldn't have wanted to part with ourselves. And finally, we focused on "participation." We asked our writers to find us other writers. We asked our readers to pitch us to their local bookshops. We asked our friends how we could do what we were doing better, and in doing so we watched the magazine become a collection plate for a diverse range of opinions.

The way we phrased those values was more serious. We said we were fighting to make literature more accessible and, by publishing a new issue every two weeks, faster and more relevant to the times. We said that, through our editorial decisions, we were bringing down the haughty nature of high literature that surrounded us. Whether we were or not, it worked. What started as a way to publish those artists from the park became something bigger. It grew. In three years, we published 300 writers from over thirty countries. We got the magazine stocked and sold in the bookshops of our dreams: Shakespeare and Company, City Lights,

Foyles, and Powell's, to name a few. We won some awards. And we got some of the recognition we were thirsty for.

Clearly I'm proud of that magazine. I'd be lying if I said I wasn't. But, looking back, it's not the numbers or the recognition I'm proud of. What I'm proud of now is the community that, by way of that magazine, I was blessed with a chance to be part of. Everything I think I know now comes from that magazine, from infinite hours spent reading publishing submissions: within those stories and poems, the joys and pains of my generation. By reading the thoughts of young people, young people from all over, from all six inhabitable continents, I was able to witness the community between us. The community of our moment. The community of mutually growing up in the times. I was granted access to backgrounds I'll never know personally. I was explained places I'll probably never have the chance to travel to. I was allowed the opportunity, through art, to trace our similarities, the collective catalysts of our happiness, and, because we were still so young then, the seeds of our psychological struggles.

That moment, I'll call it my "Paris moment," ended nine months later, though the magazine went on three more years. I divide this history into a moment because for a time, for that time, we had nothing to worry about beyond self-inflicted financials. We were living in Paris, being young and artsy. But like the magazine, people began growing up as well. Some couldn't afford to stay in Paris. Some didn't see a sustainable future in the city. Many moved away. Things changed. The community fractured. And I, addicted to that type of collective moment and its psychological access, went looking for it in other places.

My New York moment

Due to visa problems and a low bank account, I moved back to the US, to New York, where I became a waiter. During the day, I sold breakfasts and brunches to thirty-somethings. I smiled at them and sometimes they smiled back, all while I served them eggs, benedicted, all so at night I could keep the magazine going. When I wasn't working, I was searching for a new group of young

people to discover. I found them at a place called Mellow Pages, a lending library in Bushwick, Brooklyn.

Mellow Pages was a beautiful thing. Packed into a ratty warehouse across from the Morgan Avenue subway station were stacks of books written by young people. You were allowed to take those books home with you in trust and for free, a fact I found honorable in the money vacuum that is New York City. What was better than the price was that when you brought those books back, you would find, on the couches and chairs that made up the little surplus space left over by the books, the writers who had done those books' writing. Whenever I talked to them and told them about the magazine and my time in Paris, they often answered to the effect of: "Oh; I didn't know anything still happened there." I remember finding that odd. Wondering why. I knew there were interesting things happening in Paris. And though I was slightly offended by their doubts, I remember finding the doubts exciting. I guess I thought that in New York, a more "relevant art city," I might find a more serious progression of art as a means to greater understanding.

Those young people I spoke to, those writers, made up a friend group the media had deemed a movement. They were called "alt-lit," but really, they were a group of friends. In their work, they were attempting to translate the Internet into literature. Their stories and poems were shorter, more irreverent, more immediate, and more fun than anything I'd ever read. But hidden in their work were also darker realities: the scary potential for the Internet, and modernity more generally, to mold our psyche. In their structure (as spatially founded on the Internet as it was in Bushwick), and in their content, they became a reflection of the frightening opportunities I find in our digitizing life: the smudged borders between honesty and violence, the growing liberty to use uninformed opinions as weapons, and the hyperbolic siren call to shock as a means to gain attention.

I loved and hated their work simultaneously, which is my favorite kind of emotion, my favorite type of conundrum. I found their work at times so true, and at others, so knowingly false. By way of my place within the community, I was constantly reflecting

on those writers and what they were doing. I wasn't a part of their friend group, though I wanted to be. I was on the periphery, looking in, going to their frequent readings, watching and trying to learn.

The humans of alt-lit came into my life at a fortuitous time. I was, then nearing my mid-twenties, beginning to hear rumors of people from my past falling by the wayside of the mind. Through phone calls and texts with friends from my youth, I was relayed growing worries in the language of mental health. People I knew began describing themselves with words like "depression," "anxiety," "schizophrenia," and "bipolar." These were words I knew to exist but had never, at that point in my life, found relatable to anyone considered "still young." The art of alt-lit attacked these subjects, messily and immediately, and in doing so, allowed me to analyze for the first time the effects of modern society on our minds. The writers of alt-lit spoke of digital communication, financial instability, and a variety of bleak futures. They spoke of loneliness, unfulfilledness, disconnection, and nameless worry. They wrote of the issues I was starting to hear spoken about outside of art, and for that, they were holy. For that, I thank them.

I spent an odd and individualistic year in New York. I lived in a small apartment deep in the east of Queens with roommates I didn't know and hardly spoke to. I went every morning to an emotionally absent foodservice job in Manhattan. I learned from a group of people I wasn't personally connected with. Rightly or wrongly, I came to judgments and conclusions.

Around halfway through my time in the city, I saw the alt-lit community beginning to fracture, just like mine had in Paris, but not for the same reasons. Some of their writers were becoming famous, something that none of us in Paris ever were, something I could see was insidious. In the conversations I overheard, I could tell the fame was sparking jealousy, self-comparison, and doubt. Fittingly, all the problems I feel the Internet sparks. I felt the tone of the community changing. I watched as some of its members moved away. Though they claimed it was for reasons of money and stable futures, I felt the movements were just as driven by a desire to live lives in places with less of the mental stress inherent in fame-chasing. I remember thinking those forces must be what

"New York" is: a city whose success stories feed on the bodies of those who have failed to stay, failed to succeed.

At the same time, my magazine was failing. Not for lack of trying, but for lack of the human community that made it beautiful. In our spatial disjointedness, I was struggling to connect with the writers we published, to understand what they were saying, and to maintain the happiness I had previously felt in publishing their words. Having been allowed to experience the human highs that an art community can create, but also its inherent fragilities, I began feeling disheartened by art as a means to create the stable pleasures of interpersonal understanding. Also, I missed Paris. I missed how it made me feel. Beyond the glamor of "being an artist," I missed being directly connected to people I knew, who knew me, and who together, as a function of place and time and desire, had pushed one another toward daily improvement. All together, this was my "New York moment": learning more about the mind, finding doubts, and missing Paris.

Eventually, the magazine shut down. Maybe it had to. Maybe it had run its course. But also, maybe it was from my own doubts at the time about art's effectiveness at changing the way we connect with one another. In the absence of a purpose I felt confident in living, I went searching for new ways to promote that existence of community I was addicted to.

My university moments

In 2015, I went back to Paris and back to school. I'm sure I was driven there by some sort of nostalgia for my previous life in France, but I purposely avoided returning to the art community I had known. Instead, I enrolled in a master's program to study urban politics. The studies gave me a visa to be in Paris, which I needed, as well as access to knowledge I perceived to be a more mature version of community-building.

I spent the first year and a half of the two-year program in quiet rooms, extremely devoted to the subject. I learned the increasingly urban future of our world, how fast the world is losing its rurals, and the effects that losing them will have on our

collective society. A concept called "urban agglomeration" began to fascinate me: an economic forecast showing how certain cities are exploding in fiscal gravity. The concept's equations explain how fewer and fewer cities will consume the majority of global employment opportunities, and in turn, how more and more of us will be forced to live in those powerful cities. The prophecy ends with average humanity residing in mega-cities that are becoming impossibly unaffordable, unable to leave as these mega-cities become the only places to make any income at all. The research was very Neo-Tokyo and exciting.

In response, I went down two paths. First, I researched urban infrastructure technology, wondering if the larger start-up culture driving its progress might save us, through innovation, from our bleak economic forthcomings. Second, I began exploring affordable housing construction, going so far as spending a semester in Los Angeles studying under the god-teacher of that subject. I felt that, in the ballooning of economic inequality that will come with agglomeration, more efficient housing construction would be necessary to keep the growing middle and working classes respectably housed. In my head, these subjects made up the foundations of community. They were physical: income and shelter. If improved, they could prevent changing; they could keep people living in the exact places they wanted to be. Looking back, the subjects could just as easily have been my own attempt to find solutions for the personal instabilities I saw divide my communities of Paris and New York.

Unfortunately, the farther I went down those academic paths, the more they seemed ineffective. Regarding start-ups, the more I researched, the more I realized they were part of the problem. In a theory I tried titling "the Start-up Power Paradox," I came to a conclusion that start-ups themselves are actually making cities more expensive. By leveraging our general need for cheaper everything (transport, food, travel, housing), start-ups are growing, becoming more powerful, pulling in high-income employees, making cities more expensive in direct relation to how often we use those start-ups' technologies. Further, by promoting the gig economies inherent in their tech success, start-ups are placing us

in direct financial competition with each other, fame-chasing in a more foundational way; a fact I can only believe will be destructive to communities.

In regard to housing, the more career affordable-housing professionals I spoke to, the smaller I saw their work's potential influence. Though I saw, and still see, their work to be holy, I noticed that a lifetime of above-average effort only resulted in the addition of 100 to 200 units of stable living space in a single, individual city. The numbers seemed ineffective for community improvement on a global scale. Our magazine had sold almost 30,000 copies. I felt, I'm sure idealistically, that the network effects of more interesting and dynamic communication could improve community more efficiently.

In response to my doubts, I switched my studies to focus on political participation in the time of tech-efficient communication. Unknowingly again, like I had with technology and affordability, I was regressing back to a concept I'd contemplated during my magazine moments. I became obsessed with the idea that personal mobile devices might allow us to better participate in our own politics, to better govern ourselves, and to build community out of our collective liberty. I began research on a theory in which we, urban citizens, would take partial control of our tax revenue and directly influence its expenditure. I wondered if, with the grace of instantaneous digital communication, we could discuss and develop more ingenious solutions to urban issues. Then, not unlike crowdfunding platforms such as Kickstarter, we could vote for community projects we saw as most pressing by directly distributing our own tax dollars toward them. Maybe it was ridiculous, but for a moment, the idea turned me on. It felt like an exciting way for diverse groups to share their realizations and to bond through multidirectional education.

A distaste for my own ideas came quickly, again. I understood that my ideas were hyper-local. An average individual's daily genius for problem-solving is limited in scope. We really only know what we can see in front of us. And though that knowledge can create beautiful solutions to our local problems, it can't connect us across the increasingly global scope of our world and its problems. More,

a limited spatial focus felt capable of building barriers between our localities, causing us to think only of those close to us, preventing us from understanding and learning from the world; the learning I learned to believe in most while working on that magazine.

Those realizations came at a time of chaos in the world. It was 2016. Politics were becoming hyper-localized in a bad way. Hyper-polar. So bounded they made me sick. It seemed we were all limiting our understanding to opinions that shared matching labels. It felt like there was constantly less room for empathy when politics were the medium for discussion. I felt that any communication guised in the political would only support this manic categorization.

The chaos wasn't limited to politics, either. It was creeping into our minds. Pains were moving past pathologies. The mental health rumors I was hearing, the ones that had previously been frighteningly self-diagnosed, had seemed to skip the phase of medical diagnostics and had developed into a hard question for some: was life really worth living? That terrified me. And that made me feel a greater need for action—action that promoted purpose on an individual level.

Almost unknowingly, almost subconsciously, I returned to art. I called up the art friends I had still living in Paris. I asked them if they wanted to put on shows. I found houses and galleries to put them on. This wasn't something massive or important. Really, I just wanted to see those artists' beauty, to witness their unique understandings, and to reside in their individualized collectivities. I just wanted them to hang their paintings and play their music and for the crowd and me to be exposed to their ideas.

People came and people danced and people drank. There were discussions, and the discussions felt good. The artists' beauty and the discussions' goodness became ultra-inspiring. Their ideas and their understandings were pushing me. I began studying less in school. I started trying to write a novel as a way to help me answer my own questions about the digitally social, socially unstable world we find ourselves in. I guess, unsurprisingly, it blended my magazine moments with my university moments. It was about cities, fame, friendship, mental health, and the way in

which, by way of technology, opinions are becoming beautiful, big, and dangerous.

My culminating moment of realization

I finished my studies in the same place I'd started them. In art. The worlds of politics and academia felt stunted by bias and theory. I'd only witnessed the good ideas inherent in them getting shot down by economics and bureaucracy. Art, on the other hand, when done well, when done honestly, still felt capable of producing the empathy and intermingling I was craving.

I guess it's a problem-solving that I'm after. A problem-solving that's personal. A problem-solving that tackles the problems of politics and sociology. One that quells our fears of economic instability. One that dampens our stresses of urban living. One that limits our self-comparisons born from our life online. One that makes us feel less lonely. One that doses us toward a more normalized, holistic approach to mental health.

What I don't want is a problem-solving that's full of answers. Rather, I want one that lays us open to a community of mutual education, mutual understanding; a problem-solving that gives us a deeper collective empathy.

After witnessing multiple moments, multiple worlds, I believe it is good art that can deliver that problem-solving best. What I'm now looking for is artistic creation that beckons us with gorgeous aesthetics and, after catching us, reveals itself to be founded on the same questions we the viewers have been asking ourselves, obsessing over, and wondering how to answer.

My "why do this book, even" moment

For all the reasons I've just gone on about, I see artists as potential funnels for empathetic questioning. Artists spend their lives obsessed with themes, often just one or two, often one or two that we have been obsessing over as well, just in different ways. Their role, as I see it, is to simplify those obsessions into attractive, observable, understandable, and challenging outputs. If the art is

good, we will rewatch, relisten, relook, and try to relate. From there we can learn our own answers, sometimes big ones, but sometimes just the small and beautiful answer that comes from knowing we are not alone in our questions.

I went looking for artists whose work beautifully achieved some of that certain sort of answerless problem-solving. In this book are filmmakers, musicians, writers, fine artists, photographers, and chefs. Their work is very different. But in general, I find all their work to be expertly concerned with the pressing issues of our time. Our now.

These artists all live in or are somehow connected to Paris. Paris is my home, and clearly I am biased in my desire to show it off. I want to prove wrong the doubt inherent in the question, "Does anything still happen there?" Yes. Things do. And so sometimes the artists and I discussed Paris, what makes it nice, what makes it weird, and what about it affects and influences us. But most of the time we didn't talk about Paris. Instead, we mostly talked about the questions we shared and what it's like to be young now but getting older, to be "millennial," if you want to call us that.

With the questions I asked, I hoped to disengage from the capitalistic nature with which we treat our contemporary artists through interview, asking only about what they've just done and what they will do next. I've always found it criminal the way we treat artistic output, implying through our questioning that artists are responsible for producing something new, for us, immediately after completing the project we are currently discussing. I understand we're living through a moment when religious gods are being replaced with artist and socialite icons. That doesn't mean, however, that we have to treat them as factories of our need for purposeful content. If it's the inspiring, possibly famous artist from whom we derive meaning, then we can at least put in the effort to slowly and critically analyze what they have to say. Not in an academic way. Just by looking at our lives in relation to theirs, reflecting, going back, reflecting again, and then thinking of our individual world as altered by their insights. The questions I chose to ask were chosen in hopes of distilling those insights.

These interviews were all very long. I've only been able

to print a fraction of what these artists had to say. Most of these interviews lasted nearly three hours. That was on purpose. I designed them around the concept of exhaustion. I wanted these interviews to break us, both them and me, to free us by way of fatigue from the predetermined, externally influenced opinions we all have toward everything. I've chosen to print the parts that were most beautiful. The parts where the artists questioned the questions we share, and better, the questions I never realize I have been perpetually asking. I've chosen to print the responses that uncover, no matter the question asked, a narrative of similarities between us as dictated by our mutually living through this specific moment.

My hope is that this book can be like a community. Not a community of the artists in this book specifically, because there are tons of other interesting artists living and working in Paris today, artists I hope to speak with in the future. More, I hope for this community to be one of ideas, similar to the community I was lucky enough to touch through my magazine. I hope that in reading, you find yourself in this community, with similar questions and your own unique beliefs toward the subjects we covered. I hope that the words spoken, which I've printed because they are interesting to me, are also interesting to you. I hope the artists' words make you think and want to research. That's what their words did for me. After speaking with these artists, I began to research facts about city life, millennial stress, loneliness, the effects of social media on our bodies, and the growing ubiquity of mental health problems in society. I learned a lot from these artists, these people. I have more to say, but I don't want to get too specific. I don't want this to turn scientific. That can come later. For now I just want to show people who are similar to us, going through the same things we are. People whose ideas make up a community, whose words are full of empathy, and whose thoughts offer opportunities to learn from one another. That's why I wanted to do this book. That's what made me happy while doing this book. And that is what I hope will make you happy while reading it.

<div align="right">Will</div>

Filmmakers

Talking with

Yotam Ben-David

about subtlety, homogenization, and the secrets in our favorite sounds.

"I try to liberate myself from the question of authenticity. The only thing I think is kind of authentic is my loyalty to my own point of view."

It's hard to summarize a person who "just gets it," the phrase itself representing summary comprehension of questions and answers we can't even put into words. I first saw one of Yotam's films at a festival in Paris. I was sitting on a hill. It was still technically summer, but it was the first cold night of the fall transition. The friends who'd invited me hadn't brought jackets and were shifting uncomfortably, pulling their arms into their sleeves, trying to make jackets out of T-shirts. I was distracted from the cold by the wild way the giant screen showing Yotam's *Thunder from the Sea* blended into the city around it. The film takes place at night. A twenty-something boy in light-up sneakers plods through the summer countryside while chatting on his phone and sending texts. The lights of the shoes and the lights of the technology play on your eyes. The boy arrives at a bonfire surrounded by three friends. Nothing really happens and that's the best part about it. Because in the nothing, in the catch-up chat and gossip of four boys home on holiday, is everything we seem to be going through in our lives, everything we're trying to "just get." Confusing politics. Fading connections. Failed loves. The average joys and tragedies of conversations with important people that go well for a moment, then come to an abrupt and awkward halt. Every so often, from behind the giant screen, the Paris Tramline T2 train would poke out and run down the hill, rumbling and sparking like it wanted to be a character in the movie. Somehow, at least for me, the accidental blend of the film and the festival setting made the conversations and the visuals so much more personal. As I walked home through the night streets of Paris, I noticed the lights loud and the sounds hard and I thought of my friends back in my America-home to whom I owed "You ok?" text messages.

Instagram: @yotam.ben.david
Find Yotam's films at tao-films.com and kinoscope.org.

My favorite sound is mollusks—oysters, mussels, clams—being tossed in a pan. What's your favorite sound?

I'm not sure it's a cliché or not, but my favorite sound is the sound of wind blowing through trees. It's interesting you asked this question because when my boyfriend and I were on vacation recently, outside the city, every time there was a wave of wind in the trees, I didn't notice that I always said the same sentence. I would say, "I love this sound."

Is there a certain type of tree? A certain type of wind?

There is a specific kind of wind in the afternoon, especially in hotter places like where I grew up—when the sun starts setting and the air starts to cool down as a first sign of the night that's approaching. This wind moves through the heavy trees and usually it's also the moment when flocks of birds begin their evening dance flying around the sky.

After I see your films, I become so aware of sound, I feel like I hear everything. I've only had this with a couple other films. I really liked the sound of the plastic bottle you drink out of at the start of *Long Distance*. When I'm drinking from a plastic bottle I squeeze it, to make that sound. When you're creating your films, how do you think about sound? Is it something you're aware of in the writing?

It's something that exists in the script. Actually both the image and the sound are things I write directly onto the scripts. That's why my scripts are sometimes exhausting to read, because there's a lot of detail.

Do you have a lot of auditory memory? Do you have a sound catalogue that you're pulling from?

I'm just very interested in the sensuality of things. That's why I was happy you mentioned the bottle. It was the beginning of the film and it was very clear for me that I wanted to linger on that sound, which is really odd, something that we hear every day but we never really listen to. It has a certain uncanniness. There's something familiar yet far from us.

Do you go for lots of walks?

I've always liked walking, specifically in Paris. I prefer walking to taking the Métro. I think for me it's a way of meditation and I think my best ideas come from that.

Are there different purposes when you go for a walk? Because two of your films have this walking component, which I found very powerful.

I grew up in a village, and as a child I would go to the wood, and take walks, and it was usually a place for fantasy. It's also an interesting moment because when we walk and go into a reflective state of mind, there is a dual quality to what we do. We go into our own mind, our own thoughts. At the same time, we're in a place, and I find a relationship between the two very interesting. It's sort of a bridge between our inner world and the outside and the relationship between the two creates a third option.

The thing I admire most in your work is your ability to reserve, to hold back, to be subtle, not to give the audience everything they want. When I edit other people's poetry, I often tell them the first thing they should do is to cut their last line to achieve that. Do you delete a lot when you write your scripts?

I do delete quite a lot, especially when it comes to dialogue. Many times I think that I need to put the words on to the character, only to see that it's not necessary because we can feel it in the image, feel it from the context.

Is it a conscious effort to restrain?

I think one of the things that repeats most in all my processes is this idea of asking, "How much can I give that will plant something in the spectator allowing them to relate to the character, but not giving enough, in order to leave mystery and a place for interpretation?" If we give everything to the spectator, it's not respectful, not giving them a part to participate with in the film.

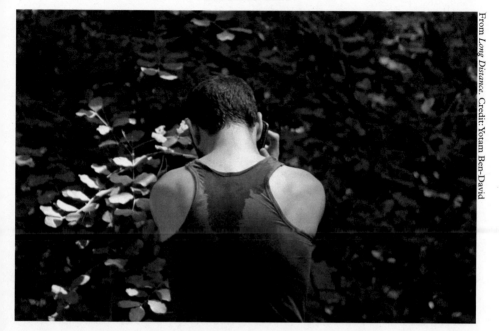

From *Long Distance*. Credit: Yotam Ben-David

Are there filmmakers who inspire you in that specific regarding subtlety and restraint?
My favorite director is Apichatpong Weerasethakul; do you know him?

No.
In his films he often plays with a certain openness for interpretation, with laying one thing next to another and allowing the meaning to come out of the meeting between them without judgment. When there's an idea that could be troubling, that could be odd, he tries it out to see if it has an effect without trying to tame it into a formula. When I start a new project I think there's always this notion in my head, to have something that is inexplicable, because that's what allows me as a filmmaker to keep my desire and interest in the subject. Even for myself as a spectator, the most interesting films are the ones I want to watch again because I'm not sure what I just saw.

When you meet a new person or hear a person's stories, what inspires you most?
I'm interested in fragility. I'm interested by different things in each character, but the tension between the fragility and the facade is something that I like to explore; how much do we reveal, how much do we keep to ourselves?

I think that's very "on brand" with the experiences we're having across society right now, the facade versus the fragility. It's easy to connect that to social media. It's messing with our ability to understand what we share, what we let people see.
And also what is truth. This obsession with the facade has reached a point with social media that sometimes people represent fragility in a way that's not honest, just because it has a certain superficial appeal. It makes me quite sad. And it's also a thing I quite like to insist on in my films, some sort of honesty.

The facade of fragility, why do you think people do that, where does it come from?
I think it has to do with "like" culture. People are looking for easy formulas for approval. To be liked in a very fast-lane way. To create certain formulas that would create an immediate empathy. But it's a superficial empathy. It's okay when we consume quick empathy in the form of cat videos and give

25

our brains some light entertainment, but I do think it becomes dangerous when it is our own presentation of ourselves to the world, when we diminish ourselves and our experiences and thoughts into superficial templates in order to easily get some kind of a quick approval.

I've been thinking a lot about hashtags connected to emotions, fragility that is worth Internet currency.
It goes exactly back to what I talked about in the sense of finding formulas that are relatable. When we hashtag something, we limit its sense to something very specific, and everything around those emotions that makes them complex, makes them more than one word with a hashtag at the beginning. That influences the psychology of people.

I notice you shoot with high-definition, modern cameras. Especially in photography and film, I see a use of old technology to achieve a visual aesthetic from the recent past: eighties, nineties, early 2000s. When I ask people why that is, they usually say it's to achieve authenticity. Why do you think people say that?
I just find it a bit nostalgic. It goes back to this idea that you can create an instant authenticity by using a solution, and I think it's much more interesting, trying to represent an emotion, state of mind, or atmosphere, than to go through an external, forced aesthetic. I think the question of authenticity is one of the more complex

questions we have today, and it's two-sided. We're able to represent more types of life experiences, but it creates a false idea that an absolute authenticity exists. We should never think there is one thing that is authentic. We have influences. We represent things that cannot be directly represented because they pass through our interpretation. So I try to liberate myself from the question of authenticity. The only thing I think is kind of authentic is my loyalty to my own point of view.

Talk to me about light, how it inspires you.
The first word I said as a baby was "light," in Hebrew.

I especially like how you play with non-natural light. The new lights that never seem to turn off. The lights we can carry around with us everywhere.
It goes to this idea of trying to represent the present day. I see a lot of filmmakers trying to resolve this crisis of representation of technology. For example, you have a dialogue in texts, so people put the texts on the screen and it becomes a bit of a weird mix with comics. For me, it's more interesting to look at human beings and see their interaction with technology because cinema allows us to reflect outside ourselves for a moment.

I found it very brave, the way you represent technology. It's done naturally, as a point of interruption but not in a way

From *Remains*. Credit: Yotam Ben-David

that felt you were making a point. It was just there because it's there in our lives. What effect do you see technology and its non-natural light having on our daily lives? Why do you think it's hard to portray the way technology appears in our lives?

Most people are nostalgic, especially in art; people think technology is ugly, so they avoid representing technology. One of the things I enjoy is actually to find beauty in technology and to accept it as something that is part of our present day and to find a way to find poetry in technology and in the mix between technology and human beings. I think cinema is about trying to look at our society, about trying to look at our culture, and it's more interesting to find a way to face the technology rather than to avoid it. These easier solutions of representing technology avoid a certain truth about how it really feels. We're still separated from the technology but we go to sleep with it at night.

Another great way you use subtlety has to do with power dynamics in romantic relationships. In _Remains_, for example, there is a surface-level power of the character Thomas over Itamar. Itamar then subverts Thomas's power by sleeping with someone else and in turn, seems to gain his own power by maintaining "options." Can you speak to the place of power and easy options in our romances?

I wanted to see how there are two sides to the same thing: power. And that each character has a side that is weak and a side that is strong and how it's just a game of volumes between the two. Itamar plays the role of the submissive, the weak, but at the same time, he has something that is more stable, just by the fact that he lives in his own country and he's not an immigrant. He has a sort of peace inside him. He doesn't have the same need Thomas has, to assert his power. So I was interested in playing around with those ideas, to see how I could subvert the power play in a way that would introduce another aspect.

I find the act of Itamar's cheating to be interesting. We don't see much of the psychological leading-up to the cheating. We just get the quick and surprising sexual act with an unknown "other option." The act itself is very submissive, not unlike his relationship with his true partner.

To me, it's not so much a matter of options, because in the end he goes back to the cycle of power from earlier. To me it was more this idea of taking the dynamic he has in his own relationship and taking it outside the house and seeing it when he's trying to escape, trying to understand himself. What was most interesting to me was this sexual act and the way it embodies all of the questions that he's asking and also the duality of things. There's something very planned that he's taking control of, but at the same time, he's still submissive. It's an act of liberation but he's physically filling his own mouth with a penis. What was interesting was less the question of options, more the attempt to exit the cycle of dominance to find out something about this nature of letting go of or taking control.

You grew up and did your art training in Israel. Now you're in Paris. What brought you here?

The official reason was political. I was really politically active in Israel. I gradually became depressed with the possibility of a political act in Israel and I felt like the country was becoming more and more fascist. My boyfriend felt the same, so we were both looking for another solution. And then Paris was just a choice that had to do with the role of cinema and the fact that cinema is so important here, both in terms of legacy but also cinema today. I'm really moved walking past a cinema and seeing people standing in line to see a film, which is something you hardly see in Israel. There's something comforting here. It creates a reality; it's not just nostalgic. The insistence on keeping cinema alive creates a reality for cinema.

Your movies are all set in Israel. What does Paris teach you about home?

It's hard for me to separate Paris from the

experience of immigration, but I think the main thing is just a change of perspective. First of all my own experience of myself outside the culture I know, the idea of trying to understand a new culture in a very intimate way, day to day. It makes me scared when I look at the place I left and see how quickly it changes, since it's been four years. I feel like there is a certain distance between myself and the place I left now and it makes me ask questions about identity and also about the place itself and whether it's me that's changed or the place or both.

Your films *Long Distance* and *Thunder from the Sea* take place in the Israeli countryside. What does this sort of location mean to you, especially now that you live in one of the densest cities in the world?

I think the strongest thing about it, both in real life and in cinema, is that there is something very humbling about nature. Because we live in such an industrialized urban environment, it's a very important place to go back to, to remember we're not gods.

What about our urban life makes us forget to be humble?

I think we become very consumed with our day-to-day problems, with the systems we invented that enslave us into money, certain routines, technology. It's a good reminder to get out in order to understand that we can make different choices outside of the reality we've constructed.

You often include technology in the wilderness. Where does that idea come from?

I think it's just a matter of contrasting two ideas and trying to come up with a third option. It's an approach I have in many things. It's funny to talk about it in a conscious way, but I think, maybe because I'm Gemini and I have these two sides [*laughs*]. I think it's a way to relate to the world through extremes and to try to find a compromise that actually says something very true about our nature... no pun intended [*laughs*].

I've seen your films subtitled, from Hebrew, into both French and English. There is a lot of subtlety in the language of your films and I'm sure, a lot of potential for subtlety to be lost. Does the translation of your films into those two languages affect the way you go about writing and production?

When I write, I write in Hebrew. For me, first of all, Hebrew is the most beautiful language [*laughs*], and I love it, but it's also the most direct way for me to communicate something between me and myself. Right now we're translating my first feature into French for the producers here in France. In all of my films, the question of language is quite dominant. In *Remains*, English is very dominant. I try not to approach the films from the language point of view, but in the production process, it's one of the points that becomes complex. In *Thunder from the Sea*, it's especially complex because it's a film that is very verbal and uses a lot of slang that is very specific. You have a gay character so you have gay slang, and then you have the slang of the Mizrahi teenagers. It's a mix of very specific dialects and we had some quite complex questions translating it. I found that in English it was easier to translate, especially when it came to the gay slang. Then in Hebrew you have a lot of slang that comes from Arabic, both coming out of the local Palestinian culture but also because of the fact that Mizrahi Jews spoke—and some still do—Arabic as their mother tongue. When we translated the film to French, it was beautiful to find solutions from the influence of the Arab immigration on French slang and the fact that French slang among second- and third-generation Arab immigrants also brings Arab words into their vocabulary. When I watched *Thunder from the Sea* for the first time with the French subtitles, I had this really beautiful experience. It was the first time that I experienced the possibility for this story to be something that people can relate to in many places, even though the story is so, so specific. ◊

Talking with

Léa Mysius

about childhood memories, trauma, and the dangers of remembering.

"I think formative memories really determine who we are. . . . We are all products of culture and education. Even before being born, you've already been predetermined. Then, if you want to find some freedom, you have to overcome that predetermination."

The most difficult ghost-moments of our youth are hard to avoid, and yet also, somehow, just as hard to remember. They haunt, and yet, they are hollow. Our difficulties become little films we screen on our eyelids when we try to ask ourselves, "Why?" It's often our youthful traumas that we use to explain our present actions, but we also bend those memories, beyond their history, to justify our subjective conceptions of reality. I like that power, and it scares me: the idea I could be fabricating the objective truth of my past, in my own interest. I find the beauty of that bias in Léa's movies. In her short films, *Cadavre exquis, Les oiseaux-tonnerre*, and *L'île jaune*, and in her first feature, *Ava*, there is a common theme that can't be avoided: youth. Youth and what it does to us. In all Léa's films there are children faced with challenges. In those challenges, I see the characters' futures. I see the new paths those kids have been pointed down by trauma. And I see the adults they could become when the film they're in is over: changed, not for the worse or better. But whenever a Léa Mysius movie ends, and I close its little window, and I shut my computer screen, I'm also always left to wonder if the character will even remember the traumatic moment they've just lived through. They could easily be scarred by the experience. Just as easily, they could let the experience wash over them, leave it in their depths, live free of it for decades, only to stumble across it during some decisive phase of their future. Léa's films are surreal and colorful and full of joy. They're also eerie, dark, and ripe for potential pain. I like them for how they make me debate myself on the questions of life history that I'm not entirely confident I've ever asked.

Translated from French by Christopher Seder

31

I've read a lot of studies on memory that say that our childhood memories are often false images, more like fictional films than true recordings. How do you feel about that statement as it relates to film?

You can film memories, I think, but it's a matter of adding narrative structure. The structure of a memory is not at all the structure of a usual film. I know that, myself, I put a lot of memories in *Ava*, but then I had to add some dramatic structure to them. Because if you just put memories in, those are scraps, and it makes for a more experimental film, which is not what *Ava* is. In terms of the backdrop, in *Ava*, I filmed where I grew up. That place is filmed in the way I remember it though. So, it has changed. The backdrops aren't the same. And as a result, what has to do with memory is more my perception of those backdrops, and the way I chose to show them. It's all this stuff I had projected. This whole wild, primitive aspect of things. And then maybe also the memories I have of adolescent sensations, and all that. But I had to make those fit into the structure of a film.

To me, your film *Ava* feels like an odd and surreal memory of all the beach trips of our summer vacations, mixed together into one. Was there a clear or childhood memory of yours that was specifically important to that film?

Everything that has to do with sexuality, I think. I don't know if we should talk about memories or about the unconscious or if the two are mixed up. But in *Ava*, and then in my other films too, because the characters are all young, it's the memory of how you experience your sexuality at that age. When it's just starting out.

When I watch your films, they really make me reflect on my childhood. They make me question what I remember about my younger self and if those memories are actually true.

Yeah, that's really it. I love the concept of false memories. I remember that I have a fair number of false memories, myself. And what's more, I have a twin sister, and other brothers and sisters, too, and we have these false memories that we've made up together. I remember this one time we were convinced that I had split my head open, and it wasn't true. We'd made it up, and I remember it as you would a normal memory.

One of your early films, *Les oiseaux-tonnerre* [*Thunderbirds*], takes place where you grew up, in the Médoc, near Bordeaux. Was there a certain energy from your home that you were trying to capture?

I have a twin sister. It was really about exploring that sibling relationship. There's a boy and a girl and there's this incestuous rapport between the brother and the sister. And, it's about when sexuality rears its head. It's about how you handle the fact that you have a body, and that the games you played together as kids become no longer innocent. So you move on to something more serious. It's about how you cut the cord with your brother or sister. In *Thunderbirds*, this separation occurs suddenly, because the boy starts to desire another woman, or other women, and he breaks away from his sister, who, for her own part, is very possessive.

That's interesting, because your first memories of sexuality become so important, so hard to forget and disconnect from. They really have the potential to form who you become.

And plus, there's this voracity aspect, this aspect of figuring out who's eating who in a brother-sister relationship. What had happened, at the beginning of *Thunderbirds*, was that while they were in their mother's womb, the brother ate a bit of the sister, and that's why she has a limp. That isn't said in the film, but that was what it was about. Which is to say, he had taken something from her in the womb, and that as a result, he owned something of hers in real life.

One of your first short films, *Cadavre exquis* [*Exquisite Corpse*], seems to explore the ideas of formative trauma and loss of innocence. In the film, a young girl named Maëlys befriends a dead

body. You can really imagine the potential effect the experience might have on her future. How do you think that formative memories affect us as adults?

I think formative memories really determine who we are, for sure. We're all products of culture and education. Even before being born, you've already been predetermined. Then, if you want to find some freedom, you have to overcome that predetermination. Escaping that predetermination becomes a kind of miracle. I know that I'm fully the product of my education and of what I've been through, and that all of my films are a reflection of that. This applies both to life itself, and to the films I saw when I was very small. For instance, I would watch two movies with my twin sister, *Night of the Hunter* and *Freaks*, when I was a tiny little kid. And I know those movies have made their way into my own films today, in spite of me. Because they shaped me. I know that for some people, making movies is a psychoanalysis of the self. I don't know if it's a psychoanalytic process for me, but in any case, that must be a part of it, in some way.

What effect do you think this moment, finding a body at such a young age, will have on Maëlys's future?

I never think about the lives of my characters after films, because for me, they really only exist for as long as the movie lasts. But I also think it was a good experience for her, in the sense that she experienced death and desire. And it's also an image, in the film, of what children experience. Granted, they rarely find corpses.

There was such a sense of innocence in her interaction with the body. It made me wonder how we can experience traumatic moments through a lens of innocence. And then it made me wonder if we subconsciously reinterpret childhood trauma for self-protection in the future.

Yes, that's right; for her it's this game. But then, she really tackles this death-related thing, which I think is a lot more terrible for adults than it is for a child. In and of itself, she's just having fun with a corpse. There's nothing terrible about it, you know. That's just what adults project onto children's games. Children's games are often a lot tougher and more perverse than adults are willing to believe, even though they were once children themselves. Especially because we live in this very prudish society, whereas, as children, we aren't necessarily prudish at all. Or I mean, you can be, if you've been educated in a certain way. But in any case, very young children often have something fairly primitive and a fairly healthy connection with the earth, death, and love. Which

From *Ava*. Credit: Léa Mysius

33

doesn't mean they aren't perverse. They are perverse, but in a healthy way.

In another of your films, *L'île jaune* [*The Yellow Island*], Ena, the eleven-year-old main character, experiences a massively traumatic moment related to suicide. Immediately after witnessing the moment, Ena fluctuates between acting out a false maturity and regressing to her innocent youth. I'm interested in that moment of forgetting the trauma that stays with us. Would you say that, in both her maturity and innocence, she's attempting to forget what she just witnessed?

I wouldn't say forgetting because Ena hasn't forgotten about it. She saw it, and then she yells at the boy for attempting suicide because she's regained something. She's regained her footing. When she heads away from the island on the boat and she touches her locket, for me, this is the moment when you know she won't forget. It's a part of her now, and it has changed her. But she's not going to stay focused on it. It's just a part of the steps that have made her who she is, that have shaped her.

I know that very traumatic events can be immediately forgotten. But that isn't quite what I'm talking about, here. Although, in my next

film, there's this idea of traumatic memory as well. There's a trauma that's echoed across generations, even. The granddaughter of a woman who went through a trauma can feel the trauma without knowing what it is. Everything we experience really affects who we are, of course. And even if we act as though it didn't happen, that isn't true. It did happen. I like the idea that we carry on as though our traumas didn't happen, but then also, how they always come back, out of the woodwork. That's what makes us who we are.

In an interview for the 2017 Cannes Film Festival, you said, "I often heard that for a young director, working with children and animals is too dangerous. I never followed that advice." I find your work with young actresses—Ena Letourneux in *Cadavre exquis* and *L'île jaune*, Noée Abita in *Ava*—to be really inspiring, especially for the way you get them to physically embody the psychological challenges they face. In *Ava* for example, you're watching the physical reaction to a character going blind. Can you tell me about the working relationships you have with your actresses and how you get such young people to deliver such physical, compelling performances?

Well, so Ena didn't really read the script [*for Cadavre exquis*]. I told her the story but she

From *Ava*. Credit: Léa Mysius

didn't really understand what order things were supposed to happen, especially since we were shooting them out of order. Plus, she didn't really know what she was supposed to do. She had no psychology, which was perfect, because I just had to direct her body. She wasn't like her character at all. She was a little princess. She spoke in this little high-pitched voice, etc. And so we worked really hard at making her way tougher. For days on end I would force her to wear certain clothes, and then she had to go trudging through the mud. That sort of thing. Even though she was totally grossed out by water, mud, and stuff like that. She had to really get down and dirty. But she was brave, really. She had quite the willpower. And as a result, all I did was direct her, in terms of her voice and in terms of what she did with her eyebrows and her face. I was always talking to her during takes, because she was so small. With Noée, for *Ava*, I didn't talk to her all the time. I would just say to her, "You do this," "You do that." "More like this," "More like that," and she would follow my instructions. But they were just related to the body, really. So, as a result, she became very physical.

The physical mannerisms of each character seem so important to your films. When you're in the process of casting, do you look for actresses with certain physical mannerisms that you feel represent the character?

When I do castings, I usually know from the first glance whether it's going to be a fit or not. Like from the first look, within ten seconds. And there are plenty of little miracles that happen. Because, I mean, I do have to find the characters, but when the person comes in, I say to myself, "That's it; that's them." And I don't really know why; it's something about the way they move. They usually haven't even opened their mouths, and I already know it's them. Granted, they may not necessarily have the character's mannerisms, but I can already feel that they're malleable. If I can recognize that, I can transform them and really make them into the character. Usually, I don't really have a specific idea of who the character is. I have this vague picture of

people in my head when I'm writing, so it's such a great moment when someone shows up and boom, they're the character, and I'm not quite sure how come. After that, all I have left to do is shape them, sort of like a sculpture.

Do you connect psychological stresses, or certain traumas, with certain physical mannerisms?

No; I don't psychologize things. I don't need to construct a history of them to find out what they're like. It's just that I picture a person and I see them that way. Then, there are some things, like for instance in *Ava*, the fact that she's blind, and that she sees more with her hands, means that she also moves her head in a certain way. The fact that she moves her head like that is in relation to a physical history. She has this condition, and that's why she moves that way. But other than that, no. And then, I'm also of course inspired by the actors, who have certain physical characteristics that I find interesting.

I see a lot of young filmmakers and photographers using old technology, old cameras, and aesthetic tones from the past in their current creation. Specifically cameras and tones from the 1980s and 1990s. People are using photo filter apps like Huji to make their phone photos look like real film, the little dates in the corner included. Why do you think that is?

We've been in this race to high definition, like, the more defined things are, the better they are, and everybody was super into that. But really, it's ugly. There comes a point where, just because things are very precise, it doesn't mean that they're nice to look at. And I get the impression—I mean, it isn't like this with everyone, and it's possible to find poetry in very high-definition stuff—but it's just a bit more poetic when there's more substance to things, and when everything isn't just digital.

I feel like we demand crisp HD for sports or for other nonfiction forms of visual entertainment. But then for our fictions,

for our narratives, for our "art," people our age are looking for that blurred, retro aesthetic.

Well, I think that by using old cameras, with film and so on, you can make modern-day films. All blockbusters are made using film, you know. It's this thing about creating a modern-day story using a medium that provides grain and substance. In my mind, HD digital cameras are actually already very dated because the image looks dated right away. When you look at it you say to yourself, "Oh, that's from 2018." And it's going to age poorly, I think.

I ask because I know with *Ava*, you shot on 35 mm film. It gave the film a rich tonal quality, and made me feel like I was in a memory, but not that it was necessarily old or purposefully dated.

Yeah, I really didn't want it to be nostalgic. I just wanted it to have some grain. And we put all of this work into the images, which resulted in us getting images that were, well, very saturated, very contrasty. We were able to get fairly far with that, and to be very precise in terms of each shot. The color grading is digital though. And the lighting we chose was modern-day lighting, so there you go. However, we did push the cameras a bit to get more grain, which may have made things look a bit older. But the big difference is that we didn't project it on 35 mm. We projected it in DCP [*Digital Cinema Package, a format that allows film to be played on a digital projector*] for precisely that reason, because I didn't want it to be nostalgic. Whenever we showed it on real 35 mm film, it would start vibrating a little. It was really beautiful. It had a lot of soul to it. But it looked old. People are more used to DCP now, and I wanted it to be in that format, so that people could see themselves in the modern-day images, and at the same time, for there to be something a bit different from the normal definition. For there to be more colors, more black, more matter.

When I've asked this question to others, many have said the return to aesthetics of the recent past is due to a search for authenticity connected to our childhood. For me, authenticity isn't found in the past. Why do you think so many people said the same thing?

Because I think that in today's world, we've lost our relationship to matter. Everything is digital; there's this blur of space and time that's very destabilizing for a lot of people, and I think they need something material to hang onto, really. And when they talk about authenticity, I think they want something that looks like film, that's made of matter, but also something that's referring to the past, so that they can have something to cling onto. That's how I would put it.

Related to our visual, aesthetic choices in art forms like cinema, do you think there are anxieties specific to our generation?

I think our losing points of reference in space and time is difficult, when it comes to things becoming dematerialized. As well as the speed of information distribution. I don't know, there's all this over-information, and all of this very fast hyper-stimulation of the brain going on. And I think that causes people to feel lost.

How does that over-information, that overstimulation, affect the way we feel on a daily basis?

I'm thinking more kind of psychoanalytically, here. My mother is a shrink, so that could be why. But it's more of a general thing where humans, even if they have phones, and even if they're talking, they're never communicating. It's a philosophy thing, too, where the words that come out of our mouths aren't exactly our thoughts. Nobody else could be inside you. So, you'll always be all alone inside yourself, you'll always be facing the world alone. Which is normal, because you're a finite creature, and to express yourself, you do have to make use of imperfect means. Maybe the day will come when we'll be able to connect with one another through thought, when we'll be able to really come together with someone and to really communicate with them. But for the time being, we're stuck with these

false, measly words. It's always a bit clumsy. So maybe that's it. There are always these misunderstandings.

What do you think it means to be lonely in our modern world?

When it's totally impossible to communicate with others. That's what I think; it's feeling like communication is impossible. Even if you talk, even if you do whatever, it doesn't matter; you'll always be hindered by something.

If loneliness for you is the total lack of ability to communicate, what triggers that?

I think it can be all the time. Someone who feels really alone feels that all the time. Except, maybe, when they're in love and they find someone who understands them. That's something we often say: "That person 'understands' me." Which is to say that I feel like that person is able to, at least up to a point, communicate with you in some way. But I'm thinking of people who really feel alone, here. I don't feel like that at all, myself. I feel like I'm able to communicate, but I understand what people mean, in the sense that you can never really fully communicate. And I understand why people are looking to have sex, too, to attempt becoming as one. It's about communing, really.

If that's what loneliness is, is there a way to overcome it?

You have to be in love.

Are there movies you like that do a good job reflecting on loneliness?

Yes, there must be plenty of those. I don't know why *The Spirit of the Beehive* [by Victor Erice] came to mind right away. I'm not necessarily a fan of that film, but I don't know, I just thought to myself, "That's about loneliness." *Aurum* [by James Barclay] is a film I like a lot about loneliness. Then, in terms of my films, *Exquisite Corpse* is also definitely about loneliness.

The moments when Maëlys is alone with the body in her little treehouse?

In the little cabin, yes. It's funny, I haven't experienced much loneliness at all, but I like to write about people who are alone. Ava is also very alone, at the beginning. And then she falls in love. ◊

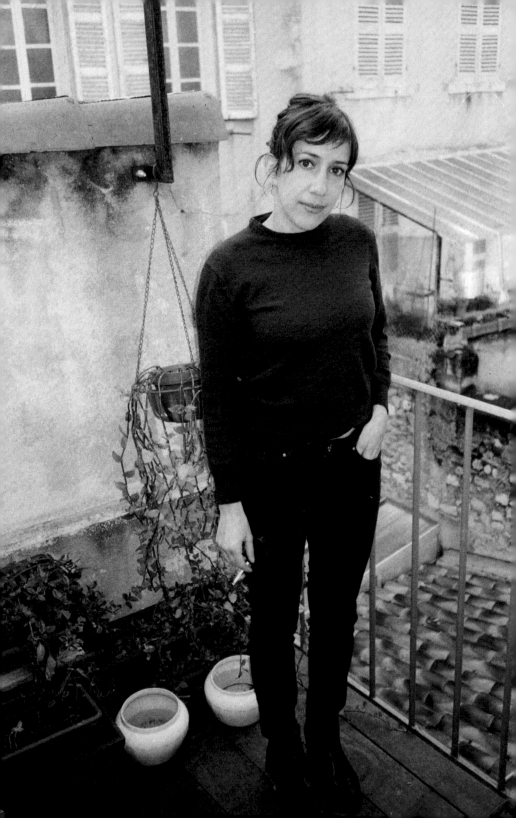

Talking with

Amélie Derlon Cordina

about the joys and fears of writing our own histories.

"What I find very moving is to show people who are in the process of building something: building up your own life, building your story, building your biography, in a way, becoming a character."

In the films of Amélie Derlon Cordina, fiction has become fully sentient. This isn't some reference to a futurist, tech-driven Armageddon of singularity. But it is a reference to the future of storytelling, as I see it. Booming into our lives are YouTubers selling staged content as daily truth, memoirs deleting average boredoms so biographies read more like dramas, podcasts hucking doubt at criminal horrors so that we, the audience, can play at being real lawyers in legal proceedings. The line between documentary and fictional entertainment has been smudged, and that's what makes Amélie's movies so interesting. Her stories are aware of themselves. Her characters are aware of how near they are to being human, but also, how trapped they are in a fictional dimension. They reference this dimension. And they discuss it. And in turn, Amélie's characters leverage this awareness to bend their personal histories, making fiction work in their favor, making reality all the more difficult to understand. I met with Amélie in Marseille, where she's from; a place, as she describes it, that has become nearly unreal to her. Amélie doesn't live in Marseille, or in Paris either. She lives in Brussels. I originally wanted to speak with her for that reason; her life as an artist, affected by Paris but actively choosing to avoid it. I thought someone like that would have an interesting story to tell. What I found in speaking with her, and what I find more interesting now, is learning how Amélie has leveraged the places and people of her real life to rewrite her own history, to shed the weight of her inherited traditions, to produce the truths she hopes to find in life, and to move between the truths and fictions as she sees fit. It should come as no surprise then, that in the first scene of her film *SAINTS' GAME* (my favorite of Amélie's), a protagonist, visibly wearing a mic for his performance, explains the concept of the Roman Templum, which he will use to stage a play. The Templum is a vaguely delineated square. Inside the square, we are a character. Outside the square, we are nothing but ourselves.

Instagram: @ameliederloncordina
www.ameliederloncordina.blogspot.com
Translated from French by Christopher Seder

I rewatched your film MANGE TES MORTS [EAT YOUR DEAD] last night, which takes place here in Marseille, where you're from. That film is full of clutter, of mess, in the set design. I want to start with the idea of disorder in our lives. What does clutter and disorder mean to the film?

I wasn't born in Marseille itself; I was born right nearby, but I would always come to Marseille. I feel like I spent my youth in this city, and, I don't really know how to explain it, I think there's this disorder that's specific to Marseille, and also to Brussels to an extent. And that's something I need, in a way. I need disorder, but I also need to be able to rearrange things. That's why I left. The disorder in EAT YOUR DEAD has a lot to do with the city. It speaks to this fairly underground milieu that exists in Marseille, about people who ultimately come together often but who are also very alone. There's a lot of—well, at least ten years ago, when I was still here—a lot of debauchery and parties and that sort of thing. So that disorder comes specifically from my youth in Marseille.

There's also a similar visual use of chaotic clutter in your film DAILY LIFE. Is it connected to the disorder in EAT YOUR DEAD? Or is it a different type of disorder?

DAILY LIFE was my very first film and it really came out of this moment when I was still a student. I had a baby, and it was just this total mess, this total disorder. There was the family aspect, which was going poorly; a botched attempt at starting a family. So there was this disorder on more of a metaphorical level, maybe, and then there was also all of this organic matter that disorder accrues: clothing, chairs, and all these bodies. At that time, I was really, really into painting; all those Delacroix and so on. I was very attracted to, or at least, very inspired by painting. I had this shot in the film that I referred to as the Sardanapalus shot, because it was like this [Delacroix] painting where all these bodies were spilling out all over the place. It was a sort of war, basically. For me, there was something a bit warrior-like to that

kind of crappy, agitated youth in Marseille. And there was something similar in my botched family, too.

In a different interview, about your film SAINTS' GAME, you said, "The purpose is not to confront our heritage but to share our attempts and will to move away from it, literally and figuratively, from where we come from." What does that mean to you?

That line is from SAINTS' GAME, and there are several main characters in it. There's one guy, Timur, who's from Dagestan, who has an orthodox background. There's Rimah, who's from Palestine and has a Muslim background. And then there's me, from France, with what we'll call a Catholic background. I really wanted to show that the goal wasn't to confront Islam to Catholicism or orthodoxy. It was more about showing the resemblances that might exist between us, through our shared will to literally leave our heritage behind by exiling ourselves, by leav-

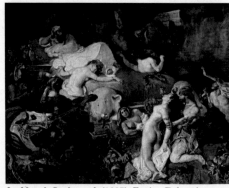

From *DAILY LIFE*. Credit: Amélie Derlon Cordina

La Mort de Sardanapale (1827), Eugène Delacroix

ing our country physically. But also, by leaving it mentally, which is to say: distancing ourselves from those religions and traditions in both a literal and a more figurative sense. Leaving it and escaping it.

What does it mean to quit your traditions? What happens to your traditions when you leave them behind?
I think one always leaves those traditions behind for fairly sad reasons. And I think that's the case for all of the characters in *SAINTS'GAME*. All of the characters left because of family issues; big disagreements. And so, for my part, it was clear that I had to leave this overly Catholic family. My family didn't accept my lifestyle, the fact that I was raising a child "without a husband," while being so young and penniless and persisting in wanting to make art. I was just a young person of my era, of the nineties. For me, as for the vast majority of my friends, my relationship to alcohol, to partying, and to love stories was excessive and alive, and sometimes disturbing. That was how it was. But I saw in my family's judgment of me and their refusal of what I was as something totally linked to old Catholic morals: they had this idea of what was "good," and it seems like I didn't fit that. In my opinion, many French people's mindset is still rife with Catholic morals.

You're from Marseille. You left for Lyon to do film studies. Then you went to Brussels. Can you speak for a moment about what led you to live and make art in Belgium?
Well, I was born in a very industrialized little town near Marseille called Martigues. I arrived in Marseille when I was seventeen. When I finished university, my daughter was already two years old. And then I was accepted into a film program in Lyon, and it was the first competitive exam I had been successful at, so I was very happy because it meant I could leave "the South." But then I only wound up staying there a year. I came back to Marseille for a bit, and then I realized staying in Marseille wasn't an option for me, for the reasons I mentioned. There

was something fairly painful about Marseille that I didn't really identify with. What I wanted was a much bigger city, particularly somewhere that was far less narrow-minded, less codified, where I could feel a lot freer. First, I thought Berlin, and then Paris. The thing was, I was already living alone with my daughter. Initially I was supposed to go to Berlin, and right before moving I said to myself, "I can't just go to Berlin; I don't speak the language, it's going to be a total mess, what with my daughter and all." So then I said to myself, "All right, we'll go to Paris then." But Paris was way too expensive and I didn't have any money, so I drew a line and found the midpoint between those two cities, and it was Brussels. So, it was sort of a non-choice, really.

That's something I always find difficult to comprehend about my life abroad, the possibility I would have to raise a child partially American, partially of a country that's technically foreign to me. With that in mind, how do you view your relationship with France?
I have a familial relationship with France. That is, I'm totally out of touch with my family, because of these huge family problems that have to do with that Catholic tradition. I very much associate the family I haven't seen for over ten years with France. So, in a way, it's sort of like I feel unsuited to it.

So is it more a connection with Catholicism, or something bigger than that?
Well, there are several things. I think the main thing was really these huge problems that I had with my family, who did not accept the path I had chosen to take. And then by association, I ascribed that more generally to an overall mindset, and I felt like France became this collective mindset I couldn't adapt to. Neither the mindset in the South, which is a little too communitarian [*in French, "communitarian" signifies cultural groups being closed off and not intermingling*] and a little too codified, nor with the mentality in Paris, which I didn't identify with either. I'm not criticizing it in and of itself, but I just don't

necessarily feel comfortable being a part of it. But of course, I'm still very attached to the landscape of my childhood, to the architecture, the towns. I like that hardness that you find in remote towns and villages in the South. Those are things that I love, but I prefer to feel foreign from them.

When you chose not to live in Paris, was it just a question of money? Or were there other reasons that went into the decision?
There was the big matter of money, but also, I don't think I'm capable of adapting to Paris. There are a lot of clichés that come up when talking about Paris and Parisian life. I prefer to remain off to the side, at a distance. I go a lot, because sometimes my movies are produced there, so there are periods when I have to go. But I think that, I don't know, I'd be very scared. I don't know how else to put it, other than that I would be very scared of Paris, of the enormous mass of fantasies and of frustration that it generates. I have this image of people who are fairly comfortable, overly ambitious, highly competitive, and a bit into society life—which, not that I'm opposed to that, but I'm unable to rub shoulders with it. So, yeah, it's more that it doesn't suit me. Plus, Paris has been filmed too much, shown too much, watched too much, so . . . let's go elsewhere!

Did you ever feel the need to live in Paris because of the film industry there?
Yes, definitely. The feeling is very recent, especially because I've grown up more, I'm more of an adult now, and my daughter is ten years old. I went to Paris a month ago to show my most recent film, *LE TERRIER* [*THE BURROW*], and the room was packed. There were people from the Cinémathèque Française. I said to myself, "Dang, you know, there's really very little about my work in the media." I've had almost no articles written about me, even though my work has won prizes. So, I said to myself, "Well, people just don't know me, do they. French people don't know who I am at all, they don't know my work." And I said to myself, "If I lived in Paris, maybe it would be a little easier for

me." Not having articles written about you isn't inherently a bad thing; it's just that having articles about you means that people will get to know you, and as a result, you have a better chance at getting produced, at living a little more comfortably. So, in terms of that, yes, more recently, I've been saying to myself, "Could I not maybe go and live in Paris one of these days?"

What do you think about that force, in Paris and other big cities, that draws in artists by their potential for greater artistic opportunities?
I'm really against all of this centralization. I think it's really bad that people think of Paris as being the center of France. I'm very moved by filmmakers like Alain Guiraudie and Bruno Dumont, even though I think Bruno Dumont is also very Parisian in his own way. I'm moved by people who, in terms of their life choices, are activists against this centralization in some way. I think that making life choices like not submitting to the centralization are necessary. And so, my not living in Paris is also a choice. It's about refusing that monopoly.

What did you miss most about France, when you decided to leave it for Brussels?
The welfare! That's all [*laughs*].

Tell me about your transition into a new place, close to home, but also far from it.
In Brussels, as soon as I arrived, I moved in with a Palestinian woman, a Flemish woman, with people from all over. I immediately started speaking English, even though I couldn't speak English at all, and so it was this totally exotic experience for me. I realized that there was a huge amount of experimenting going on and that people didn't necessarily come here to succeed; to climb the ladder. There was more of an experimental ambition. And so, whether they were singers, directors, actors, whatever, everyone was always trying things out, working with smaller forms. We would always find a way to get someone to lend us a space. I've never seen that anywhere else, such healthy competition when it came to trying stuff out. We would

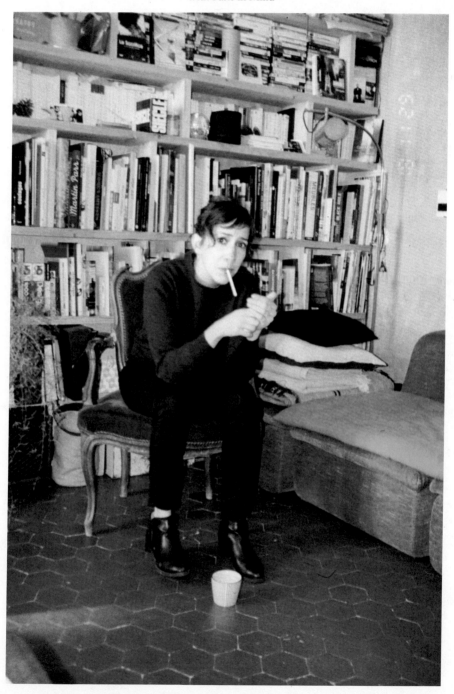

put on shows and maybe sixty or seventy people would show up. I even wrote a play that I acted in, and that I had other friends acting in, and that just made me want to make do with what I had. And I think that's a very "Brussels" thing.

Do you find that in a city like Brussels,

a place that isn't a center of the art world, that it's a lot easier to experiment artistically?

Well, I do think that it's more of an option. It's a city that's not that expensive, which has made it possible for not-so-rich people to come from all over. Brussels is this extremely multicultural city. It's pretty wild, actually, because it has this multicultural mindset. It's a city with a lot of theater, a lot of live shows, and with less film, actually. The Flemish, for instance, are really strong in theater and dance. A lot of their practitioners are very good. And in fact, they're involved in all of these things that are almost avant-gardist. I think artists in Brussels, who aren't very renowned yet, absorb some of that mindset.

What has your sense of home become after all this moving, all this movement tied to familial, emotional, and economic factors?

Home is really very simple. I just need to be with my daughter, even in a very small apartment. For me, home isn't France. It isn't the little that's left of my family, because I still do have my father and my sister. But no, it isn't that at all. It's really just my daughter and me, anywhere.

Having a daughter changed your concept of home? That's interesting, be- cause she'll be connected to Brussels in a different way than you are?

If I wanted to have a child like that, so young I mean, which in this milieu isn't very common, it was surely because I wanted to make my own family, I think. But it didn't fully work out, since you know, I found myself alone with my little girl. But, there you go; no matter where my daughter and I go, the two of us will be a family.

I'm interested in your thoughts on self-awareness, based on some of the things we've already talked about, but also on the way you present it in your films. Something I found really fascinating in your films *SAINTS' GAME* and *THE BURROW* was how the films knew they were films. For example, in *SAINTS' GAME*, you reference Shakespeare's *The Tempest*, which itself was aware that it was a piece of theater. And in *THE BURROW*, the main character described the actions of an animal as if it were choreography, and then acted out the description almost subconsciously. It creates a disconnect between the actor and the story, which felt a lot like self-awareness to me.

Yes. And awareness of the medium, too.

What is your interest in self-awareness,

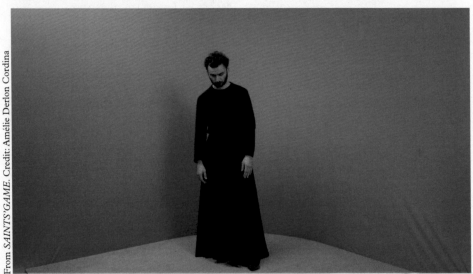

From *SAINTS' GAME*. Credit: Amélie Derlon Cordina

both in your life and in your art?
It isn't really theoretical, and it's not really political, either. It's very human. I don't want to make you feel something that isn't real, so I want to show you that I'm acting. Then it's up to you to decide what you're going to feel. This type of awareness also allows you to deliver a very clear-cut emotion, which is this formal emotion. When watching a film, I might be moved by a sentence, and maybe some music that's played over that sentence, but I'm not going to be moved by a whole big feeling that I've been told to feel. Because that kind of force scares me a lot. I find it violent.

I feel there's a new sense of identity and self-awareness in our modern culture. I believe it has something to do with technology: a new space where we can disconnect and become slightly different than our lived-in bodies.
You mean in terms of social media?

That's just one example. Like in THE BURROW, I really loved how the narrator lived the life he seemed to be critically analyzing. The analyzing comes first, but it can't prevent him from becoming that which he was analyzing. I'm just trying to understand how the average person performs the same act.
What I find very moving is to show people who are in the process of building something: building up your own life, building your story, building your biography . . . in a way, becoming a character. But it can't be a romantic idea, either; you're not going to be an actor in your own life. I mean simply: creating yourself, inventing yourself, and maybe, in turn, having some experiences that are a little bit epic . . . why not? I like this idea of deciding what your own story is going to be.

I've seen lots of people say that the image we project on social media is a falsification of self, of our ego. That we're creating a self that's not totally true, but not totally false. What do you think about that debate, the act of creating our own histories on social media?

Well, I like the idea of deciding how you present yourself. It's in keeping with the idea of coming up with your own story, which is something I find appealing. On the other hand, I do find this excessive selfhood pretty nauseating, or the representation of the self that brings about.

But do you think that freedom allows for dangers in falsification?
Yes; of course. People are showing themselves in their best light. They're advertising themselves. That's what that is. And so, it becomes this marketing of the self. "If the media doesn't want me as a star, then I'll make myself into my own star," that sort of thing. This highly contemporary relationship to stardom is terrifying; it's a new form of class struggle! I think it can be problematic, toxic, because you can fall into all this self-comparison. So yes, I think people overdo it, and that it isn't all good. But in and of itself, if it's a medium that's put to good use, it can be great.

The concept where I always get stuck is: if we create a false identity and we know we're doing it, and if we all know we're playing that game, why then do we still get hurt when that false self gets judged? I guess I'm wondering how our self-awareness changes when we artificially alter it.
I think it can generate a lot of feelings of resentment. I don't know if the identity is really false or not. We're human beings, so of course we're going to admire, become jealous, get hurt. As soon as you make yourself into this public thing, it's just like with any work of art. You have to expect positive or negative reactions from the viewer. And anyway, who ever said that fiction wasn't fully a reality?! [*laughs*] ◊

Musicians

Talking with

Adam Naas & Merryn Jeann

about friendship, collaboration, and their effects on the brain.

Adam: "You gotta open your heart somehow, because otherwise you're fucked in this industry."
Merryn: "If you're gonna be making music all the time, you need friends who understand what you're doing and how you function so you don't make excuses for yourself."

I think about friendship a lot. I think about the way it bends and breaks and puts itself back together. I have a photographic memory for moments of prolonged laughter I've shared with those I'm closest to. I think about those moments often. I think about how I can be better at friendship and wonder, in turn, what that "better" might do for society: if "better" can leak out of private relationships and get on society's shoes, on its hands, on its cheeks. When I see serious friendship, friendship that is burning hot, I watch it and I think about it and I try to touch it so I can emulate it. In September, a few weeks before this interview, I witnessed a moment of that hot type of friendship. Adam and Merryn, two solo singers from France and Australia respectively, were sharing the stage at a concert. They weren't singing like they were supposed to, because they were too busy laughing. The crowd had come to see them sing, but in my head I was thinking, "This is my sort of thing. This is what I paid for." The way they laughed, the way they held on to their private moment of laughter in front of a sea of expectant strangers, told me so much about two people I knew individually but not collectively; friendship-ly. I'd known Adam for years and Merryn for months (Adam introduced me to her) before that concert and before this interview. I knew they were both about to release their first major solo albums. I wanted to know how their friendship was helping them to survive this major moment, survive the music industry, and survive their lives generally, because for me, seeing friendships like theirs is the sort of thing that keeps me living.

Instagram: @adam.naas and @merryn_jeann
www.merrynjeann.com

[*To Adam*] **What are your first thoughts when I say, "You don't know me because I don't know myself. Am I plastic, a consumer of what I do?"** [*One of Merryn's lyrics*]

A: What is interesting in this line is that the first part is talking to yourself and the second part is talking to someone else. So it's like this weird thing between what I think about me and what you should think about me and why I wanna keep you safe in this relationship we're having together. First I gotta know myself before knowing you and before you knowing me. So it's like this back-and-forth of trust and intimacy.

Merryn, in one sentence, can you describe Adam's voice?

M: To me Adam's voice is just completely free. I feel like it's, well, there we go, end of sentence.

I want to talk to you two about friendship. Your friendship and friendship generally. Is that cool?

A: Yay! We love that [*they start holding hands*]. We're so good at friendship.

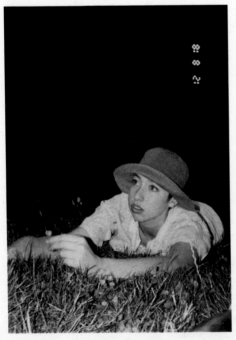

What aspects of each other's music move you the most?

A: I love the way she—can I talk to you? [*Directed at Merryn*] I think it would be better. I just love the way you take some risks in your music. It's not even risks because it's who you are. That's the beautiful part because we can tell by the way you're doing your music that you're not trying to please anyone else but yourself. And the way you remind me of Gershwin's music and the beautiful way music should be.

M: I've had the pleasure of listening to Adam's new album, and every time I see you I keep forgetting to tell you. Your presence in your music is very daring, very much you, very free and I feel like you're quite vulnerable. What you sing about is very emotive, it's about love, it's about sex; a lot of times it's hard for people to talk about those things with such attack.

What have you learned from one another musically?

A: I think I already told you, Merryn, that actually. I realized that my voice was also like an instrument and it was thanks to you because the way you were using your voice, it was so new to me. Especially with French, you can't really play with the sound. It's hard. But in English you can, and the way you came up with that freedom in your voice. I found that so fucking reassuring; it made me a bit more trusting of my voice thanks to you.

M: Seeing Adam perform, you're like, "Fuck yeah, this is what I'm doing, this is how I'm feeling, I'm gonna move my body, this is how I'm gonna sing this, I'm gonna make some orgasm noises." It's bold. I know personally I'm still trying to figure out that complete trust within myself. Just doing what you wanna do.

Tell me about how you met. Describe the moment, what you each felt.

M: Wow, I wrote it in my diary because the first time I saw Adam we were at the train station.

A: Gare Montparnasse.

M: And I was sitting with my friend and we were like, "Oh those guys look so cool." And

we were like, "Oh my God they're getting on the same train as us." We didn't realize we were both playing at the same festival, Hello Birds, in Étretat.

A: Then, I saw them too, they had this aura around them. We both got off the train and there was this guy waiting for us to take us to the festival we were both playing. Merryn was wearing a Parcels T-shirt. I don't usually talk to people I don't know. I'm so fucking shy. But I saw the shirt and I was like, "Okay, I like this band. It would be a good icebreaking topic." So I gather all my fucking bravery and say to her, "Hey I like this band," and she was like, "Cool, they're good friends of mine," and I was like, "Okay!" I wasn't really interested in the T-shirt. I was interested in her because she had this great smile, and the way you were looking at me, you went straight forward into my eyes, you were not trying to look away. It was like, "Hey I'm with you right now." It felt genuine, which doesn't happen that often.

Merryn, do you remember how you felt after you two had that first conversation?

M: I was so excited because the thing is, we both ended up playing one after the other at this little chapel, this beautiful chapel on top of a hill looking over the bay and it was awkward because I was so thrilled. I remember saying to my friend, "This is so exciting, new friends, *new friends*!" I was so excited to be making new friends because I had just moved to Paris and didn't really know anyone . . . well, not people who were "my people."

You recently played a show together in Paris, in September 2018. You each played solo sets and then a song together and during the song you had a moment of improvisation together, chatting on stage. How did that moment make you feel, coming from that first train ride to the point on stage?

M: From then till now! I've never thought about it like that . . .

A: I cherish these moments because they are the most important parts of a show. Even the shows I do on my own, I try to keep a certain

spontaneity. And you know, I'm really proud of my friends and I want people to see them as I see them. So that moment was perfect because it was the perfect combination of Merryn as she is as a person and who she is as a musician, and who she is to me as well.

What does having a friend in the music industry, a friend doing something similar but different, do for you psychologically?

M: It's so easy to go down a road where you have to work and you isolate yourself from everyone. If you're gonna be making music all the time, you need friends who understand what you're doing and how you function so you don't make excuses for yourself. I feel like it's important, if music is everything you're doing, you need to have those moments where you're with friends where you're still functioning with people rather than just working.

A: Knowing Merryn and having her in my life is reassuring because we can talk about everything. The spectrum of conversation we can have is infinite. Every time we talk to each other, time flies. We end up talking

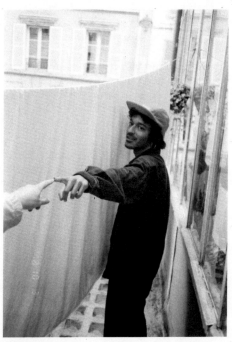

to each other until three in the morning, reading poetry to each other. Two minutes before we were having a laugh about how cats are fucking stupid, wondering if stars can talk to each other. It makes you feel like you're still a kid. It's the kind of relationship where you're using your imagination to change the reality and it doesn't matter if you share the same opinions on things; it's just talking to each other about what we feel. You gotta open your heart somehow, because otherwise you're fucked in this industry.

Adam, your first full-length album, *The Love Album*, just came out. To me it's sleepless nights thinking about the joys, tears, and manias of love. Why did you need to write it now?
A: I need to write about that because at the moment, love is the only thing that's important in my life, which is so fucking stupid. I needed to experience and write about all the different aspects of love. Not just the love that you can feel for another person but also the love that you can feel for yourself, like how you consider yourself. Do you love you who are? It was important for me to get myself around this topic that is so difficult.

The first song on your album is called "No Love Without Risk." I'm obsessed with the ideas of bravery and absolute loyalty in love, romantic or platonic. What risks do people need to take to be in love?
A: I feel like this risk I'm talking about in regard to love is probably the risk that is so general in our life. I'm trying to feel this feeling of being frightened, being afraid, cause I feel like it makes me do things now. I feel like it's an emotion that makes me wanna change things about myself and the world that surrounds me. It makes me feel like I'm a kid and I can change reality.

I feel like there's a lot of fear in the world right now, and I agree that fear is a motivator, but I feel like people are using fear to create hate; you're using it to create love . . . so, when you get afraid,

how does it trigger something more positive?
A: You can't be brave if you don't feel fear. If you are very hateful, it's because it's the easier way. But if you wanna spread love, you have to make a choice to acknowledge the parts of yourself that are full of hatred. Because it would be stupid to fight it. And then be brave enough to go the other way.

Is love what you expected it to be when you were younger?
A: Not at all, but that's the good part. It's a living thing. It's a living emotion deep in us. So it's always different for everyone, and that's the thing I like the most about love.

It's interesting that, that love is a living organism?
A: I want it to be. There are a lot of people who think love is just a social construct and I find that pretty sad. I don't wanna believe that. I would be crushed if one day that was true. It comes from a place that is full of compassion and empathy.

Merryn, you had a huge song a few years ago with another artist, something like 200 million plays; now you're about to release your first solo EP album, which is a lot different from that song. How did that first success affect the way you think about music? And how has your music developed since then?
M: It was very exciting. That song took me around the world; that was fun as a moment, it was a pop song and up until that song I was like, "Fuck pop music," being a dickhead basically. But it was so nice to perform to people who felt so happy and so excited to be hearing this music, and I was that chick who sings the song they listen to every day. In those moments my understanding of pop music was totally flipped. If you're being true and having intention and people are receiving it, it's so beautiful and I was grateful to be a part of that. I got to see the industry without being completely signed into it contractually, and knowing that doing the pop thing wasn't for me. It came down to a realization that you have to be honest about

what you're making.

You have so many lyrics I really love. Can I ask you to talk a little about some of them? Like, "Am I just a part of this, a stranger to the time? Well my body is just a shape but within it my soul is found." Where is the dissonance between your soul and your body because of these strange times?

M: It's very internal, it's in my mind. I feel like I can see life is beautiful, that my friends are beautiful. I can see that we're laughing. But then there's this middle, this numbness, physically and emotionally it's very different. When I wrote that it was like, "I might die but I have a soul. Right now I'm struggling with having a soul because I can't connect to it." And so it shifts. It feels like meditation; you have a thought and you just observe it, then let it go, rather than drowning in it.

You say, "Mystery has done me wrong, my words, they are not my own . . ." Mystery can be a bad and good concept. In what way can it do you wrong?

M: I was referencing something more negative, which connects to losing innocence, the first time I started keeping secrets. From that mystery, I started lying to protect people, which brought even more negative things into my life. And then I started lying about how I was feeling. So I think, "My words, they are not my own," is saying that I'm trying to put on a brave face right now.

I've been doing research on young people and the mental health stresses of city life. Research shows that having a strong "social network" in the traditional sense of the word, friends and family, is the best remedy against the negative effects of urban life on the brain. Because you two seem to provide each other such strong support, I wanted to talk to you about mental health in the city: What does mental health mean to you?

A: I really feel like if we were born a hundred years ago with what we've got right now in our brains, we'd be considered as crazy people. So I feel like mental health goes with

your surroundings. What was crazy in the past is very acceptable right now and what is crazy now will be acceptable in the future. So I feel like it's a misjudgment of temporality.

M: Maybe mental health is defined by society before you can define it for yourself? Let's say society calls someone crazy because they're living a more psychedelic existence. Maybe they would only deem themselves crazy because of all the judgment they feel from everyone else. I often feel that those people that are called "crazy" are so in touch with what's going on.

You both made similar points about society defining words before we do, and temporal acceptability . . . how do you think society is making us view mental health?

A: There are so many people now, and I feel like maybe society is trying to regulate itself by making people the same as everyone else. Like they're trying to create a common and general personality now, and that's the worst part ever, and that's why I choose to be a singer and a composer and someone who is gonna put emotions out there. Society points fingers at people who try to stand out. But

you know what, *I like it*, and I find people like that pretty fucking awesome, because we are the weird ones and we're the underdogs and we're the freaks and that's cool.

M: This type of homogenization is just people trying to connect, trying to feel a part of something.

When you look at the people around you, what does it seem like people are the most confused with in their lives? What gives them the most stress? The most anxiety?

A: Projecting ourselves in the future. I feel like this was a big struggle for me and all my friends . . . understanding who we are and what the world is and how these two fit together.

M: There's this great song on the Lee Hazlewood and Nancy Sinatra album, why can't we be like "Storybook Children"?

[*sings*] "In a wonderland, where nothing's planned, for tomorrow." It's hard when you understand that everything is a lot bigger than you had thought.

Adam, you're born and raised in Paris; what does this city give you on a daily basis?

A: I've got a very strange relationship with Paris because I'm very in love with the city and I'm also in love with all the myth around it. And me being a maniac romantic depressive person, it's the perfect place for me. I always feel like everything is possible in the matters of love in Paris. That really inspires me. I think it's the only city I could be inspired by.

If you were to move away in the pursuit of your music, what do you think you'd miss most?

A: When I was fourteen, everything had a sense of danger and I actually liked that very much. But now everything feels like a big bed. Like when I take the Métro I feel so good. I don't really like the bus. I always take the Métro because I like the choreography. It's funny how we never bump each other. You know, how there is this person who has this life and you're never gonna know this person ever in your fucking life, but if you just went five centimeters on the right you would bump this person and maybe you would start talking, maybe talking for three hours, maybe! And maybe you would start having a relationship and maybe that person would be the love of your life. You're always five centimeters away from that person.

M: Always five centimeters away from love.

Merryn, you moved here recently; how has the transition been? Why did you move? What do you find the most inspiring about the city? What do you find the most difficult?

A: Because I made her . . .

M: I've come to France quite a few times since I was a kid and always loved it; I always romanticized it . . . [to Adam] What to you is that romantic thing?

A: About Paris?

M: Yeah. It's not like everyone is off the grid, doing beautiful poetic things all the time. But there's this energy here that I've never felt anywhere else. And you're from here, even Parisians can see how beautiful this city is, and often when you've lived in a place your whole life or you're from somewhere . . .

A: You get fed up with it.

M: You're like, "Ehhhh," you're blind to it cause you're used to it, like, "Oh yeah, that's just the fucking Sacre Coeur."

A: I don't know, there is this je ne sais quoi in the air [they both laugh]. It's a city that actually lives; you just have to walk thirty meters and you'll end up in a different quartier, you're gonna see so many different people, and it's not a really big city when you think about it, it's not LA, it's not New York. It's a city with a lot of character; it's a very sassy person.

M: There's something very special here that I connect with, the characters, the energy of people, the personalities, a really "I don't give a fuck" mentality. What people often define as rude, I'm like, nah, they're just having a look at you.

You incorporate a good amount of French into your lyrics and your videos. Why do you do that? What does this second language do for you? How does it make you think differently about your music?

M: To be able to speak another language generally is a cool little secret thing you can have, because you can have another personality. I might say "Genial!" when I want to say something else, but all I've been hearing is "Genial!" so I'm gonna speak it; you have a different way of relating with people. Recently I've been trying to write for French songwriters, writing their lyrics, but then taking away their lyrics and using their syllables and writing English into that. The other day, Adam was translating my lyrics, and that's a whole new way to write. Because we don't write like that in English; we use different syllables. It's all so different. The way I'm gonna write French is not the way you're [nods at Adam] gonna write French because you have to think about it differently. It's cool, the different relationships you can have with language and people.

Are there places in Paris that you both go to make yourself happy?

M: I love going bike-riding, also to Buttes-Chaumont, the park. That's the best. Tai chi nine to ten every morning; do it, it's free. Also going to really busy areas, and then leaving them feels great.

A: [laughs] I relate to that so much. For me, every apartment where my friends live are these little secret places where I can go and chill. It's so good to know people where you can just go over.

M: Like, hey I'm busting, can I use your toilet?

A: Yeah like, "Hey dude, I really need to take a shit right now, is that possible?" And even then, maybe it will be the start to a fucking great night . . . you never know. ◊

55

Talking with

Bagarre

about building a modern band, screaming a modern message.

"It isn't music that changes things. But it does help the people who change things to go on living."

Bagarre's music fucking bangs. "Fucking bangs" is a phrase I'd always wanted to use but never knew how . . . until listening to Bagarre. Their basses knock your consciousness. Their choruses scream your anticipation and release. But under the screams and the bangs of their "club music," Bagarre's music is sweet, sexual, political, caring, and kind. Their lyrics are full-on honest acceptance of confusion (environmental, governmental, financial, romantic . . . everything). Their music contains the exact type of self-questioning, self-critical self-awareness I look for in those my own age. Take the line in their song "*La vie c nul*" ["Life Sucks"]: "Behind the screen / But not in the ballot box / I voted white / In the moonlight." That's everything. Tech-distracted. Politically numb. Eveningly-mysterious. Listening to a Bagarre album, *Club 12345* for example, is like living the everything of a day. There are moments of calm when self-doubt creeps around (on the song "Honolulu"). There are moments of anger when no one is safe (on the song "*Écoutez-moi*"). There are moments of joy (on the song "*Danser seul*") and there are moments of masturbation (on the song "*Diamant*"). In Bagarre's art there is, fully contained, high to low, the daily coaster of our manic emotions. Speaking to Bagarre is an everything experience as well: five members, each with a stage-named performance persona. Each with a differing opinion. Each with a desire to make music that means something more than the unconscious bangs of a club banger, without forgetting that club bangers can mean something too. Sometimes club bangers, music that does nothing but fucking bang, can mean everything to those of us brutalized by the underlying horror of everything else in our lives.

Instagram: @_bagarre
www.noussommesbagarre.com
Translated from French by Christopher Seder

[Bagarre is made up of Emmaï Dee, Majnoun, Mus, Maître Clap, and La Bête. They are five people, but as Bagarre is passionate about speaking with a complex, unified voice, I've blended their answers into a single "person"; a band.]

If Bagarre was an animal, and that animal was two animals put together, what animal would you guys be?

Well, a wolf, for starters. A platypus, too, because there's this tale about the platypus, that it's never satisfied, like, the beaver's tail, the duck's beak. There's something about hybridization going on here that's interesting. I think that there's a thing with the phoenix, too, because we're kind of always reinventing ourselves. A platypus-phoenix! That sounds like the ugliest thing ever [*laughter*]. No, but it's true that with the subjects we take on, things change, they evolve. Currently, I think we have this feeling like we could never die. That we'll always be able to reinvent ourselves, in a certain way. Also, we could do a number on this question by putting together two animals that are already combinations, like a chimera and a hydra. Or a centaur and a chimera.

In the song *"Mal Banal,"* **you say, "We love symbols, not violence." What symbols are you talking about and what do you think people see in them?**

That was about saying: today, what matters is as much the representation of acts as the acts themselves . . . in terms of how we perceive things. In the song, there's this whole part that goes, "I would like this, I would like that, and yet I do nothing, and I like doing nothing." And the "We love symbols, but not violence" thing is to say that, well, yeah, we like Che Guevara, but we'll never take up arms because we're afraid to die. There's this paradox that exists between a humanist fervor, this desire we have to change things, and the violence that fascinates everyone and makes everyone think violence is how you solve things. The reality of really saying to somebody, "Well, if you want, I've got a gun, here you go, have it, go shoot a president down," and then you're like, "Well, actually, no . . ."

The line in the song "I'll douse myself in gasoline" was a reference to Mohamed Bouazizi, who started the Tunisian revolution, and to that guy who set himself on fire in front of the unemployment office. That's really a symbol of a kind of individual revolt that can become political: self-immolation. And it was about saying that, really, I'm light-years away from setting myself on fire. The only thing I do—which is not a political act, but an act of withdrawing into oneself—is to get drunk off my ass, and that's it. And that's the end of the verse, which kind of speaks for itself.

What role do you think music can play in politics?

We have a line about that. People often tell us that we're a socially conscious band, that what socially conscious bands do is change things. And we have a tendency to respond, in our opinion, that it isn't music that changes things. But it does help the people who change things to go on living. Because the truth is that our actual firepower is pretty limited. We know a few activists, and we know what we do is not the same thing. Maybe we help them along, financially when we can, or by signal boosting their cause

when we can. In terms of communication, we have weapons. But we aren't changing day-to-day life. That's it. We are next to it; we stand beside, but we are not the weapon.

For instance, if you really throw yourself into a concert, or give it your all for the amount of time it takes to listen to a song, and that song then gives a lot of people strength, it becomes something they can take with them, into real life, to have at their side, and it will add to their self-confidence. It helps you to live, basically. Music saved my life, personally. There came a point in listening to it when I said to myself, "Holy shit! I'm not all alone; there are other people who think the same thing I do!" It meant that even if I was the only kid in the middle of the countryside with long hair, I still wasn't all alone. And it felt like having my own mini self-revolution. That I wasn't all alone in it. And that changes everything really, because you exist, and if you exist, then others exist. And that just changes everything.

Your lyrics often discuss political debates of the moment: gender, violence, progressivism (and its struggles and failures). How do you mix the political opinions of five people into one musical voice?
Well, we all express our viewpoints differently. We don't say the same things. We allow each idea to exist. Granted, we have lots of heated debates about them. But I think that everyone gets to say something that's specific to themselves. And what's more, if you put our various topics into categories, I think you might even find contradictions between them. But we embrace those contradictions.

Has there ever been a political topic you couldn't come to an agreement on and so decided not to put into a song?
We aren't trying to have majority rule. We don't say to ourselves, "We all need to be 100 percent in agreement with what so-and-so is saying." So-and-so just needs to be pushed to clearly say what they want to say, to understand it, so that we can understand it, precisely so that we can help them along with

that idea. We always push each other to go all the way, to follow through with our ideas, to try really saying what it is we have to say, what we're feeling. And to really break that barrier of coyness, of discomfort, and the fear of words. So, no, I don't think we keep each other from saying anything whatsoever; on the contrary, we really push each other to take things to their logical conclusions.

I like that idea of accepting the fact we all contain contradictions in ourselves, and how, by creating a single voice that speaks for multiple opinions, you explore that fact.
Only neoliberals don't contain contradictions. The thing is that there are plenty of differences that exist, plenty of little particularities within a greater whole that exists insofar as people say, "We have lots of differences." Which is sort of like what we do—we're five individual people, and yet, we're part of a whole. And our commonality, the thing we share, is that we're different. The Internet has collapsed loads of barriers. Geographical barriers, age barriers, barriers of difference. And as a result, the Internet allows you, without knowing it, to communicate with people who are very different from you. Because my story doesn't resemble your story, so if I just try to tell you my story, and to tell you that my story is such as it is, well, the thing is, you aren't me. But you can potentially relate, in your own way, to my experience. And that's what we try to get people to feel.

You released your first album, *Bonsoir, nous sommes Bagarre*, a few months before the *Charlie Hebdo* attacks and your second, *Musique de Club*, a month before the November 13 Bataclan attacks. A lot of the images and messages in those albums linked with the politics, emotions, and sentiments Paris experienced after those attacks: violence, pain, confusion, and malaise. But those albums predated the attacks. I wanted to know if the two Paris attacks changed the meaning of those albums in your mind, in hindsight.
What's funny is that it gave different values,

or different meanings to certain lyrics that we had on the EP, such as in *"Mourir au Club"* ["Die at the Club"] and *"Ris pas"* ["Don't Laugh," *also slang for "Paris"*], which, I mean, does talk about a guy who's fed up to the point that he blows himself up on the subway. Which is really quite close to being a jihadi. But that stuff was already in the zeitgeist at the time, really; it was in the collective mood.

It was very strange when people started re-posting *"Ris Pas"* as a sort of ode, more or less, to their Paris, after the Paris attacks happened, since it was a song about something that was fundamentally pretty much the opposite of that. People flipped the meaning of the two songs around. *"Ris Pas"* became an ode to life, even though it advocates the opposite of that, and *"Mourir au Club,"* which goes, "We are going to try to experience something, even if that means dying from it," was taken to mean, "We're going to die at the club." So, they flipped the songs' meanings around, because people just do whatever they want, really.

Your most recent album, *Club 12345*, which came out in February 2018, was Baggare's first album to come out after the attacks. Did the Paris attacks, and your music's relationship to them, affect the messages you wanted to put in that album concerning Paris or France more generally?
Our song *"Béton Armé"* was a way of expelling the whole mess that was caused by that. The thing is, if you don't take responsibility for what you're setting up when you organize society—I'm thinking for instance of the fact that we abandoned people in the suburbs, and that when you're left alone and abandoned you literally lose your mind, which is not to excuse them, that isn't the point, those things shouldn't be confused—but people shouldn't be surprised when at a certain point . . . I mean, it's like when a couple have a fight, it's not just that one of them is a pain in the ass; it's that both of them have a problem. And it's the same with this. These aren't just like crazy people

who have come out of nowhere, fallen from the sky, and come to destroy everything. These are people who live in France. They're people who grew up in France and who have a problem with that. So, really, the problem stems from here. We are the problem.

With your album *Musique de Club*, you put out five videos, one for each track, with each member of the group playing the lead in one of the videos. I've noticed in your work that songs, and the videos that go with them, live both individually and as components of something bigger, an album. The releases are staggered so they live on their own for a while, but they come from a unified idea. Why that structure?
The thing is that the album format is basically thrust upon you by the music industry. When you're an artist, what you would really like to be able to do is have songs come out one by one, as if you were reacting to what was going on. You'd like to be able to react at the same pace as society does: something happens, you go to your studio, you talk about it, you make a video, and you release it, just like a YouTuber would, or as you would a tweet, just like that. Music is maybe, with photography, the art form that takes the least amount of time to make, but it still takes time. When you see people online talking to you continuously through their [*Instagram*] stories, through their YouTube channels, by tweeting all the time, the thing is that you start to want to talk the same way those people do, and at the same pace and with the same spontaneity.

You tour a lot in tiny towns, in the countryside, in small villages. When you tour there, you bring the idea of being in a "club." In other interviews I've heard you discuss your album *Club 12345* as more a social idea than a physical space. Are you trying to create something by bringing your music and your ideas to places that aren't Paris, that might not have clubs? A movement of some sort?
It isn't necessarily a social movement, but maybe it's a collective energy. It's this thing

like, "I'm going to do this," "It's going to be like this," "I'm going to have my moment," and well, that's priceless, really.

We have this thing we say, that was one of our slogans and still is one really, which is that, "You are the club—the music is yours." And that involves saying that only exists if people are listening, and if people believe in it, and if they're actively experiencing the stuff we talk about, the things we're saying in that moment. And that's what makes the difference between going clubbing and going to a concert.

So explain to me the idea of a "club," beyond the physical space.
The difference is that when you go to the club, you go for you. And often, there are as many reasons to go as there are people who do so. And people meet inside of there. And, in fact, you usually stick around in a club for a while; you stay for four to five hours. You move around, you go and have a smoke, you go take a piss, you go drink, you go dance, you go flirt, all sorts of stuff happens. It's just the soundtrack that generates intimacy. The music is so loud that you get the feeling you're in total silence. As a result, you can think your own thoughts, you can dance on your own. And then sometimes, you can say something to someone, and nobody will hear you, and if you make eye contact with someone, you get the feeling that you're the only person doing so. Everything becomes softer and more full of possibility. And so, that's the moment that we're trying to recreate every time we perform somewhere. We try to recreate it in people's ears when they're listening to it alone at home, but we also try to do so at our shows.

that you're able to realize yourself through. It's true that recreating the symbolic idea of the club, which really is one of our stated purposes, a club to which everyone is invited to show up as they please, as they are, a space of freedom, I think that's something that's dear to us. But I don't think it's a movement. It's more this "energy."

A collective energy?
There's a link between the various audiences we encounter. In Dijon, as in, say, Lille, on the last tour, we saw there were similar types of people who would come, and that it was also a mindset. And we saw people who would come to our concerts and who really understood the sincere desire we had to distribute and create a moment. That's why we say we're inspired by "music at the club." That's the space that we want to create, and it's also the moment when you say to yourself, "Fuck it; I'm allowed to be who I want to be . . ." That kind of sounds like this promotional spiel, in the sense that it's the sort of thing one might say in an interview, but it's true. There's this thing where we tell ourselves that people are showing up with that desire. That there are people showing up,

Can you describe to me an experience you had with this club idea, outside a major city, in a place that doesn't really have clubs?
We did a concert in the Aveyron region, for instance, which is this very isolated part of the French countryside. And we played in a *salle des fetes*. A community center. A town hall thing, it's a place that will host everything

from musical events to gym competitions to, I don't know, wine festivals. And here, there were just kids and then people who were either a bit or a lot older. Basically, there was everyone, the whole village was there, more or less. I think most of them didn't know us, but because there was an activity, and since there's like one activity every four months, I think they would all go to anything. And so we did this show, and that time we got the feeling, more so than in loads of other places, that this was our work, or that it was most important there. They weren't coming to see us, specifically; they were coming to all wanted to sing.

Why did it take a long time to set up?
Because it isn't easy, because running it is complicated on a human level. Everything is easier when one person says, "This is how it's going to be." For instance, you mentioned Wu-Tang Clan as an example. As it happens, they're all very close, on a human, historical level. Some of them are basically brothers or cousins. But they also all have skills. And they were kind of recruited on the basis of their skills, and then later on, they existed independently of one another: ODB,

experience something. And as it happens, that's what we tried to do, we tried to make them experience something. And as a result, it was this great moment. We're like troubadours; we go and try to enliven the lives of people going through fun or not-so-fun things, and who are sometimes a bit isolated.

I'd like to try making a link between politics and something you often discuss: the hierarchical structure of your band . . . the fact you don't have one. To me, your band is a bit like Wu-Tang Clan meets the Occupy Movement. You have individuals with different skills and specialties, but you spread that across an equal horizontal structure of both individual attention and decision-making. Was this something you developed when starting the band, or did it develop over time?
It's a thing we knew we wanted very early on, but that took some time to get set up. Because it isn't easy. We very quickly understood that it was what set us apart, too. The fact that we

Ghostface Killah, Raekwon, and so on. Us, on the other hand, we were just friends. We didn't necessarily have any specific skills. So we had to get some skills. We all wanted to exist, we all had something to say, but we didn't have any skills. There wasn't one of us who was good at freestyle, there wasn't any Ghostface Killah, there wasn't really an ODB, you know, charismatic and all that. We all had the same stuff, except the skills. So, we worked on things.

If no one person has the responsibility to make a final decision, how do you decide a song or video is finished?
Ah. That's not easy, that. That's a real tough one. The truth is there are definitely steps, including for example in terms of the text; we know when there's something missing. But it's always hard to say to yourself, "It's finished." It's never easy to say to yourself— except that you do have deadlines, which push you to move toward finalizing things— but otherwise you can just keep on going with different versions, endlessly. Instant satisfaction is rare. I think it's easy for

something to never really be finished, and that it's really another person who often has to say to you: "It's done."

How does that work psychologically? By having a group with a very equal organization structure, when you pitch an idea, are you less scared of being shut down? Of being told, "No, that doesn't work," of being told, "That's finished"?
I think we all have egos that exist and that are our own. I think there's this really strong and beautiful thing about being able to make remarks about each other's stuff and to push each other to erase, a bit, that negative ego that we can all have.

There are times, when you feel your idea isn't good enough, you don't necessarily want to hear that, or in any event, you don't necessarily want to hear it on the day when you don't have a good-enough idea. You might be okay to hear it the next day. To listen to yourself and to say to yourself, "Yeah, okay, it's not that good." But on the day of, you're like, "Nah, come on, fuck you, my idea is good." That happens; of course it does.

What do you think this sort of group dynamic has taught you, after four or five years of being together? Have you found more productive ways of saying no to one another?
We might say no to a piece, but not to a person. But then, one thing that's funny, and this is a thing where I think we are also defending something that's an inherent part of Bagarre's nature and DNA, is that we want to operate in a way that goes against the times, which is a time of individuals. And that's something that's dear to us, and that has real value. Especially in the worlds of art and music, which are far more made up of individuals, and sometimes of collectives that are really just collections of individuals who are juxtaposed in this more distant way. We are a band. And that's no longer in the zeitgeist; there aren't many bands anymore, and that isn't just for economic reasons. It's just that that's the way things are now.

There are too many of us to take a selfie! That's it, really. There are too many of us, sometimes, for the media to get it. Because in addition to that, as you'll have noticed, the way that we present our views is pretty dense, it's pretty complicated; it espouses a number of different stances, and all that. Even the idea of being on TV, when going on set is an option, when we have to explain the idea of our group, and we have to do a two-minute elevator pitch for TV, believe you me that not all stations are into it. But we decided to make what is different about us, which may seem like a weakness, into a real strength. And I think it is one, for starters, anyway. ◊

Writers

Talking with

Nina Leger

*about judgment and sharing sex stories
in a world of male sexuality.*

"There's nothing scandalous or transgressive in talking about sex. . . . I wanted to describe sex like you would an aloe vera plant. Like a rose in a glass case. Like a lamppost. To bring that same eye to bear on it."

Before ever reading a word of Nina's *Mise en pièces*, I watched it spark an argument on YouTube. Fitting, I think, for something so expertly crafted in modernity. The video is a rerun of a nationally televised talk show about books (because they have those in France). The argument itself is really a scolding and a defense. An embarrassing scolding and a fascinating defense on the subject of sexuality. The scolder is an old man who, frighteningly and demographically, I could see myself becoming in the future, if I'm not careful, if I don't spend my life learning and accepting and changing. In his lecture, the scolder scolds a younger woman, explaining to her what sex *is*; what sex *should be*. The scold smacks of stasis. It smacks of a tired man who's forgotten that the world moves forward, develops, redefines. Funnily enough, the older man ends his scold by telling the younger woman that her conception of sexuality is dated. The defender, the younger woman, is Nina. She responds calmly and simply, "No; it's your conception of sexuality that's dated." And now, after having read *Mise en pièces*, I can see that she's right. There's no *is* in sexuality anymore. There are no *shoulds*. Any that remain are related to violence and consent, and as so, are a given. Nothing about modern, consensual sexuality is interesting anymore. We've shed our taboos and are simply waiting for greater normalization. We're all implanted with little kinks that, with the help of the Internet, we can find are not uncommon. And that's boring. And that's gorgeous. And that's the beauty of Nina's novel. By hiding gorgeous, acceptable modernity under the guise of a woman who sleeps with the men she passes on the streets of Paris, Nina challenges us as readers to realize that a book about disembodied cocks and late-night hotel liaisons has nothing to do with sex. Nina's book is actually about everything interesting and worth debating underneath sex: self-acceptance, self-love, judgment, and the necessity we have as a society to progress.

Twitter: @NinaLeger1
Translated from French by Christopher Seder
An English translation of *Mise en pièces*, titled *The
Collection*, is now available from Granta Books.

Mise en pièces **plays with the idea of reflections, mirrors, angles of observation. There's an image I loved of a hotel room with facing mirrors, and the room repeating. What does the image of standing in between two mirrors, facing one another, mean to you?**

Infinity. Infinite replications.

There's a moment in the novel when the main character, Jeanne, tells her friends about her wild sex stories in order to stop them from leaving a party, to keep them present, to keep the party going. At first, the friends seem to enjoy the stories, but eventually, as the stories get more intense, the listeners devolve into judgers, judging and pathologizing Jeanne's life choices. I find sexuality to be an interesting catalyst, sparking excitement in the vicarious, but only to a mysteriously defined, finite limit.

When Jeanne talks about her sexuality, what arouses her friends is the idea they can get hold of a secret, that there's something that's a bit illicit, a bit devious. I think, today, obscenity relies on how we perceive and judge sex stories, not in the stories themselves. The true obscenity is this impulse that makes us think, "Oh, it's a secret, oh, it's hidden, I want to know more." We want to know, and once we know, we judge: when Jeanne finally tells her stories, she's judged by her friends. They feel an urge to help her change her ways. Sexual activity, when it's too intense in a woman, is considered as something wrong. For example, judging is what we do when we call a woman a nymphomaniac. The term is not an objective way to describe someone's way of life, but to identify an excess, a pathology of which the cause has to be identified and treated. Nymphomania is one extreme part of a discursive system in which men are seducers, while for women, sexuality is considered a weakness more than a power. In the novel, the people listening to Jeanne's stories don't stick to the facts. Beyond the anecdotes, they are longing for explanations. They want to know the reasons why she acts like that. But Jeanne won't give explanations. Then her friends impose their own explanations onto her. They reduce her to causes that produce effects, implying those causes ought to be cured, in order to avoid those effects. More often than not, explanation is a tool of judgment and condemnation.

What I find odd, in the act of sexual-story-swapping, is how we want to hear the most risky stories, ones that imply danger or living on the edge. We're not looking for someone to describe their very average sex, no matter how enjoyable. And yet, when someone actually lives out a wild story, then tells people, it makes the story-sharing awkward, the sharer often ostracized for it, often later, behind their back.

I hope one day, we'll get over our fascination with things being scandalous. Things about sex are not scandalous anymore. But we still act as if they are; we're still looking for the juicy side of things in stories about sex when it's not the most interesting aspect of it. What matters won't be the acts carried out, but how they shake up a person. Sometimes, a very banal, bland event can shake up a person more than a wild adventure. But to do that, to become detached from the obvious in the stories we hear, we have to learn to become better listeners. Which is not an easy thing to learn.

On the surface, this novel seems to be about sexuality. But I don't think it is really. I feel that sex is the bait to draw people into an arena. It feels like *Mise en pièces* has more to do with judgment than sex. It feels as if sex is a test for the reader: will they judge Jeanne for her inexplicably ultra-sexual life or will they see the beauty, beyond the devious acts? It also feels like Jeanne is aware of the judgment she might receive from the reader for her lifestyle. For example, "She tried to read, but kept stumbling at the bottom of page 263 of her book. . . She didn't know how to make sense of these words, imagining them to have been directed at her." I like this quote because, for me, it relates to

> "From this murky moment of hormonal delirium, she will fashion a late-night anecdote for when parties empty out, when just a close-knit circle remains and when, in order to keep the group together, to stay just a moment longer sitting in the same light, people tell secrets to try to amuse the others."
>
> From *The Collection* (*Mise en pièces*)

the way perceived external judgment can consume us. So, how do you think the perception of how others see us determines how we view ourselves?

Your first question was about two mirrors and I answered "infinity." But if you picture a body inserted between these two mirrors, and this body sees itself replicated multiple times, I think that's how. If we pay attention to judgment, we see ourselves replicated many times. Sometimes it corresponds with our actual beings, and sometimes it's far away. But we see it, so we tend to take it into consideration. Acting according to the image people reflect back at you is a real trap, but maybe deciding to be blind to it is a mistake, too.

I feel that what you just said speaks a lot to judgment in the digital, social media moment. How do you think technology is changing both judgment generally, but also the fact we're becoming more aware of the various perceptions the world has of us?

What strikes me in some social media, I'm thinking of Twitter for instance, is that you're faced with what strangers think about you. People talk about you in the third person as if you weren't there, but they mention you so you receive the notification. I remember logging in on my Twitter after one quite violent TV show and getting notifications

like "@NinaLeger is crazy she belongs in an asylum" and other horrible comments, things that were really degrading. Many people—many women, I should say—have known much worse. I don't want to say that society is becoming increasingly violent, but still, these were comments I shouldn't have seen, except people were adding my name to them. Social media creates a weird derealization where people who don't know you, who have no right to talk to you the way they do, tell you things they would never think of telling you face-to-face, in real life. I think there's a failure to realize what it means to express how you see someone, especially when we express it in a violent way, because this stuff is more about passing judgment and insulting people. Social media can do amazing things. #MeToo existed thanks to Twitter. But the mass outpouring of violence on women who started talking through #MeToo was also permitted by Twitter. This violence has always existed, but had been contained. It used to be very difficult to directly reach the person you wanted to affect. You had to put a lot of effort into it. Now, it only takes one mention.

You just referenced a TV program I want to discuss. The show is called *On n'est pas couché* [*We're Still Up*], and it airs on national television. The show invites writers on to discuss their work and then have it publicly critiqued and debated by other writers. I saw your episode before reading your work. It's what got me so interested in the book. In your episode, you get in a heated debate about sexuality with an older male writer, Yann Moix. He says your view of sexuality is boring and dated. I found the moment bizarre and intriguing: an older person telling a younger person what sexuality is supposed to be, judging them for their views. Why do you think Yann Moix reacted the way he did?

For him, I think, his relationship with sexuality is all about transgressing, daring to talk about things that people don't talk about. He wrote a book called *Partouz* [*Gang Bang*]; he belongs to this moment when people saying

what had never been said was important, but now, I think we're living a different moment. There's nothing scandalous or transgressive in talking about sex. To him, writing about sex implies the desire to be transgressive, and if you write a book that isn't, it means you've failed. Well, my aim wasn't to write a scandalous or transgressive book. On the contrary, it was to show that describing the active sexuality of a woman who sleeps with many men is not sulfurous anymore. Yann Moix believed that I'd failed to reach a goal that wasn't even mine. He could not see that I was following another path. I think that nothing having to do with sex is scandalous for our generation. Besides, at the risk of oversimplifying, it seems to me he has a very male-centric view of sexuality. It was obvious in the references he cited, that all were references from the start of the twentieth century.

Yeah, Georges Bataille, for instance.
That's right. And only men. When *Mise en pièces* was released, there were a few negative reviews, which all corresponded to the same pattern. There were three, one from Yann Moix, one from a Swiss journal and one on a literary blog, all signed by white men of around the same age as Moix, all of whom made the same remark: "I got bored." I found that accusation of boredom very interesting after noticing it had already been directed at other women writers who talked about sex. When women write about sex, it's boring—but when Houellebecq talks about being bored with sex, it's fascinating! The boredom argument is always doubled by another: "It's been done before," meaning: other women already wrote about sex, so what's the need for more? In terms of my book, there was this article where a man said, "Oh! Another woman talking about sex!" and then he mentions others: "We've already had Pauline Réage, Marcela Iacub, Leila Slimani, Anaïs Nin, Catherine Millet, and now we get Nina Leger." These authors wrote books that have nothing whatsoever to do with each other, but the critic lumped them all together because, to him, it's just women talking about sex. As if all the women talking about sex through the ages have only

one thing to say and that it can only be said once. We've just started talking and they want us to be quiet already. I've never heard anyone say, "Oh no! Not another man who talks about fucking; it's been done before." Never. Neither have I heard anyone say "Oh no! Not another man who writes about adventure or travel." With sex though, and with women writing about it, it's as if there's a quota.

I was struck by his insistence on a concrete idea of what is obscene and what isn't. It feels like nothing is really obscene anymore (beyond let's say, violent things). We have kinks and fetishes. They're all becoming normalized. In their normalization, we lose opportunity for judgment, which I find good. One of the things I loved was your ability to remove obscenity from graphic images, which feels in line with obscenity becoming kink. What are your thoughts on the obscene in contemporary sexuality?
Obscenity is something you see when you shouldn't be seeing it, something you hear when you shouldn't be hearing it. This is why in the novel, my idea was that we stand in

each room with Jeanne. We aren't peeking through the keyhole. I wanted to avoid having anything like the "Peeping Tom." That's also why the first scene is a description of an erection. You could say that it's frontal. Some people thought my aim was to shock with the first scene. It wasn't. My aim was to say: "Here's the deal. We see." I wanted to get over the scheme of erotic novels where you have to get through the boring bits to finally get to the sex parts, and, as a result, when you get there, there's something juicy and scandalous about it. The idea was for people to see it all right away. Without veiling. Without hesitation. I wanted to describe sex like you would an aloe vera plant. Like a rose in a glass case. Like a lamppost. To bring that same eye to bear on it.

It's interesting you say that, about turning sex into a viewable object. For me, the setting of the book, though it's technically Paris, is really a morally objective dimension. Cocks are removed from bodies and become signposts, or lampposts, of repetitive days. By treating the sexuality without gravity, you allow the reader to self-assess their own morals at a time when sexual morals are being critically questioned. I find that judgment often leads to self-assessment, for good or bad. What is the place of self-assessment in *Mise en pièces*?

To me, in the novel, Jeanne's self-assessment lies in what escapes the reader, and what escapes me. It's not the things I won't say; it's not that I know the truth about Jeanne without saying it. It's that she escapes me too. Often a novel runs the gamut of a character. And here, I liked the idea of: there is a novel, and Jeanne runs the gamut of it. She remains opaque. I also liked reversing visibility— you see everything of the male bodies, but you don't see Jeanne. She's a woman who's no longer placed under observation, but turns observer. For me, that's where there's an aspect of self-assessment. In her opacity, really. In her just being, without it being explained. Because when something is explained, very often, it's being justified. There's nothing further from self-assessment

> "The guillotine blade of judgement fell, and its sharp sound conveyed how confident Jeanne's friends were when it came to distinguishing the clean from the dirty, order from disorder, them from her."
>
> From *The Collection* (*Mise en pièces*)

than justifying something. In my opinion, self-assessment means not having to justify yourself.

Do you think, without external judgment, we would perceive anything we do as bad or good?

I think it really depends on us. You said how the book implies the reader. Because so few things are said, the reader has to be implied. I didn't think about it before, but it reveals things about people, how they react. Sometimes, I found myself in tricky situations, or uncomfortable situations, with people telling me things in reference to the book that were actually about them, without them even realizing it. Sometimes I would get people telling me: "Ah, no! I can't read it; it disgusts me." And, we were talking about obscenity, but in a way, they were the ones being obscene by saying that. Because it wasn't about the book; it was about them. And they were then giving me something very intimate.

I personally believe that after judgment and self-assessment comes shame, or the potential for it. In *Mise en pièces*, because there is very little written judgment, very little written self-assessment, there is no real shame present. How do you think shame functions and why do you think some have more of it than others?

It depends, first, on the context you grew up with. Christianity was founded on the idea of shame. Today, we've inherited it from this society that came up with the idea of shame, and the awful notion of hell. That's

really such a horrible idea, when you think about it. Saying to people: "You acted badly, so you're going to suffer for the rest of eternity." So shame is internalized; that's the first thing. Self-producing shame because of built-in structures. And then there's also the environment in which you live. Sometimes you live in an environment where people are accepting of all behaviors, and other times, you live in an environment where people are more disapproving. The size of those environments can vary, which is to say, it can be one's family, but it can also be Twitter, for instance. And so, all of that alters the geographies of shame.

Reading your novel, I was reminded of novels from the Nouveau Roman literary "movement" in 1950s France. For example, probably the most well-known Nouveau Roman, Alain Robbe-Grillet's *La Jalousie* [*Jealousy*], creates an isolated setting, a lonely farmhouse, to allow for the exploration of a single idea, jealousy, and how it can infect the mind with obsessive repetition. I feel like your farmhouse is actually sexuality and that allows for so many more routes of exploration: judgment, self-assessment, shame. Do you think that sort of literary style, a single point of deep reflection, is good for modern readers, modern brains and thinking patterns?
I don't know if I would connect it to the way brains work, but in any case, I do think it's important, when you're reading, to feel that some thinking has gone into the novel, and that the novel isn't gratuitous. I'm not a fan of thesis-novels, but with all of the excessive literary output out there, there's nothing I drop faster than a novel that feels as if it has been written solely for the author's own pleasure, by this person who just had this desire to write. I think that is something very important today, and I think that it was also something important for the Nouveau Roman: producing novels that are not sheer recreational pursuits, novels that think about what a novel can be. There isn't as much room for literature these days, so it feels that every novel ought to be more necessary. With

Mise en pièces, there was something I wanted to say, a way of talking of female sexuality I wanted to elaborate, a place I wanted to build. For my next novel, I will move on. Especially because with sex, people suspect the author to play the lurid card only to get attention. It's very important for me to show that I didn't pick sex by chance, as any other subject. It wasn't just a fancy. I wanted to think and tell something specific about sex through literature.

How do you feel the Internet and technology is affecting literature and the reader?
The access to information that the Internet gives a writer is amazing. It can be a huge help, having access to things without having to do endless research. But sometimes it can also be a mistake, like when a novel becomes documentation. Since readers also have access to information, you can decide not to explain things. So, let's say you have the "Houellebecq school," the Wikipedia novel, a novel that uses Wikipedia and that's very informative about the topics it deals with. And then you have a novel that assumes readers have access to Wikipedia, and so related information is accessible somewhere else than in the novel.

I found the pacing of *Mise en pièces* to be very well done. The writing moved quickly, but not uncomfortably so. Not "fast." I felt it was very connected to the speed of modern urban life. What are your thoughts on the trope of limited attention spans, faster speeds of life, and the need, or not, for literature to adapt to that?
That's a big question, and it's a tricky one. I think it would be foolish of me to say that things are going faster, and literature has to cope with it and make the most of it. But it's true that speed is also a threat, because reading is a slow activity. It requires concentration. It's solitary. When it's said that people are more alone with their screens, they forget you share things on a screen; people can watch the same thing on two screens, or the same thing together on one screen. It's

annoying to read when there are two people present. Reading requires solitude and time. And so, I think the question is twofold: on the one hand, literature should not deny what the pace of society is, and on the other, it has to integrate the speed in its novels. But the real question is, will literature still have its place in society if society keeps going faster and faster? Apparently, uh . . . [*laughs*]

I find myself getting into debates about contemporary literature and our incorporation of technology in it. I find we often go too far in each direction. Either it's blatantly explanatory about tech use, or it's so far from modern technology that writers set their novels in the past to avoid having to write the confusion of tech in our daily lives. I guess I prefer the former to the latter. I find it lacks bravery to avoid assessing our weird tech-present by setting a novel in the pre-cell, pre-Instagram past. With *Mise en pièces*, I found you incorporated technology in a subtle way while also setting the novel in the present. What are your thoughts on the topic, on how to approach technology in contemporary literature?

You can write a falsely modern novel by putting a Samsung Galaxy in it. What I find interesting is to ask ourselves: what can this contemporary world shake up within literature itself, within the language; for something to be of its time without necessarily being an overview of that era, and as a result, risking being forgotten along with it? And so, it's this idea that contemporary literature shouldn't be an account of things, but rather, a way of speaking. I would like to succeed, myself for instance, in doing something where the way of saying things is from today, the way of thinking, of building things. Today, we're used to things interrupting continuity, to viewing several things at once. I want to look for the contemporary in that, more than doing lip service to bearing witness, which can have the added effect of making literature that's too anecdotal or hyper-specific. Also, no modernity is universal. It's often made up of very local aspects, and sometimes, when

we write, we tend to forget that. It isn't just a matter of describing what's going on; it involves articulating how to transform what a text is, that immemorial thing that is "The Text," about which we have the impression as if it has never changed. But the thing is that it has! Things shift, but in a way that's so fundamental that the shift may not be that visible. Novels that go around proclaiming their own modernity with lots of little flags, with phrases such as, "New technology is featured in it," "The language is very contemporary," those novels become anecdotes. I think that to do contemporary writing, you have to be worthy of the contemporary, and not just take it as surface phenomena. That's what I would like to succeed in doing, and it's what I like to find in books, and what gives books that are being written today the potential to be a historical novel, while at the same time, also very contemporary. I would like to achieve that even more. ◊

The Collection. Cover Design: Jo Walker

Talking with

Lucy K. Shaw &
Oscar d'Artois

*about getting married, achieving placelessness,
and remaining individuals.*

Oscar: "Detachment from place seems like a way to avoid some sort of realness. But realness isn't real. It's a thing that's always out of reach. . . . This is just our way of avoiding something, in the sense that everyone is avoiding life all the time, in various ways."

Lucy: "If you find yourself in a situation where one of you is from one country and the other one is from two different countries, what on earth are we supposed to do? Where are we going to go where we're both fine?"

The first time I saw Lucy and Oscar read their writing was at Mellow Pages, a lending library housed in a warehouse, the warehouse housed in Bushwick, Brooklyn. This was years ago. Mellow Pages no longer exists, but it remains a place that's important, for me and for many others. For a moment, Mellow Pages was the epicenter of a writing movement called "alt-lit." That movement, if I may use such a trendy word, was born from the Internet: a concept, a catalyst, and a non-physical location that the movement attempted to represent in words. Alt-lit itself no longer exists, but it gave the world something important. It gave the world its attempt at a literature that's pared back, like the Internet is succinct, messy, like the Internet is fun, and emotionally honest, like the Internet is with its dangerous freedom. But more, it gave the world its writers. Writers like Lucy and Oscar. Two writers who write beautiful, simple, crushing sentences. Sentences like: "Being in love means that rooftop in Manhattan when you said, 'Don't do it' & I said, 'I was just thinking that,'" (Lucy), and "& isn't it funny how people try to explain how their pain is physical / like, 'i felt it in my heart, right here' / & then they point" (Oscar). I lived in New York when I was young and trying to learn how to write. I watched Lucy, Oscar, and alt-lit from the periphery, from the back of a packed-in Mellow Pages. I watched and I learned. I watched as the movement broke apart and moved on. I watched as Lucy and Oscar moved away, got married, and made a life for themselves in various places around the world; sometimes in Paris, near me, and sometimes nowhere for very long. In watching, I've learned from them how to make a placeless life out of love and writing. By watching, I'm still learning, from their new writing and from the odd and mobile life they've chosen to live.

Instagram: @lucykshaw and @oscardartois
www.profoundexperienceofearth.com

You two met and started seeing each other while living in Brooklyn in 2013. Tell me the first memories you have of one another.

L [*to Oscar*]: Do you want to go first?

O: Sure. I met Lucy . . .

L: You don't remember the first time?

O: Was it at the bar or at brunch? Which one came first?

L: It was at Mellow Pages.

O: Oh yeah, but that doesn't count.

L: Why not?

O: Because I can't really remember that . . . My first memory of Lucy is with my friend Jordan, who I'd moved to New York with because we were lit buds from college. We were like, "We're going to go take Brooklyn by storm." [*laughs*] So Jordan had started going to the Mellow Pages and he was like, "I met these alt-lit superstars. Now we're going to brunch. You should come." I wore a massive military onesie I bought from a vintage shop. I cut off the shoulders and it didn't really fit. And a fedora. And so they were like, "Who is this kid, this guy with the fedora?"

L [*to Oscar*]: You thought I thought, "Who is this cute guy?"

O: No, I said, "Who is this kid with the fedora?" [*huge laughs*]

L: "Oooo, cutie."

O: I'm still embarrassed about the hat. We all left brunch and Lucy was like, "I don't know what I'm doing. Can I hang out with you?" I said, "Okay. Come back to the apartment with us." We all started playing video games, like *Mario Kart* or *Super Smash* or something. Lucy was like, "Can we do something else?" And I was like, "Okay."

L: It was a two-player game, and everyone else was just watching.

O: So there was this massive silkscreen Audrey Hepburn painting our neighbors had left in the hallway staircase for a month. Lucy was like, "Why don't we do something with that?" And I was like, "Oh, no, no, we can't touch that. That belongs to them." But then, it had been in the hallway for so long. So we covered it in sriracha, money, cigarettes, cut-up beer cans, matches, nuts, train tickets, just whatever we had on hand really. Lucy wrote, "Hello international art world"

Audrey. Credit: Lucy K. Shaw

on it. It became this gross work of art. We called her *Audrey*. So it felt . . . it felt fun. It felt different from video games. And brunch. I was like, "This is cool. This is something else."

L: I felt like I was being a bit belligerent just saying, "Let's make something," thinking other people would say no. But Oscar was like, "All right, let's do it." And then we were doing it. I remember when we were doing it, we were both moving around the painting. We were interacting with the thing and each other. Moving around felt really natural. It was like, "This is very weird, because we don't know each other."

In 2015, you two got married. As you've explained to me, it was a mix of love and visa practicality. It's something you both wrote really interesting things about. For example:

Lucy: "Do not feel any different about your relationship, or your new Husband. Nothing has changed. The institution doesn't mean anything. You're playing the system. This is a punk marriage! Just kidding. Everything has changed and the peripheral people in your life

are all preparing themselves to let you know exactly how." [*How To Be A Perfect Bride*]

Oscar: "**I wanted to bleed freely from whatever wounds I had incurred, and for the blood to mix with the blue water running down my pale body, and for a ray of light to come in through the slit in the window & pierce me in such a way that I ascended, an unholy virgin, broken, wrapped in liquid purple, and suddenly consumed in crystal fire. But I also wanted to hold the door open for old ladies at the grocery store, or to help them out if they dropped something, maybe in a bid for Karmic forgiveness for those desires. And I wanted to play with big, messy dogs, and eat big hearty midmorning breakfasts, and have a Sunday Kind of Love with K.**" [*Ramen*]

How do you feel people reacted to your decision to get married?
L: They reacted unfavorably, I would say.

Really?
L: Yeah, people were like, "What are you doing?" Which in hindsight, I'd like to say I feel I understand better, but maybe I don't.

Why do you think they reacted like that?
L: I think, because they had certain ideas about what marriage is.
O: And what being an artist is.
L: Also, once we decided to do it, a month later we were married.
O: We didn't give anyone any time to get used to the idea. Not that it matters really. But . . .
L: It felt like, "You can't have that life," or something. It's hard to know why. At the time, I was hurt that people didn't understand. We didn't do it because we thought it was a fun idea. We did it because we're from different countries and it was complicated. We wanted to be together and it seemed like the best way to ensure we could.
O: The annoying thing about it was the perception that, either you could have a visa wedding, or you could have a finished

coupledom in suburbia. Goodbye. A seven-children wedding. As if there's no middle ground. And that meant we were discredited. Like we were removed from punkdom. But it's such a big symbolic deal in people's lives. You get born, you get married, you die. There are only so many episodes in a traditional life. So maybe it has this weight in people's minds that makes them react in a scary way.

In your work, you both speak to the institution of marriage and your skepticism toward it. What do you think of marriage now that you've done it?
O: I mean, I think it's bigger than you expect it to be. It's real. Or the symbolic thing is weightier than you might think initially.
L: It was like, "This is actual." But it was much better than I ever would have expected. I didn't think it would change anything, but it did. It depends on everybody's different circumstances. One thing that happened to us was a visible change in the status you hold in the other person's family. You become absorbed into one another's family in a very immediate way.

Have your views changed on relationships, generally?
L: I don't know if my view of other people's relationships changed. But there's something really great about knowing neither one of you can just leave. I mean, one of us could leave . . .
O: But it would be very insane. The fabric of our lives would certainly fall apart for some time. And so I think that's a cushion of sorts.

Do you feel less averse to the institution now?
O: Not really. Well . . . maybe. But I didn't suddenly think, "It's amazing." It's just that the legal thing itself effects this tie, that then is immediately real, that's more than you think. Maybe the institution is grounded in something more ancient or something. So sure. In that sense, yes. But in terms of the actual way that it's evolved over the course of history, getting married doesn't particularly change my opinion.

Do you think, for people our age, there's any growing aversion to marriage?

O: There's plenty of reasons to feel weird about marriage. It's a fucked thing. It's about property. For us it was as practical as it was emotional. There's a way people can use that sense of its, sort of, uncoolness, and turn it into gratuitous categorization where you put people aside or say, "I don't want to be associated with that." And at that point, it's just about being cool, which is boring.

I feel we're living through a hyper-individualized moment in society, that individuality is made profitable by things like Instagram and contemporary fame culture. How do you think individuality is affecting love and marriage?

L: Well why did you want to talk to us together and not as individuals? What makes you think that we're interesting as a couple?

O: I don't think we think of each other as an artistic duo.

I think the reason I asked to interview you as a couple was for exactly that reason: you're not a duo. You both produce your own work. You both seem to have maintained individual artistic identities and outputs while being in a relationship. So maybe a better question would be: how has marriage made you feel about your own individuality?

O: I think that writing is a place where I'm just me and I have an expanse of space for myself. But at the same time, I think we feed off each other quite a bit. Even if it's not in any kind of direct way; certainly we talk a lot. Obviously we bounce ideas off of each other constantly. But there also has to be another space. It's important to be able to make space for the person to do their own thing.

L: We've realized that only one of us can really be writing a book at one time. It's almost like one person needs to be, like, protected while the other one is working. Like, only one person can go to the weird place.

How long did it take you to realize that type of partnership was needed to feel good while producing?

O: I would say it's an ongoing realization.

L: You just see what doesn't work. And then you say, "Well, let's not do that."

You both write really honestly about the challenges of personal identity, monogamy, pain, and sexuality in modern romance. For example:

Lucy: "And I had thought about how the reason I had realized we could never work was because we had all of the same type of sadness, and we had none of the same type of joy. I had looked out at the raindrops on the outside of the windows, as they were sliding down the glass towards the Earth and I had wondered when I was going to take on the challenge of really loving somebody." [*The Motion*]

Oscar: "a cool game u can play / with desire is try saying u want a thing / u think u want / out loud / then watch as / the opposite becomes true." [*Teen Surf Goth*]

I know many people in our generation experimenting with non-monogamy, polyamory, and other relationship alternatives. What are your thoughts on our generation's attempt to balance a more "interesting," "liberated" life with a natural desire for companionship?

L: I don't know really. Are "alternative" lifestyles actually wild? Or are they also just mostly domestic? I guess it depends.

O: There's something like a fantasy of liberated-ness. For me specifically, in *Ramen*, it has to do with a sort of Satanism, I guess. [*Lucy laughs*] It's religious, is what I mean. It has to do with an idea of sainthood. But a weird, inverted sainthood that's about getting fucked on the floor in prison or something... There are contradictory psychic states that exist side by side. In terms of exploring polyamory and stuff: I think there's a way you get sort of, discursively over-involved, where the exploration doesn't really work out because you're so busy fretting about the idea of it. In the gay community, it's more normal to be non-monogamous, largely. It's just the re-

ality. So I think it's possible for life, amorous life, to move in a different direction. But I think there's a problem with it becoming hyper-theorized.

I'd like to transition a bit, to talking about place (and placelessness) in your lives together. About two years ago, you both started working online jobs you could perform anywhere. I've watched you two move around the world frequently, your base being Paris, but then living in many other places most of the time. I've watched as you've continued producing your artistic work while moving. Some people might call you "digital nomads," a lifestyle I find fascinating but also frightening. What do you feel is your relationship to the concept of home?

O: I used to be more nostalgic about that physicality of home and the romance of Paris. Now, I don't think I have it anymore. It's sort of cliché, but home is much more mobile now. It's a couple things we have in a weird old box that we take around with us. And I think, even after I left New York, I still had an idea of it as home. I think I've shed that, which has taken some time. And now the only thing I would associate with home is a sort of abstract idea of the ocean, or something. Not something I can return to in any way other than like, swimming or dying.

L: My home is being with him. It's a lot easier to be wherever you want when you're not by yourself. I feel like wherever we go, we can make a life. Even though we move often, it still feels meaningful to like, go into a restaurant and they know you. Or when we go to our bar, the Vintimille [*in Paris*], and they make a big fuss. They're like, "Where have you been?" And we say, "Oh, we've been in Greece or whatever." And they're like, "Oh, my God, you two are always away." Something like that, in a more normal life, wouldn't feel like that big of a deal.

Lucy, in *The Motion*, you say, "My life exists in three countries and on the internet. Twenty-seven years into the past, an indefinite amount of time into the future, and 'forever' in the form of whatever I have written down. There are so many directions to go in. There are all of these people I keep on accumulating. There are people from my life that I have decided it would be simpler to avoid ever seeing again, and there are people I talk to every day, with whom I plan some type of vague and wonderful future."

How have you two begun to feel about your relationships with others, friendships, now you've unbounded from having a consistent home?

L: It's easy to be friends with other people like us. Other people who are international in some way, whether or not it's by choice, or how they grew up.

O: Yeah, it helps to have people who are in the same sort of temporal, spatial vacuum that we exist in. They're aware that ties go beyond place, or the day-to-day seeing of each other.

I've heard a concept being thrown around: "millennial burnout." Basically it's a mental state many millennials find themselves in; a constant overwhelmedness brought on by our tenuous urban, economic, environmental reality. Overworked with shrinking financial rewards. Unfulfilled by our expensive, stressful city lives without an idea of how to, or the potential to, escape them. In competition with one another on social media, and in turn, real life. All amounting to an inability to accomplish common and "worthless" tasks like going to the post office or responding to non-work emails. You each have quotes I think speak to this stress:

Lucy: "The ingénue is a stock character in literature, film, and theatre; generally a girl or a young woman who is endearingly innocent and wholesome. The term comes from the feminine form of the French adjective *ingénu* meaning 'ingenuous' or innocent, virtuous, and candid. The term may also imply a lack of sophistication and cunning. Of

course, no one can afford to be that."
[*The Motion*]

Oscar: "then thought 'i have to stay stoic' / how stoic i was being made me want to cry" [*Teen Surf Goth*]

How is your "nomad" lifestyle leading you to view the common stresses of our daily lives?

O: I'm that person, hundred percent. I have endless tasks I'm always putting off because they don't really have an instant gratification, or much gratification at all. I don't think the moving makes the burnout go away. It's just different. I'm burned out either way. We could move back to a super-expensive city, and then what? Then we're . . .

L: . . . just doing the same stuff, just struggling more and wanting to do the stuff we're currently doing but not being able to.

Do you feel that by disconnecting from traditional society, or at least disconnecting partially, you feel less stressed than you used to?

L: Yeah, for me, I love it. We have a different way of experiencing things that I'm more suited to, naturally. If you're in the same place too long, even if you're not involved in it, there's always drama going on with people. Fights between friends and like stuff like that. I guess one way of being in control is to just remove myself from the situation. So for me, it's great. I get to see things I didn't know existed. I get to see them for a long time. I get to know different places and try to understand how people live a normal life in different cultures. But I don't have to feel like every day is an adventure or something.

O: Detachment from place seems like a way to avoid some sort of realness. But realness isn't real. It's a thing that's always out of reach, regardless of what it is you're doing. So no. I mean, like, this is just our way of avoiding something, in the sense that everyone is avoiding life all the time, in various ways.

L: And if you find yourself in a situation where one of you is from one country [*Lucy is from England*] and the other one is from

two different countries [*Oscar is from France and the US*], what on earth are we supposed to do? Where are we going to go where we're both fine?

Lucy, your new project, *Profound Experience of Earth*, is a travel-writing publication that speaks beautifully to place, movement, and how we experience the world now. I find it's especially interesting in reference to your mutual lives together. Can you tell me about the project and how you came to start it?

L: Once you start thinking about travel writing as an idea, it doesn't sound very cool: it's a historic tradition of "man goes alone into the world, discovers things." Or the new loud yappy blog version of travel writing: it's people who don't seem to reflect on anything. There's a lot of stuff that tells you how to get somewhere, what to do when you're there. But not much that questions why you would travel, or how travel actually makes you feel. When I started researching travel writing, I couldn't find anyone reflecting the experiences I had. When you go to new places, there's a lot of confusion, a lot of discomfort, a lot of figuring out how to carry your body in a place that it doesn't really know how to exist in. It's too hot, you're tired, you didn't sleep very well. You've got to carry all of your possessions on you for some time to get to where you're staying. And you're worried about all the little things. Like, is the Wi-Fi good enough for me to work? Then maybe, you go for a walk, you climb up a hill and you look out and say, "This is an incredible view." But then you have to get back down the hill; it's getting dark, you're hungry, and you haven't eaten since yesterday . . . so I wanted to produce something that reflected those experiences. Travel is something you can actually do if you prioritize it. Making travel seem more accessible and more human feels like an important thing. You don't have to go thinking you're going to have an epic, out-of-body experience, just because you're in a different place. That's so stupid. That's not gonna work. And also, we're overwhelmed by photographs of people we know in weird places. We don't know why they're there. Are

they working? Are they on vacation? Did they go for a reason? I wanted the publication to help answer those questions.

O: There's this cultural imperative, I think, to experience things positively and only have a good time. You know, like, "I saw this, and it was fabulous. And amazing. And it was epic as fuck." But it's not always like that. It's really not. The only way that travel writing is going to be interesting is if you're honest about that. And then maybe you see a glimpse. It's the same with a profound experience of nature . . . it's only glimpsed.

I found in your writing that you each have quotes about profound experiences:

Oscar: "if i send you a pic of this sunset dyou think you cld have / a profound experience of it for me?"

Lucy: "We joke sometimes about the 'Profound Experiences of Art' mentioned often in Ben Lerner's *Leaving the Atocha Station*. When I asked Oscar if he had had one, he told me, 'I had seven,' and then paused and then smiled and then added, 'like a woman.' I laughed and shook my head, and then smiled too."

L: That's really good that you found those, because I didn't know they existed [*both laugh*].

What would you each say is a profound experience for you now? Or the most recent you've had?
O: When we went to Delphi. I was into Greek myths as a kid and I was thinking, "What would be a nice thing to do for my thirtieth birthday?" Lucy got me this Stephen Fry Greek myths book last Christmas. That got me thinking about them again. So as a joke, I said, "Wouldn't it be funny if I went and consulted the Oracle?" I didn't know what to expect. I didn't think I was going to see the Oracle. I hadn't really informed myself on what happened; on how they did it. So... Delphi was like hundreds of temples. We couldn't really figure out what the actual Oracle temple was. Like, "If I was gonna ask my question, or consult the Oracle, where would I have addressed my thoughts?" And I guess in retrospect, we realized that we walked right past it [*laughs*]. We ended up at this other site. It's a series of five temples, and one of them is this reconstructed thing with pillars and it looks sort of oracular, so I thought, "I guess it's that." And then we walked past these five buildings and got to a tiny, modern janitor's house. There was a cat, so I thought maybe I would ask the cat. Or a grasshopper or something. Then I thought, maybe the Oracle is in the janitor's house because it was the last building. I was filming. I turned around, faced away, turned around again, and a guy had appeared and was standing outside staring at me really intensely. I was like, "What is this?" Probably it was the janitor just thinking, "Why are you filming my hut?" But I hadn't seen him before. I just had this moment, staring into his eyes and being like [*Oscar gasps*] . . . you know? Because obviously I had built up this Oracle fantasy, kind of as a joke, kind of not, but mostly as a joke. Then I turned away again and when I turned back, he was gone. He'd disappeared. Where? What the fuck was that? You know?
L: That didn't happen.
O: It did happen. Well, like, he stared at me.
L: There was no maaaan.
O: There was a man! So it was something. That was a profound thing that happened to me.

And you Lucy? What's a profound experience for you?
L: Anytime I go in the sea.
O: You're more succinct.

When did you have your most recent profound experience?
L: I got absolutely wiped out by a wave, in Loutraki, in Greece. I got wiped out twice. I got up from the first and there was another wave coming. It just makes me feel kind of, good. It's comforting. ◊

Fine Artists

Talking with

Julien Creuzet

about the surrealism of technology, identity, and birds of paradise.

"One identity is not singular. It's a plural. It can be many things, with a dark side, a good side, with different aspects, and unconscious parts too."

Because of their length, referencing your own poetry, many of your piece titles are shortened in print with an ellipsis in parentheses. What does the ellipsis caught in parentheses mean to you?

I use parentheses for many reasons; sometimes one title is one possibility to give one interpretation about one piece. I think the question of the title is really important, and for me the title needs to be very free and very open for the question of interpretation. For example, your name is Will, but I can put Will with a parentheses, and if I use Will and a parentheses, because I don't know you very well, I just met you three minutes ago, I can have a lot of interpretations about who you are. The question of the parentheses is that, a possibility to open ideas and give more sense of the future and the past. It allows the title not to stop, to have potential.

My favorite piece of yours uses parentheses-ellipsis: _Ricochets, The pebbles that we are, will flow through (...) (Épilogue)_. That title, how did it come to be? What ideas affected that title?

If you think about the movie _Star Wars_, the title is very open and you can make a free movie. You can say the title and you could make the movie before or make the movie after. It's the same with _Alien_. I think for me a title is the possibility to have movement when you read it in your head. A good title of a book or movie lets you travel directly. You can have physical movements with just a few words. In one sentence you can move.

One of my favorite lines in your poetry is, "How did the world manage to reach us?" What does that line mean to you?

I'm just one point, or one point of dust in the landscape, in the world, in the society. Sometimes I can imagine a fiction, and for me artwork is a fiction, because you make interpretations. Interpretations are not objectivity. They're subjectivity. Subjectivity for me is the beginning of fiction. When I make fictions with my sculpture, with my work, my performance, my poems, my movies, it's a way of beginning to speak about society and how to use "us" as potential in that society.

I've noticed there's a big growth, in the literature industry at least, of memoir, people's real stories. I'm interested, when you use the word "fiction," why you think society or maybe the capitalist side of society seems to be obsessed with "real" stories instead of fictions.

All real stories are fiction because they're one interpretation. When you open the book of history it's one point of view. It's not the point of view of all civilizations, and when I decide to take a real story, maybe it's a fiction, a potential of truth, and I can use it. I can put it inside the path I need to go.

Do you have an idea of why the market is demanding these nonfiction pieces? What's that desire right now to have more nonfiction than fiction?

For a very long time in cinema, you've had a specific category, documentary. What does that mean, "documentary"? Is it real or not real? You go somewhere and you record and you make an articulation of images and voice, with the voice of the narrator. It's interpretation. Normally the titles of documentary need to be a mirror of the life, but you can have different points of view. Now I think the good documentaries are "documentary fiction." Artwork is the same. Artwork is just a constellation of many ideas, many points of view, many feelings you can have about emotion, infinite perceptions. It's a constellation.

I think I was originally drawn to _Ricochets, The pebbles that we are, will flow through (...) (Épilogue)_ because it contains bird of paradise flowers, which are my favorite. What do bird of paradise flowers mean to you?

The bird flower is poetry, how a flower can be a bird. It's like a metaphor. It's not a real title, because the flower lost its native name. When Europeans arrived in different countries, in Africa and America, in Asia, they gave things Latin names. You can say in French, _fleur de paradis_, "paradise flower." I like the idea the imagination can give to this flower.

condemned earth
the day
sun breaks out
human dying star
the evening
the wifi sprung up in me
gas layer
around me

the wifi dazed me

in the ice or in the fire
I hate to be there
desert, populated
evocative
great speaker
Spit his venom

kondane latè
jou a
soley kase
moun mouri zetwal
aswe a
wifi lan te gonfle nan mwen
kouch gaz
alantou mwen

wifi a m 'mele

nan glas la oswa nan dife a
mwen rayi yo dwe la
deze, peple
evok
gwo oratè
krache venen l 'yo

Do you feel that the world is forgetting its history?

You can't forget history. History is the earth. History is a question of landscape. We change. Now the world is smaller. You have more interactions with other countries, other populations. We don't forget our specific culture; we try to understand each other more and in doing that, everyone has their particularity. Their particularity is a particular identity. And everyone is a singular identity. There is a question of specific cultures changing, geographic cultures; they continue and the world changes and the cultures change, like the specific culture of Paris or a specific dance from the desert. Civilization transforms. It's normal. You can stop and say, "Focus on the traditional thing." The traditional thing is interesting but the traditional is the past. The question is, can the present be a traditional present? You have new interpretations all the time, new directions, new perceptions. And now you have new dancing. You have new rituals, new religions.

I've been reading how technology and social media might be working to homogenize the world.

When Christopher Columbus left Europe to find the American continent, what happened? He made a homogenization of Europe, taking their society, their sculpture, and putting it in the Americas. Everybody needed to be Catholic. Everybody needed to wear pants and T-shirts. It's the same thing. What happens next? You take a culture from Asia and put it in the United States. Everyone mixed like that. Now everybody knows, "Okay my neighbor is this guy, from this country, and I live in the same building with France, the United States, England, Spain." It's like a metaphor; it's one building with different neighbors. You make your life in your apartment and we all live in the same building. Which culture have we lost? No one could answer for real. Who owns which culture exactly? Your culture is a composition of many cultures.

Do you think homogenization connects

with cultural appropriation?

That's a very interesting question. It's important not to take and say, "It's mine!" We can learn about each other. I can give you a new perception, but the reappropriation is very difficult. It's the same thing in art, culture, and music. I think society now has many references. For example, when you eat a certain cheese it has a certain history, it can contain elements from very far away, and it's mixing all these forces when you eat that cheese. It's the same thing with a hamburger, with pizza, with pasta. It's long stories. You need to respect the genealogy, you need to know the genealogy. If you take something, you need to understand why you use it.

What needs to be reformed in our perception?

Now we are very close to each other.

Because of technology we're very close?

A boat is a technology. A plane is a technology. And the society is a technology. A town is a technology. I think you need to respect the culture and the space of every person. I need to respect your space and I can learn about you and I can respect you. And I think that's very important. I can't take your arm or finger and say, "It's mine." But I can take your ideas and say, "It's mine." And I need to respect that.

Do you think technology is making things more simple or more complex?

I think technology is making a possibility that reality will disappear. It's the first step for sleeping for your entire life. Because technology, social media is a *chronophage*. Time eater. And it eats you; it eats your free time. Every day you use your smartphone when you wake up, in the toilet, before you close your eyes. I think that's a problem.

I would like to know how many people have met their long-term romantic partners through dating apps while both sitting on the toilet.

Interesting.

Kind of beautiful, no?

Yes, take a picture of your shit.

You know there used to be a website called ratemyshit.com?
No?

You used to take a picture of your shit, put it on the Internet, and people would rate it one to ten. But that was not one of my questions.
[*laughs*]

I find that technology often pushes us toward the most cliché, hackneyed, simple conceptions of ideas, identity, etc.
Technology is not necessarily a reduction of interpretation. It can open the question of interpretation. It depends how you use the technology. With technology, distance is shorter and you can have interactions with people very far away. It's impossible to think without technology. You need to think with technology. You don't need to use technology by choice. There is a necessity to use it. I think with technology, you can have more identity. When you speak about Afro-Futurism, I think it's very interesting. And now with Afro-Futurism, comes new Afro-Surrealism. With technology, it's not a question of "futurism," it's a question of "surrealism."

Where does the surrealism come from, in regard to technology?
It's a possibility to transform. A possibility to have incoherent thinking. You can have ten voices at the same time. It can be futurism but at the same time it's surrealism. With technology I can use English, or I can be female, or male. I can speak with many people at the same time. And if I put all the information on the table, it's a very informal archive.

Outside of your friends and family, do you think you're part of a certain community in Paris?
Yes. When I'm alone. Sometimes I have eye contact with people and we look each other in the eyes and we say hello. We understand each other and we meet. We don't need to speak. Sometimes we can have a friendly

moment, we can joke and we can speak.

I find that eye contact in Paris is different than any other city I've lived in.
It's different everywhere.

Here I find it much stronger, happening more often, much more intensely.
It depends which people you have eye contact with. Sometimes you shouldn't continue the eye contact. You need to stop directly because eye contact can be a provocation, eye contact can be dangerous. It depends. But you need to look to know. And I think it's not good not to look. You need to find the eyes to understand immediately what will happen.

What would you say is your current definition of identity?
Identity is the movement of the ocean. The movement of the wind. I met you five minutes ago. I don't think I'm the same as five minutes before. I have a lot of details about the language you've used, about the interaction we can have for this interview. The person I am changes all the time, it evolves, readapts with the situation. Identity is that for me. One identity is not singular. It's a plural. It can be many things, with a dark side, a good side, with different aspects, and unconscious parts too. I think identity is readaptation all the time and to be conscious about life, the situation where you are, which people you have discussions with. If I meet a person on the street, my language changes, I don't use the same language, not regarding speaking French, but because my language changes depending on if I meet an older person, a young person, a marginalized person. After that you have social context. Social context has a colored emotion. A French country has a different colored emotion than other places, and that color has to do with the identity and emotion.

And the energy?
And the energy. To be in this bar, this space, maybe it used to have old buildings, a cemetery, trees.

It's funny, I was talking to the artist Bianca Bondi about this, the history of objects and the energy that is carried by objects through history. This seems like the same idea. Like, what energy does the rock that made this floor have from being brought here and how does that change the energy of the place?

It's the same for the future of this place.

Do you think art has a place in helping people understand larger social concepts better or in a different way? Concepts like politics, identity, homogenization, appropriation?

I think art can be both a utopian place, but at the same time you have the art market. The art market is a business. And how can you get critiqued through politics of the art market; it's very difficult to deal with that. I think the good art, the best political art, is just a person, a *syndicalist* [union worker], making things for the society. Who goes inside a museum? Who goes inside the gallery? Who goes inside the art fair? Who has the money to buy a sculpture? It's the top of the society, and then those people say, "Okay so now we can speak about the question of decolonization, the question of gender and feminism and racism and blah, blah, blah." For me it's very difficult for this interview to be very real and sincere. But I'm a utopist too, and I hope it's possible with art to speak with a new language, the language of form, the language of sculpture and performance and try to touch. ◊

Talking with

Bianca Bondi

about science, the occult, and forgetting ourselves.

"The spirit world is all about energy and vibrations. Objects, molecules, and matter. Everything has an aura and hums on a non-visible plane, leaving a residue— as does technology."

Bianca and I started speaking on the Internet. We exchanged messages about art and, for no reason in particular, I didn't look at photos of Bianca during our initial conversations. Bianca invited me to a group show she was in and I went. When I arrived, my phone was dead. I looked at her pieces, beautifully odd bags of fake hair and liquid chemicals scattered around the floor, then I looked around the room for her. I had no idea what color her hair was or what she looked like and I was too shy to ask the dozens of strangers, "Are you Bianca? Are you Bianca?" I texted her later, telling her what happened, and she told me not to worry, that she had another show the next weekend. Bianca is nice. At the next show, where she exhibited a piece called *Hundred Wealth for Channeling Purposes*, I stared at her work and learned more about Bianca, for a second, without having met her in person. Even though I've met Bianca in person now, the best way to describe her is to describe how I really got to know her, through that piece. It fills a room with a mix of mechanical and ethereal energy. Glass tubes growing crystals are tied by copper fittings to planter boxes growing baby bok choy, to planter boxes growing rusted teapots the same turquoise color as the crystals, to planter boxes growing unlit candles so brightly colored they look to be lit. The piece has a magic to it, somehow infusing the dead with the living, the colors of Earth with the colors of digital night. Her piece then, and all the work I've seen since, was and is alive with chemical reactions, scientific mysteries trapped in manufactured elements of our modern life, glass and plastic and limited imagination, pushing back against their entrapment, trying to leak their magic into the world.

Instagram: @binnekant
www.biancabondi.com

What is your reaction if I were to say we have forgotten our selves?

I think as a society it's as if we spend the first part of our lives trying to figure out who we are through accumulating belongings. This curation of self is meant to confirm the identity we chose to portray, our aspirations of self. We spend the next part not being bothered, because we know who we are and no longer feel the need for external confirmation; we have settled in. Then there's the third part when we realize how much we have forgotten along the way.

In one of your recent shows, *Diet & Psychology*, you explored how the food we eat links to our thoughts and feelings. Can you tell me more about it?

I got into these podcasts on all sorts of things ranging from scientific research on how salt is actually really good for our body. How we lack it in our diet, even though everything is saying less salt! No salt! Same thing with fat. Or how medicine is constantly changing. New statistics are always coming out. We're over-consuming different degrees of scientific research and awareness of health and well-being. I wanted a continuation of my vitrine pieces, but instead of chemical reactions made from elements that make great reactions but are toxic, like the gases released before the recrystallization of copper sulfate, I said, okay, let me experiment with raw elements that we actually consume, and make those react. So I went overboard on the wine, salt, vinegar. And these were my tools for creations.

What is your understanding of the connection between diet and psychology? Or something like mental health?

By changing diet, you're capable of changing on the molecular level, the chemicals that lead to depression. This is groundbreaking. Through further research and discussions with doctors I have become so optimistic about where we are heading in terms of healing and new perspectives for complicated diseases.

What does psychology and mental health mean to you?

Mental health comes down to understanding that your body is a holistic entity and that the mental manifests physically and vice versa. It comes down to the awareness that one needs to take care of oneself on a molecular level also, like reading ingredients in medication and face cream, choosing organic, wearing a gas mask when working with chemicals, for the effect to resonate best on the greater whole self.

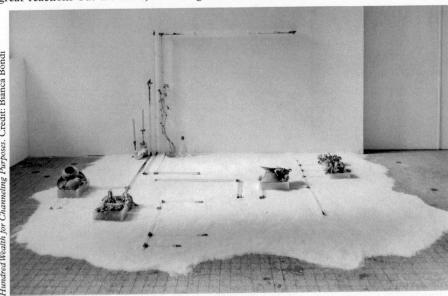

Hundred Wealth for Channeling Purposes. Credit: Bianca Bondi

You realize that best when you're physically sick and mentally you're okay. And you realize you have two dissociated parts of your body that you always assumed were a whole, that are fighting each other. A lot of people walk around being mentally not okay, but because they're physically okay, they don't realize that.

When you speak of mental health with your friends, what words do you use specifically?
I guess in instances I've spoken about it, I always relate it to past trauma. Past trauma embedded in the psyche. Dealing with that, bringing it to the surface. So, repressed memories returning as myths, that should be truths.

That's like one of your titles, *Repressed Memories Return as Symptoms of an Inner Disorder, They Also Return as Myths.*
That's my favorite title. That's actually a quote from the most beautiful book called *The Silence of Animals*. I thought, as is, it's just so perfect. I thought that was beautiful to relate to memory and how, as you repeat a memory you have, it almost becomes the status of a myth because you no longer remember what's true, what's not true.

Let's talk about some of those shows. Some of your work. How did you come to adopt installation art as a way to express yourself?
When I first started making art, I was a painter and I realized why I wanted to paint was just to color in, because I was so obsessed with colors. So with this radical rupture that came with understanding that I was wanting to paint for the wrong reasons, I started saying, "I make installations," because I'd seen this word being thrown around and I didn't really understand it. But I knew it wasn't just a sculpture; it was a sculpture in the space, and for me that just made so much sense. I started throwing the phrase around, I guess because my work works with the space around it. I like to do things that are big and work not just with the architecture of the

space, but also with the energy and the air quality and the humidity and all those things. Because as I'm working with things that transform, all those factors react on the art.

Something I like about your work is first the strong aesthetic principle. Then there are some very clear concepts. Then there are some concepts that take effort on the part of the viewer to understand. How do we shrink the divide between the art world and the general population, who often say they are averse to "high" art because they feel they don't understand it?
Something that's always irked me about art is this elitist status, where you feel you need to have had a basic art history program to even begin to understand a piece. How I deal with this in my work is by appealing to aesthetics, colors, words, a focal point, something to incite curiosity and catch one's attention. Art is visual poetry. It needs to be as open as possible, universal. I try to activate the aura of a work, and one of the ways in which I do that is by speaking from personal truth but in a language that resonates in others. At the end of the day, finding art is much like coming to religion. It sneaks up on you at a moment in your life when you need it most. If people continue to fight for art and artists, it's because it is so necessary. We can all do with a reactivation of the imagination and a reconnection of experience on a level that is not always easy or quick to decipher. Some of the best artworks stay in our minds and only reveal themselves in time.

In a lot of your interviews, I often find that the writers and journalists interviewing you are obsessed with your links to magic, to the occult. Why do you think that is? What does the obsession say about us?
I think it's because, when I first started giving interviews, especially as a young artist, it's sort of like, you don't really know what you're trying to say, you're just saying it. The easiest way for me to talk about my practice in the beginning was to talk about what was a major source of inspiration for me, and that

was the practicing of magic and everything that was related to that. Obviously that triggers people's interest because that's not something very common for people to say. It wasn't particularly trendy at the time, whereas now it is. It's hard to meet someone who doesn't have at least a slight fascination for the unknown. People wanna know more, it's like, you have secrets to tell, and actually the secrets are within us all anyway.

Do you think the interest in magic, the occult, rituals, has something to do with our repression of it in Western culture?

I think that's important to bring up, because when you repress something, you force it to go underground, and anything underground has a halo around it. If you take the context of France today, you can't actually practice Wicca; it's illegal. You cannot have a coven. In a society which is *laic*—secular—without religions, the religion of Wicca is illegal. It's not just frowned upon; you can go to jail. This is just so strange to me as Wicca is neo-paganism, which is a way of living in the most natural way possible, the most connected to the earth. It is about free will and manifesting the positive. The most important law in Wicca is "Ye harm none, do what ye wilt." That kind of says it all.

What is the contemporary function of ritual and the occult?

Like I was saying, I got into these podcasts. I was a latecomer to podcasts. My favorites have been these New Age podcasts, usually two people, two women, who invite guests on their show to speak about things like drinking water that crystals have been cleansed in, or dating cycles and moon cycles and just general New Age techniques for healing and self-care. I think it's fascinating, the amount of podcasts that talk about this kind of stuff. You feel there's this resurgence in interest in all things related to the occult. Already it's found its place on a technical platform, and you see the sheer amount of interest in the different varieties of techniques. I think that's really encouraging and inspiring and I think it's something that's been so important from the beginning of mankind and it's still

got its place today. Or even more so, because people feel less taboo about saying, "Listen, I worship the moon."

I feel that when people focus too much on your interest in the ritual and the occult, they seem to overlook the scientific elements in your work. How would you relate the scientific processes in your work with the ritualistic elements?

Science was a default thing. I found myself attracted to science because, for example, I was crazy about schematics. The more complicated the better. Or things like making chemical reactions to produce colors that you could, for example, have this dark, deep purple color and then with one little stir you could make it transparent again. That's everyday magic but it's not called magic; it's called science. I find science connects with the occult for the very obvious fact that the beginning of alchemy was science. It's just that back in the day we didn't understand the science, so we called it a strange phenomena.

Which rituals do you draw on with your work? And how do they relate to the science-driven processes?

I started practicing techniques linked to the occult when I was six years old. It's just that I didn't know what it was. The science came later, when I was in high school, thinking I needed it for a career. Whether it's ritual or science, both have clear, set rules you have to follow, things you have to do. I'm not doing science or ritual; I'm doing art—and that means you have to forget those rules and find your own way. Why I get so passionate about the art-making process is that it is the most liberating way to reconnect to the world. Making art, it is important to know how and why things existed in art-making through history. Then figuring out your own path, respecting where your liberty got its rooting.

How is our access to technology affecting our connection to the spiritual world?

The spirit world is all about energy and vibrations. Objects, molecules, and matter. Everything has an aura and hums on a non-visible plane, leaving a residue—as does

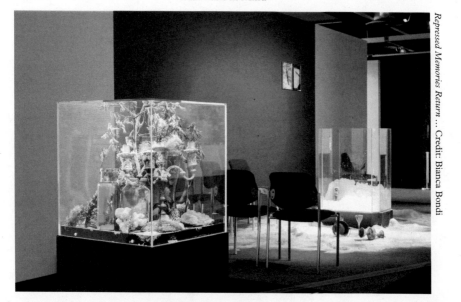

technology. I feel like, if you're trying to be as close as possible to the earth, to the air, to natural raw materials, that's the last thing you want, is to bring in the interference of radio waves, Wi-Fi waves. But it is also the natural evolution of our society. It's positive in the sense you have podcasts, Instagram, informing and educating more and more people about other ways of life. But I've been part of covens where people are like, "Oh, the circle is so beautiful; let's take a photo." No, this is something that needs to stay hidden, you need to appreciate the beauty. You can't have your phone in the circle where the waves are interfering.

Could you explain how the vibrations work? How the tech vibrations affect the spiritual vibrations?

I am very interested in this idea of animism. Objects have a soul. In animism, an object that's passed through time acquires its soul because it has lived. Take this teapot for example. [*Bianca picks up a fancy-looking teapot on the table.*] It's made of silver, so that silver had to come from somewhere, then be molded by someone, and now it's pouring tea, so it's acquiring the stains of the tea. What I think is really fascinating is a new branch of philosophy which has come out in the last few years, maybe the last six years,

OOO, object-oriented ontology. It's saying that it's pretentious of humans to have always assumed that everything is understood from our viewpoint, and it asks us to see the world from the point of a raw material or an object. And someone like me, who already believes in the soul of objects, to have the science side, it strengthens my belief about what's next. For someone to take the occult and discuss it from an OOO perspective, I'm dying for that to happen.

Can you tell me in a couple sentences what OOO is? An object-based understanding of the materials, which go into the things we own?

[*Bianca finds a book by Graham Harman on her table.*] Oh perfect, this is a great way to sum it up: "An object is more than its pieces and less than its effects."

Especially in your vitrines, you include what seem to be very specific items, objects, materials, chemicals. When you find an object, what kind of importance does it connect with you psychologically? Like a Turkish teacup for example. How do your selections carry symbolic value to you?

First, I think it has to be a personal attraction. This might be related to the collective

subconscious, or epigenetics. Why do you like this? You've never been to Turkey, you don't even like tea. And that's fascinating; it's the perfect starting point, to follow something you don't even know why you like. To see where that leads you.

Can you speak to the importance of the glass, the confining element, in your vitrine pieces?
When I did the show at the Cite de Sciences, they were worried about children putting their fingers in it because I was using different chemicals, so there was this safety hazard. So we put these glass boxes over them, and this was fantastic because not only did it keep my spaces moist for longer, which promoted bigger crystals to grow; once the glass came over, the gasses were contained and the different gasses interacted more so than dissipating at different speeds, and so this created results I couldn't expect. From then on, I've tested in different ways. And what I'm interested in when I do these compositions is collecting articles from all over the world that shouldn't meet but now are composed and left to vibrate together. This is another way of producing an aura through an artwork and communicating through what may be invisible but can be felt.

What do you find interesting about the process?
I'm interested at the microscopic level, watching something transform or recompose, how it reacts, how it's out of the control of the artist. This is what's interesting, because no contemporary art we make, unless it's stainless steel, will last. Nothing will last. Take my latex pieces for example; when you tell someone, "You're buying this thing that's gonna fall apart," immediately they panic. But everything will slowly fall apart, like us. And I think that's so fascinating. It happens before your eyes in a more rapid process than other artworks. You see the piece age and then you see it disappear and it's gone. What's so exciting is that process. If you're watching it every day, you don't notice, but it's like when you see you parents after

months, all of a sudden they've aged. That makes you think about aging. I think I get excited because if I don't get excited about the aging, I would get depressed. So I'd rather make it into something that is poetic.

I've been asking everyone about loneliness. I feel in relation to both science and spirituality, you might have an interesting take. What does loneliness mean to you?
That you feel misunderstood, and that no one truly gets you or you can't relate to anyone and no one relates to you. Isolation.

A psychological isolation?
Yeah, a state of mind.

When did we transcend the stereotype of a physical isolation?
Maybe the shift in the stereotype in the word came about with technology, because it's never been as easy to connect with other people as it is now. We've never been so within reach, and yet, perhaps as a society, we've never felt so lonely.

Where do you think this change is coming from?
Maybe it comes down to vibrations and energy and chemical reactions and pheromones.

You told me a story once, about a girl who wanted to connect with someone she was in love with. You advised her about ritualistic ways she could do that linked to pheromones. It's interesting to me to think of overcoming loneliness in a similar way. How could we try overcoming loneliness ritualistically?
She understands I have this passion for things occult. She had her own experiences, finding out about it her own way, then coming to me for advice. One day she says, "I've met this guy, the guy of my dreams. I need you to help me. How do I make him love me?" I told her, "You can't do that; that's complicated on so many levels." She said, "But I need him; I don't care." I said, "Well, whatever you do comes back threefold." That's just the basic norm for everything. So she was like,

"Just tell me, because I know we should be together, and I need to make him realize." So I gave her three different ways she could go about this using magic, calling the universe, summoning her will. And I think she was expecting something sweet, like to write a little word on a paper, blow it a kiss or whatever. When I told her the various ritual ways which involved getting the guy to unknowingly consume her pheromones, she freaked out.

So if you were struggling with feeling lonely, not physically but mentally, what could a person do ritualistically to try overcoming their loneliness, their feeling of being misunderstood?
You step away and step back and change your mental state. In a ritual sense of defeating loneliness, you make a puppet of yourself and a puppet of other people. And then you bind them together. And if you find that the loneliness is a state of mind, you bind the minds together, the heads. Then you go further, using herbs and stones and organic materials that symbolize overcoming fear. Let's say you have shyness; bind all of those elements together, then you bury them somewhere safe . . . to vulgarly sum up sympathetic magic.

In a different interview, I read that you put certain ideas in your work to "disconnect from your obsessions." That sounds a bit like art as therapy. Do you ever think of your art in that way?
There have been moments in my work where I haven't realized it at the time, but creating the piece was a way of speaking about something that had happened. Then you feel a weight that's been lifted because you channeled it through the material and in the material transforming, you transform yourself. That's a form of sympathetic magic.

I want to end by talking about my favorite piece of yours, *Hundred Wealth for Channeling Purposes*. The colors were very moving for me, a mix of natural and artificial. The greens of the baby bok choy, the turquoise of the candles.

Can you talk to me about your relationship with color?
It's important to surprise people by color and color combination. There's something inherently attractive about unexpected combinations which you can't explain. In that piece I was trying to use colors of chakras. It's something I've always been drawn to. I think it's such a magical thing, the light spectrum. How it's all these different colors but it comes out as light. When you dare to put bright colors in, you attract an attention and people don't usually want attention, but it's an important mechanism to draw attention to things that matter. It's a great carrier for the message.

You talked earlier about a purple you can change with a stir. Working with color, can you talk about the things you've learned about it?
Potassium permanganate?

Yeah. Can you tell me about it? The science behind it?
But then that would give away the magic.

Yeah, then don't tell me. ◊

Talking with

Gaëlle Choisne

about modern love and our modern love for the image.

"We have to love, but capitalism gives us a very idealistic idea of love; pure. Without problems. Without problems of money. Without contextual social issues. It's quite weird."

In a giant concrete room I found giant gold oyster shells, giant playing cards, long messy bed sheets hanging from the ceiling, tiny cigarette butts, tiny photographs, small liquor bottles, and a television facing away from its potential viewers. The room felt like a brain full of memories. The sizes of everything, odd, inverted, felt like the memories of the unimportant things we unknowingly give the utmost importance. The room, an exhibition called *TEMPLE OF LOVE*, was a temple to the joys of love, but also a temple to the pains. Standing in it, I remembered my best memories of hand-holdings and funny debates and sex with all my failed romances. The memories gave me a sad thankfulness, reminding me of who I was and how I became that who. Leaving the room, I felt happy in that way that reading a good autobiography by someone else makes you feel like you've been reading an insight about yourself. Gaëlle, the artist who made the room, is a photographer. But she's also a sculptor, a designer, and an installation artist. She thinks about what the image is and what the image can be. She thinks about how the images, and those of us who find ourselves in them, are wrapped around with questions of heritage, religion, gender, and politics; all the big ideas that define our most basic experiences. All those big and little things in Gaëlle's temple were the beauties and barriers of love sociological. I wanted to talk to Gaëlle about love in the modern world, and how the image, so many images, brings us up and weighs us down.

Instagram: @gaellechoisne
www.gaellechoisne.com
Translated from French by Christopher Seder

You're from Normandy, Cherbourg; you did your art studies in Lyon, you have family connections to Haiti, now you split time between Paris and Amsterdam. What's the importance of each of those places for you and your art?
It's a good question. I like to be connected with this experience of the world, different countries, different smells, different energies. I like to feel that, to be inspired by that. I like the process of travel. It's a part of my process with my work. I think a lot when I take a train, I work a lot when I take a train. This movement, where my body is in motion and at the same time static, it's quite weird. It's an important moment of my creation.

So it's the movement between places that teaches you things?
It's both, not just being in a place but also the act of getting there. That's why I prefer the train.

What's the reason you spend a lot of time in Amsterdam? You have a relationship with Paris through your art, but you live in Amsterdam more of the time?
I've had a residency in Amsterdam, at the Rijksakademie, for the last two years. And I've fallen in love with that city totally.

What does it give versus what Paris gives you, in terms of inspiration?
Paris is a violent energy, always in action, a bit too much sometimes. Violent energy but sometimes really beautiful at the same time, like, "We exist, we are here." Amsterdam is really contemplative, like a breath. Really a balance.

And Haiti, you told me you haven't spent a ton of time there, but that it's still an important place for your work. How does its secondary space in your life inspire you here, in Europe?
I would like to live there. I cannot describe that properly. Oh my God, it's a super-crazy energy, super strong, you can feel it around you, that you're not alone. It's like a regeneration; every time I go there, I come back full. Really full. My spirits and my mind

are changed. And I see the world differently. I have another point of view where I saw, or tried to understand, another manner to live. And the violence, the strong violence too, but also a really beautiful landscape, and a beautiful nature. I find my vitality there and take it with me. So maybe give me my capacity.

That's interesting. I went to Naples this summer and I felt a similar emotion to what I think you're describing, violence mixed with beauty. Not a violence to me personally, but a violent energy.
Yes, I went there too!

And the violence made me feel alive.
Yes, it's like love.

Exactly! That's what I said, that it was the most romantic place I've ever been. It's like violence and sexuality, and this weird energy that comes out of it. At the same time, there is this beauty of the food and there's Pompei right there and the bay. Exactly, it really was like love. A true love, not an easy love.
Yeah, a visceral love.

I want to talk to you about love in relationship to contemporary life and in relationship to your exhibition TEMPLE OF LOVE. I went through the gallery, and before reading any of the material or artist statement, I took these notes:
•An internal space, inside a brain, that she made visually tangible. Our untouchable, unchangeable personal histories—past loves, tragedies, violence, pain—which define both our love and our capacity to love.
•The objects are really just our memories, their size dictated by the importance of each memory.
•The single television facing out, the microscopic aspect of our self that we allow the world.

What do you see as the sociological benefits of love, beyond the individual?
I'm happy to hear that, because it was my

intention. I thought deeply about Foucault, *The History of Sexuality*, and this story of love and capitalism. I think this is exactly the problem, because we have to love, but capitalism gives us a very idealistic idea of love; pure. Without problems. Without problems of money. Without contextual social issues. It's quite weird. It's *lisse* [cheesy], *très très lisse*. Very boring.

So, *TEMPLE OF LOVE* is a work where I play with balance and tension using these small chains. They can be economic links, or they can be seduction, or a social symbolic link. At the same time it can also be the slave. These tensions and balances can physically become a translation of the way I feel about relationships with a person, or multiple people.

What can love help us achieve in counter to the negative experiences we have in our lives?
The process of love is uncontrollable, a slavery state. Sometimes it's completely crazy and can become a repeating image. Like the videos, loops, in the piece, they are images of movement, and yet it is close to a still image. Our love can be an infinity and never stop. I create spaces with cushions, where the sculpture is between the functional and the artistic, in the service of the idea that "I made this object for you," so people can use it and share with the exhibition.

That's funny you say that because when I went there, I sat on the cushions and then said, "Shit, am I supposed to sit on this?" I could tell other people sat on them because there were butt indents. I really liked that because there's an aspect of love in that; our ability to let ourselves be comfortable but then say, "Ugh, I don't know if I can do this." And I think about that a lot, when we fall in love it gives us an individual freedom in a certain way, to forget other aspects of our self and be free.
I have this attitude when I work. Freedom, being uncomplex. I forget everything. I don't care about any judgment when I work, I

Detail from *TEMPLE OF LOVE*. Credit: Aurelien Mole

just make. It's pure love. It's this generosity I want to give. So this functionality of the sculpture like the table, the footbath, the cushions, was also a social aspect that I wanted to discuss. Social love. Political love. A necessity today, because we have real problems. The tools, the images and the screens give us a manner to accept violence. The sensitivity of the population is falling because they have so much access to violence. The banalization of the violence was also a motor to make this exhibition.

When I was in your exhibition I was reminded of past experiences, past personal traumas that have potentially prevented me from falling in love. Also aspects of society that prevent us from being in love with other people and the actions of other people that prevent us from being in love with society. What aspects of modern society prevent people from being in love, personally and universally?
I think individuality, this growing importance of individuality in capitalism, prevents love. You have this feeling that you can just "be

yourself" and it's enough. The idea that you don't need others or the community. That you can be alone, do everything and you don't need others, don't need your neighbors, don't need a family. In the capitalist system, if you have money you can be yourself and that's it. Sometimes you have to give up a part of your individuality when you fall in love, so it's quite counter to this system.

There was a quote I was reminded of at your exhibition by an English writer, W. Somerset Maugham, from his book *The Razor's Edge*:

"It is very difficult to know people and I don't think one can ever really know any but one's own countrymen. For men and women are not only themselves; they are also the region in which they were born, the city apartment or the farm in which they learnt to walk, the games they played as children, the old wives' tales they overheard, the food they ate, the schools they attended, the sports

they followed, the poets they read, and the God they believed in. It is all these things that have made them what they are and these are things that you can't come to know by hearsay, you can only know them if you have lived them. You can only know them if you are them."

What I think Maugham is saying is that you can't fall in love with someone you don't know and that it's hard to know someone if you didn't play the same games as a kid, eat the same candy as a kid. That all these little differences could contribute to a larger unknowing of a person. I'm not saying I agree with that, but I find it interesting in relation to the idea of the things that prevent us from being in love.

It's true but that's why, for me, a strong love is an experience where you forget everything and you don't care about knowing or not. It's this question, like I said, about the fact that why people don't love is because they are afraid, because they don't know. It's also a protective mechanism that society built for them. They can pay for insurance, have a garden, have an alarm. But at the same time it's true, if we can translate, change, or displace our fear, and start with a feeling of love first, then we will see what happens.

In *TEMPLE OF LOVE*, you speak of love through the lens of certain cultural struggles. How is love connected to oppression? Exoticism? Colonialism? Difference?

I'm the pure product of mixing. My father from Brittany, my mother from Haiti. So for me it was completely natural to have two cultures. At the same time I was born in France, I know more of France than Haiti, and I felt sad when I thought of how I'd missed this part of myself. I speak about this ethnocentrism and the violence of the projection. I have this problem in my work because sometimes the institution wants to focus on me being Haitian. But I was born in France, so why don't you say I'm French? At the same time, I'm really proud to say I'm Haitian because it comes from my mother.

What does it make you feel when they do that?
Sometimes the institution uses it like an instrumentalization. It's really complex, because at the same time I'm proud to have this double position. I can feel like a tool and an object, an exotic object. Some institutions promote that properly and with a lot of respect, and sometimes you can feel that is just because it can be attractive for the exoticism.

How does history affect love? Because that to me connects with the exoticism, how we cast onto the other our perception of them. What do you think that is doing to love?
It's a difficult question.

Maybe we can start with the image. We can now see images of so many people who are different than us. What do you think about the fact that technology allows us to see so many images of people, and what do you think that's doing to exoticism?
Technology can help to give different points of view and give voice to different cultures. So we have more access to difference. It's really important. I think the accessibility to the image, to make images, gives a possibility to see and share unseen parts of the world.

The image, and the fact that we have such access to it . . . is that helping us actually connect more or is it just allowing us a new form of exoticism? Are we really connecting better with people who are different than us?
It's never just the tool. Like anything, if you use a tool with exaggeration it becomes dangerous. In this way, it's quite difficult to say it's good or not because of course we have access to lots of things. We can make ourselves close to a lot of things that are very far away from us. But at the same time, we are really far away from the people really close to us. This is the real effect.

We can see people more clearly now; they're sharing more photos, we can look at their lives . . .

It's the completely natural prolongation of the history of photography. The portrait, the selfie, was completely natural. A painting of a selfie didn't surprise us. So I don't know why the selfie is such an interesting anthropological question of why the human being needs to recognize themself with the representation of themself? It's like people forgot that we've been doing that forever. Photography gives you a distance needed to see yourself. I become another because it's just a single moment in my life that I captured. So it's not me anymore.

What do you think of the proliferation of portraiture and the human image on the sense of our living self?
It's this manner to love yourself. To try to understand yourself and love yourself. It's a question of ego and existence. With social media, you have this new way to exist for others.

In your piece *Cric Crac (Épilogue), 2013-2015*, you say, "The image places the question of zombies as central. A survivor; dead and alive at the same time, animated without desire, sedentary and nomadic." Can you speak for a moment on the concept of zombification and what it means for the living?
Zombification is quite a long story about slavery. Sometimes I think it's this lethargic state where you don't have self-consciousness. You are just a body and your soul is gone. So it means, if you recognize yourself, you're alive. For the human being, maybe the self-portrait through technology is just a manner through which to live, to have an existence. The fact that if you create a distance with yourself, make a self-portrait, you claim to the outside world that you exist: "This is me, look at me." But you also recognize yourself, alive. It's a manner of resistance. At the same time you become a slave to this self-representation. Because it's only a projection, a virtual projection, so you forget to be alive in the real life. So it's really a strong dialectic between two faces.

Why do you think a large portion of soci-

ety needs to remind itself that it's alive? It's a good question. Because they realize that it's not enough to be individualistic. That it's not money that can give us power. Or maybe it's because they know that they will die.

I guess I'm wondering what's happening to our collective brain that might mean we need to remind ourselves through self-portraiture that we exist, that we are not zombies. That's why I was so fascinated by your concept of zombies, because we often talk about feeling useless or alone or not fully present. So maybe, what is the benefit of taking all those images psychologically?
Survival, existence. Forget everything in your life. You're just living in nature, in the forest, naked. You have this object. A mobile phone. And you can take a picture. You realize you can catch something from reality in a flat image. It's incredible. It's magic. So it's a fascination also. A manner. to control something in the world. You now have in your possession, something from the world. But at the same time it doesn't make clear sense why you want this possession. Why you want to be the owner.

In an interview you said, "I create sculptural installations at the intersection of sculpture and photography. A hybrid of image, photography, and video. Creolization of a chaotic world." Tell me about the crossroads of those two mediums.
The definition of image, for me, is kind of like a ghost. It's difficult to understand. It doesn't exist. It's a *flou* [blurring]. It's a contradiction. We want to control something, but this thing is completely *flou*. In this way it's trying to materialize and trying to give a body to the image, to give subjectivity. By creating a body, I create an identity. In certain senses, I create a new filter to see images. In the history of photography, we speak about "surface." But it's not only a "surface," it's an object. I play with this representation: what is the topic, the subject, the surface and the physicality of the surface?

What does the print surface of a photograph tell us about the content of that photograph?
It's a contradiction too. Often in my work there is this epiphany of the image; the apparition and at the same time the dis-apparition of the image. So it's something in between, like you lost something, maybe the topic of the image. Or the representation. Or the meaning. Sometimes you gain something else I can define for you. Something historic maybe, or traces of another reality. A confrontation of different realities that have to live together in one object. Not one reality or the other; it becomes a new reality. Like the third voice or third space.

What are your thoughts on the discussion of authenticity in regards to photography and the image?
I think, for example, the GIF culture is a really authentic archive. It's a real anthropological document. A friend from Haiti sent me this image on WhatsApp: the guy who ate the ember in the video installation for *TEMPLE OF LOVE*. It's become a collective history, but we don't know who the author of the image was. A friend of mine told me, "Yeah, I saw this image, I saw this GIF." So it's become a collective imagery from the world, and it's quite weird. Because we don't exactly know which collective identity we are; it's this collective virtual identity. Maybe it's really sad because I think we've lost something in our own memory now. We live with only a visual memory, without smells, without touch experience, without energy. And that's why in my work, I try to create a non-photogenic space so the viewer can have a physical memory. Because we've lost this part. ◊

(Facing Photo) Detail from *TEMPLE OF LOVE*. Credit: Aurelien Mole

Photographers

Talking with

Billie Thomassin

about kitschy bars and dehumanizing a person out of respect.

"What I find interesting in my work is to not humanize a person at all. I'm not a portrait artist. Figuring out who a person is, or who they're trying to be, doesn't interest me. . . . I try to dehumanize my subjects, to make them into neither woman nor man. Into neither a Juliette nor a Jules. . . . They can then be like a tool, an object I can direct."

What do a naked torso, a toy crocodile, and a baby duck have in common? Nothing. So then, what do those objects mean when placed together? Nothing either. That's the point. They're all just pretty things devoid of meaning. And sometimes, in a world choking on its own complexity, nothing is exactly what we need. Nothing but cuteness. Nothing but laughter. Nothing but stepping back and humming softly a, "Hmmm . . . gorgeous." It's that pleasant humming I get from Billie's art. Interesting angles, exploding colors, faceless bodies and a relief from all the questions. This isn't to say that Billie Thomassin's photography is uncomplex. It is complex. The aesthetics are expert. The balance magical. The way Billie can draw out new beauties by merging and contrasting disparate objects is a blessing few of us have. And the fact that she doesn't ask us to do anything more than enjoy . . . well, that's holy. In her pictures, I'm reminded of curves I fail to ever notice, purples I've misplaced in my memory, and toys from my youth that I don't remember losing. Speaking to Billie for this book was a lesson in her genius of pure appreciation. It was a lesson in looking at the bars and the bookshops and the movies of our lives and finding in them inherent joy, nothing more. We did this interview in Billie's living room. It had sky-blue walls, Styrofoam statue heads, and naughty get-well novelty cards. I remember sitting in that room and giggling. Nothing funny had been said. I was just giggling from a pure joyousness of place. We spoke, I listened. I remember telling myself to learn from Billie how to just quit with the analytical, how to step back, breathe, and have more fun.

Instagram: @billiethomassin
www.billiethomassin.com
Translated from French by Christopher Seder and Jennifer Ben Brahim

When we first met, a few years ago, you told me your family had been living in Paris for almost ten generations. I remember finding that fascinating. How different Paris must be for you versus me, historically, visually. What is your relationship with the city?
I am completely, totally addicted to Paris. I feel completely at home on the street. To me, it's *my* sidewalk; everything belongs to me. It's just completely a part of me, really. I couldn't be anywhere else.

Do you think having such a long family history with this place affects your relationship with Paris?
I don't know. I like reading books that take place in Paris, I like watching movies that happen in Paris. I mean, there's also this whole cultural thing where Paris is associated with being this dreamy place. You know, as soon as you pass in front of a little bistro, you immediately start picturing the film scenes. I don't know; it just feels like you're in a movie all the time. To be honest, I feel like I'm completely in a fiction here, even though I live here, and have always lived here. But in terms of my family history, no; I don't really think about that. Even if yes, sure, I know that my grandfather, for instance, was born in a certain apartment across from the Bon Marché, and so when I pass in front of it, I say to myself, well . . . I can't really picture it actually, the fact that in 1925, my grandfather had just been born there. So no; honestly, it isn't something I think about.

Is there something you find most inspiring about Paris related to your photography?
What's funny is that I actually don't find Paris inspiring at all. Like, not at all. I feel like we don't have enough space here. Sometimes, I have this urge to make a film, or take a picture, and I'd like to have a big location, I'd like to be in a hotel that has large hallways, that sort of thing. I feel like things are cramped here. And in terms of colors, too, I don't think there's a whole lot going on. I don't think it's an inspiring city at all, really, when it comes to my work. But I feel

good here, so it inspires me in that sense. I also have this relationship with travel, which is to say that I don't like to travel. I can't travel.

You don't like to travel? That's interesting.
No. So, as a result, Paris has taken on a different meaning for me. I read a book by Paul Moran once, and in it there's a line that really struck me, and that helped me understand my relationship with Paris better. It goes: "People are wasting their time traveling quickly; they go to places where they have no business being. Paris is the whole world; I'm going to take you around the globe." And basically, when I read that line, I said to myself, "That's true, really. What's the point of going off and being a tourist in places that, really, you couldn't care less about, except just to be curious and to go see new things? Isn't it better to just be curious in Paris?"

Do you think you've always felt like that?
I used to be a little ashamed, actually, of saying that. Because when you say "I don't like traveling," you sound like this girl who isn't curious, who has no interest in other people and all that. But I really just decided to accept it, to see Paris that way, to see how I could travel within Paris, and think of it as the city of my life. I don't have to travel just because you're supposed to, and I don't have to be curious just because you're supposed to be, either. Of course, I hope to evolve, and not to remain this way forever. But I think that, unless you have these genuine urges and a real interest in going elsewhere, that it's better to get to know the place you're in first, to have the inventiveness and creativity to figure out how to travel within your own city. Paris is a great city for that. I feel like it's a place that has so many cities within it, so many cultures, and I think that there's a lot, a lot, to do here.

What do you find most stressful about living in Paris?
I mean, I'm part of the stress of Paris. On the Métro, I run, I push people out of the

way who are too slow. I like that. I find it's a pace that suits me. But, sure, there are loads of stressful things, as in any big city. There's traffic, stuff like that.

If the city doesn't stress you out, do you find anything stressful about living here? Or city life generally?
I love noise. What tends to stress me out more is when stuff moves slowly. If things are taking ages in a restaurant, that irritates me. Traffic jams, stuff like that, the Métro stopping between stations. I guess it's when that fast pace comes to a halt that I don't like. That stresses me out. Other than that [*gestures to her apartment, which is high up in the air, quiet, painted blue, and peaceful*], sometimes I find it almost too calm. I used to live in apartments that really gave out onto the street, and I liked being able to hear the sounds of the city, the cars and all that.

Do you have any specific places in Paris that are important to you?
Yes. That whole Odéon/Saint-Germain-des-Prés neighborhood is important to me. I go there quite often. It's the only place I go to the movies. I go on my own. I go and buy my books from Gibert Joseph, and I really feel like I'm in a movie when I'm doing that stuff. I go and sit down in a café, with the little book I just bought, and then I go and see my movie. I feel like it's very, I don't know, it's my own little private moment of fiction, and I enjoy that.

I find that funny, that the places that are important for you, a tenth-generation Parisian, are also places that are important to tourists here. It's cool. So there are really no places that inspire your work, aesthetically, here in Paris? Something with lots of colors? Some building with interesting angles?
Well, there was a bar I used to go to, which has closed now, unfortunately. It was near Temple [*a neighborhood in the 3rd arrondissement*], and basically it was my mom's hangout. I went a lot, from the time when I was eight until I was about sixteen. It was the craziest place in the world. The woman who ran it was a big

fan of Marilyn Monroe and leopards, and as a result, there was leopard print all over the place, and there were pictures of Marilyn Monroe everywhere.

It doesn't exist anymore?
No; it closed down.

Tell me about the place, what it meant to you.
It was such a wild place. The woman would ask all of her female customers to give her our old bras, and she hung them all up high. There was stuff all over the place, and she only played disco and *variété française* [*French popular music*] all day long. It was totally wild. And she herself was all decked out in leopard-print nail polish, bracelets, leopard-themed jewelry. She was always covered in leopard print, and she had a big red beehive, and was always plastered in makeup. There were taxidermy boars. On holidays, like Halloween for instance, she would go nuts decorating the place, filling it with spider webs and stuff that she would then just leave up for a year. There was a girl who would

read you your tarot cards on Thursdays. On Valentine's Day, a Johnny Hallyday look-alike would come in and sing. It was just this really imaginative place, and one that really had its own unique touch.

What do you think the bar did for your work?

Well, I didn't realize it at the time, but later on, I realized that actually, I had discovered my taste for disco and *variété française* over there, and that's something that influences me a lot in my work. Also, this baroque attitude of taking a scene that's already chock-full, and then just adding more stuff to it, because there's never enough. That's something I think I got from the bar. My love of using objects that are funny, I think I got that from the bar as well. They were always buying new things. There was this talking doe head. They had a microphone, and when you would show up they would say to you, "Hello, Bibi!" When I said that you don't need to go very far to have new experiences, this was really one of those places that gave you that. I genuinely believe that places are like people. You can love them the way you do people, you can miss them the way you do

people, and I find that you can have a fairly personal relationship with such things. Or at least in my case I do. So, I think that place has very much inspired my work.

What was the bar called?

It was called Au Temple. They were nuts there. At one point, the woman asked my mom to paint all of the toilet seats leopard print, and all of the toilet paper holders, too. I mean, they really took things super-far; all the seating was leopard print. Honestly, I think it was awesome to see them go to such lengths, even though it was only a bar.

It's really fascinating that you speak about a place with wild objects, wild visual fantasies. Because I see that a lot in your work: hidden crocodiles, disembodied mannequin hands, objects with no purpose on the surface, and yet, objects that make your photos something special. What objects inspire you? Or what aspect of objects? Their energy?

I would say there are two things I like most about objects. There are natural objects I find incredible, like flowers or precious stones.

It's crazy to think you can go into the desert and crack open a stone and find that it's full of diamonds. I find that so interesting, how we try to make beautiful things ourselves, but if you look at a flower, it's just perfect; you can't do any better than that. I also love it when objects are funny, because objects aren't necessarily meant to be funny. I think it's always interesting to think, "Oh, this object is a bowl," but then it can also be something else. I like objects that can be interpreted in different ways. I like giving something another purpose outside of its utility.

Where do you normally find the objects you use in your photo shoots?
Mostly in flea markets, because I love going to them. I don't like using the Internet, even if I'm sure I would find lots of stuff on it. That doesn't interest me at all. I like rooting through stuff and finding an object that interests me. So, mostly in flea markets. Aside from that, the bazaars in Belleville [*a neighborhood in the 20th arrondissement*]. I find lots of gems there!

Where do you store all of them?
I have a studio at my grandparents' place in the 6th arrondissement. The poor things are overwhelmed with my stuff!

Do you stockpile these objects without having a specific idea of how you'll use them?
Yes; it's terrible! The expression "It will always come in handy" is definitely how I approach things. If I find an object and I know it's special and I might not ever find it again, I'll buy it.

What is your relationship with color?
Color is crucial, even vital, to me. It fills me up. I need to have a colorful teacup, even. I could never do a black-and-white series. Our emotional state is closely linked to our environment, as Alain Badiou says about happiness. Your surroundings inspire you. So, if you're in joyful surroundings, you'll just wind up being joyful. If I want to be happy and joyful, I think I need to be surrounded by color. Like with this apartment, I couldn't just have white walls. Those depress me. And when I see people on the street who are all dressed in gray, I find that depressing too. In my work, I like to put a purple sweater on a girl and make the backdrop yellow. Then it really pops. For me, color is its own material that you can work with. It's great, because it's never-ending. Color is infinite and perpetually inspiring.

Any colors in particular you're connected with?
I would say no, as some colors can go either way. Like the color blue. It can be very appealing, like in *Plaire, aimer, et courir vite*, Christophe Honoré's latest film. Everything is blue and it's very beautiful and appeasing, and creates this great atmosphere. At the same time, I'm super-scared of being underwater, so blue can scare me. It can make me feel relaxed, but then it can also freak me out. The same goes for red: it can be very sensual, and then suddenly it can remind you of blood, and produce something stressful. It's difficult to assign a single emotion to one color.

One of my favorite aspects of your work is how you use human subjects. Often you don't include faces, which I think flies against every photographic trend of the moment. But also, I love how you place human bodies at such odd angles in your photographs, and odd movements in your videos. In another interview you said something like, "I like to treat humans like objects." What does this quote mean to you?
What I find interesting in my work is to not humanize a person at all. I'm not a portrait artist. Figuring out who a person is, or who they're trying to be, doesn't interest me. When I do a photo shoot, what interests me isn't showing people's personalities. I try to dehumanize my subjects, to make them into neither woman nor man. Into neither a Juliette nor a Jules, to turn into this inhuman person. I'll even ask the person not to pose and to not put themselves forward, which I know isn't very flattering for them, so they can then be like a tool, an object I can direct.

Do you have specific parts of the human body that you find more interesting?
I would say I'm obsessed with hands. But beyond that, no. What's most interesting to me is having an aesthetic that doesn't appear to be too natural. I'm not interested in photographing people in everyday positions. So as a result I tend to put them in unnatural poses. I'm very inspired by dance. I like having a style that comes closer to gymnastics or choreography, where the image is about the geometry of the body.

How do you come up with the poses? Are they spontaneous?
No; each pose is thought-out. I know exactly what position I want. But often, you have this idea in your head, and then it doesn't necessarily pan out. Increasingly, I find I like working with dancers rather than with models. I often find working with models to be restrictive. They're not very flexible. I see a difference when I work with dancers or people who do gymnastics. They're very comfortable with their bodies and will take my positions even further and offer suggestions. With models, it's the opposite. You'll say, "I want this," and they'll say, "No, it hurts." So, you have to adapt to them. But yes, the process is very predetermined and formal. Like, I'll think, "Oh, I want the body to be a diagonal shape . . ."

Was your decision to remove, or reduce, the amount of faces in your work something reactionary?
I find that when a face is being shown in a photograph, we tend to focus more on that. We tend to seek out the feeling we're looking for in the emotions on the subject's face. I think it doesn't leave a lot of room for the imagination, even though a face can be mysterious. For instance, I did this photographic series that featured couples, and I didn't want to talk about the couples, or go into their lives. I did that so we, as viewers, could project ourselves onto the pictures, and make of them whatever we wanted. It's not feminine or masculine; it's inhuman. I don't want the facial emotion of a person to dictate my photos. Also I find

that, rather than working with something that doesn't inspire me, I would rather hide it and work with a body. Because those I always find inspiring, regardless of the body.

Something I've noticed about contemporary photography, which relates to the idea of faces and bodies, is how many photographers are making themselves the subjects of their own work. What are your thoughts on this? Have you ever done this or been tempted to?
I think that when you've decided to be behind the camera, I find it strange to then go and showcase yourself. You get these photographer profiles where all you have are pictures of the photographer doing what have you. And you're like, "That's so weird; you made a decision to take photographs of other people . . ." So, I think there's something going on there already. Sure, maybe if you're an actress, and you choose to do that, then fair enough. There are jobs where you've decided that your image is your job. But in this profession, I think that you've decided to be behind the scenes, and specifically to be

self-effacing, in terms of your own image. So, I think it's weird. And no, I have never been tempted to do that at all; I think it's horrible, it's nobody's business who I am and what I get up to. For me, my work is my work, and I have neither the need nor the desire to talk about myself, or to associate myself with my work, at all.

Why do you think this is happening so frequently then, the photographer appearing in their own photographs? Is the photographer becoming more important than the photograph?

I think there's this thing going on today where the author is super-important, regardless of the field, whether it's in photography or elsewhere. I think we really have this need to know who the artist is, and for that to be related to their work, too, so we assign all of this importance to the person who does what they do. So, it isn't just about their work. But then on the other hand, I also think that there's a lot of space being made these days for art photos themselves. So, I don't know.

Even if you're not willing to go in front of the camera, are you still feeling the pressure to do it as a photographer working today?

I think your work resembles you, really. But society is really starting to make us feel . . . like, I was in a café yesterday with a friend who does illustration. She said to me: "The thing is, I have to post all of these stories if I want to be super-successful in my field!" And I said to her: "Hang on, you do know that you don't *have* to do anything, right?" And she said: "Yes, I do! Yes, I do!" So, I replied: "Well then, in that case, I have to, too. We all have to." And I think there comes a point where, when you start falling into that trap, it just never ends, and you wind up spending all your time selling yourself. I think there may be some instances where it can work, but I think that it's always weird when you're allegedly a photographer, but I can't figure out if you're an actor, or a model, or what.

I hear people often discussing photography as an overly saturated medium. Great cameras are cheap. Instagram exists. Differentiation is hard. The viewer's attention is almost impossible to grasp. What are your thoughts on trying to "stick out" in the world of contemporary photography?

I want to keep it light, and not ask too many questions. I just say to myself that I'm going to do what I want, and that's it. In any case, I think that a lot of things have already been done, and that it's hard to make something new today. I think the only important thing is to create. That's all. As long as you're inspired and actually want to do something, that's what matters. I think you can't worry too much about differentiation. You can't ask too many questions. I think that's how you'll be able to stand out. If you're always there checking out what other people are doing, and trying to figure out how you can stand out, what you're doing is actually losing a certain kind of authenticity and spontaneity. If you really try to separate yourself from all that doubt and try to work on things in terms of what you, yourself want to do, regardless of whether it's already been done 10,000 times, because rest assured, it will already have been done 10,000 times, I think that may be the only way to make something that might wind up being different. Or not, but you know, whatever. ◊

Talking with

Romy Alizée

about objectification, reclamation, and sovereignty when taking intimate photos of ourselves.

"I think it's very interesting to offer up this image that looks kind, that looks soft, but to show, with the eyes, that there's an explosion going on inside."

The nude image. Is there anything more classic? Is there anything more historic? Nudes have been and always will be. We've been representing our naked bodies since we learned how to represent, and they remain such an unavoidable, unnecessarily devious part of our culture they can feel almost worthless to discuss. And yet, in Romy's photos there are new beauties and new challenges brought about by innovation, both technological and social. Romy Alizée is both an erotic photographer and film actress. As such, she sits both behind and in front of the camera. And that's what makes her work so interesting. At a time in society when we're challenging consent, profit-driven beauty, and the proliferation of our own image, Romy's art, both as photographer and model, is calling into question so many of our sexual notions. Romy's work is feminist, body-positive, and accepting, all of which are necessary. But her photos go so much further. They confront, through their depiction of nudity, the difficulty we face in being given control of our own image: the temptation we have to capture, critique, and digitally carve idealization into our visually represented self. Knowing that Romy is in total control of her subject and its ultimate representation, her photos become supremely honest, deeply funny, and inspiringly subversive. Honest in their desire to respect who we are and how we actually look. Funny in their clear, expressive awareness that some watching won't respect that decision. And subversive in the way they persist in the knowledge of knowing that she knows that we know that she knows exactly that. Romy's photos make me want to love myself, and the way I see myself, so much better.

Instagram: @romixalizee
www.romyalizee.fr
Translated from French by Christopher Seder

Your first book came out last year, 2018. It's called *Furie*, which you could translate as "fury" or "rage" or "she-cat." Furie is also the name you use when acting in porn films. To me, it feels like a mix of sex and friendship and laughter and intensity. What did you want to express with your first book?
Well, it was like inviting people to watch a movie. It starts with a picture where I'm in a movie theater. It announces that I'm going to tell a story.

Which story?
It talks a lot about me, about sex, about desire. It has a lot to do with my experience as a woman. It talks about how these very gendered experiences I've had have influenced my idea of sexuality—what, in my images, has to do with fantasy, and what is concrete. I really don't have many images of men without their heads cropped out. Which does mean something. There is this will to erase them, to put women in the foreground. Also, and I think you can feel this, I'm bi. And I wanted to emphasize that, too. It's above all a book with pictures of women, where the men are objects, too. It's a mixture of fantasy and questioning. I wanted to make an erotic book that was also kind of funny. That was sometimes, kind of, not quite grotesque, but... there really are some pictures that leave people wondering what reaction to have. You know, like the one with the two dicks, you can't tell if it's serious or unserious. I think that's the overall idea behind the book. Being both serious and not serious.

Could you tell me about your long-term relationship with photography?
It's fairly instinctive. I'm basically self-taught. I'm not good at technique at all. When you're self-taught, to be honest, you get impostor's syndrome pretty bad. I'm not capable of taking pictures of a protest outside, for instance. So, the book is more "art photography."

Is there a certain aesthetic form you're more drawn to for your photography?
I've been pretty interested in photography since I was a teen. But more so as a model. What I really wanted to do was just to pose nude. I never had a passion. On the other hand, I was surrounded by a visual culture. When I was little, I was obsessed with magazines. I would cut out all of the images and paste them on my walls, all the way up to the ceiling. I had my *Popstar!* period. Then I moved on to fashion. I would buy *Vogue* and all that, and I would make frescoes. So, I do have this passion for images, but not for photography as a practice.

In a lot of your interviews, I find the interviewers fascinated by the moment you decided to start posing for yourself, becoming the nude subject of your own photographic work. Why do you think people are so interested in that specific moment of your life? And what does that interest say about us, the viewer?
Maybe everybody feels a little bit "normal." And when someone seems to have one day opened their eyes, realized something, and said, "Okay, I'm going to do that," maybe that moment is important for people. I think it also has to do with a reaction that occurred for me, a very political one. It's a bit intense really, but, put it this way: for five years, I only posed for men. I was sexually assaulted; there was a trial. So I really bear the marks of that. Then suddenly, I started taking my own pictures, posing for them myself. I remember that at the beginning of my work there was an art guy who told me, "You have to bring up this story because it's unique, and everybody loves stories. You're not just a random woman photographer taking pictures of herself. You have this previous experience and you've gone down a specific road."

Your photographic aesthetic is very black and white, strong characters, subversive expressions. How did you arrive at this aesthetic?
I think it's really a reference from my youth. I was very into goth culture when I was a kid, like, intensely so, not just on a basic Marilyn Manson level. I was really into real goth culture, and all the films that are associated with that, the music, the band visuals. And it

influenced what I read as well. Goth culture is incredibly rich. There's this obsession with Baudelaire. And with Edgar Allan Poe. I learned everything through that culture. There's also this vintage, pinup aesthetic thing going on, but more in the flirting-with-BDSM way. Never the more naive side of it.

In many of your photos, no matter the sexuality of the scene, you or your models hold expressionless faces pointed directly at the camera. Why?

I always ask them to look at the camera. I find what's beautiful, in general, is to look someone in the eye and to read into what's going on inside them. In fact, it's pretty rare to have these moments when you're looking at someone. I say to myself that maybe my portraits force people to stop and look. If I'm looking into the camera, it's to make the person look me in the eyes. It's kind of defiant. What is fairly curious is that with what I do, everybody talks about the gaze, even though there are all these sex scenes going on in the pictures.

Was there a moment when you realized the removal of expression, set in contrast to moments of sex, made sense to you artistically?

I was tired of sexy images of women because they're always the same. I don't particularly like coquettishness. I'm not a "seduction" type of woman in general. Seduction, in the

way we think of it, is just this total lie. When you're seducing someone, or when you see people trying to seduce one another at parties, there's all this show involved. You have to believe you're somebody else, that you're really great, even though all you want to do is go off and cry, because everyone is depressed, nowadays.

When you're having your picture taken, or taking a picture of yourself, do you feel you're being looked at? And if you do, by who?

Yes. When I pose, for my part, I try to be super-neutral. I think the thing that annoys me most in nude photography is wanting to please. But I do it too, when I do an Instagram post. I play that game to the max. I take part in it. But in my work, I'm specifically not trying to do that.

We've talked about photographic aesthetics. But what are the aesthetics of sex you're trying to capture through your work?

I think that images of sex in general are taken too seriously. They make people take themselves seriously and get caught up in this game of seduction, trying to focus on being super-hot. What does it mean for a young woman, these days, to play the sexy card? Everyone does it. There's nothing revolutionary going on there. I think what can be interesting is to take a step back and

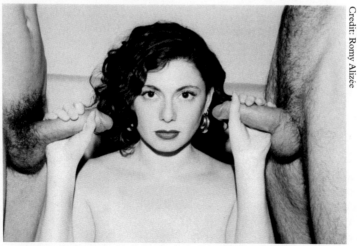

Credit: Romy Alizée

realize what that says about us, about our need to be validated, to be seen as sexed beings, which for me was a real struggle. I've always thought I was too ugly, or too fat, but I also wanted to be a sexy woman in pictures. That's why I'm not especially into, say, when *Dazed* [*and Confused magazine*] talks about the amazing feminism of Instagram artists who show their body hair, their stretch marks, but who still have these really conventionally great figures. That's just too simplistic for me.

That's one of my favorite aspects of your work, how you incorporate joyousness and humor into moments of sensuality. I find with a lot of "cool" art magazines, every exploration of sex is a hot scene, every model is traditionally gorgeous, every setting is perfect, whether grungy or minimalist, and yet somehow, no one ever seems happy. No one ever seems to be having fun in all their "perfection."
It's pretty crazy how we can forget our sense of self-deprecation. That is, we can quickly start to think of ourselves as someone who's very important. That's why I have a problem with fashion. I think that all of those poses and all those faces look the same and are totally ridiculous. I take myself seriously, but I mean, you've got to stay realistic. Especially when it comes to talking about sex, and showing that it's a complicated topic to broach, and at the same time, one that can be light and playful.

Why do you think self-deprecation is important?
Self-deprecation allows you to open up and put yourself into perspective, basically. Self-deprecation allows you to be flexible with yourself.

I find that on social media, we often perform self-deprecation in a false, homogenized way. Like, we use social media platforms seriously because they can provide serious rewards. But we self-deprecate on them to imply we're not grasping for the rewards social media fame can provide. It becomes

almost a double falsification.
It's interesting you say that, because it's true that, for instance, there was this wave of "cool," "trendy" people putting up pictures of themselves with this pseudo-self-deprecation, this really fake face. Are those just privileged people who think that privilege makes them boring? For instance, if you're a girl, and you're pretty, you're sexy, and if you play that sexy card, just in an at-face-value way, well, that's not very original. But what really bothers me is people playing the pseudo, "I'm a little ugly, actually" card. That whole "Let's make stupid faces" thing. It's trying to be like the freaks, when you aren't one, you know?

You've spoken before of your interest in the pinup-girl style, which is linked to 1950s American sexuality. What about the visuals or the narratives of that style culture inspire you?
Those characters are just pictures up on a wall; they aren't people. I like playing the pinup in my pictures, using that base, which I've enjoyed aesthetically ever since I was a little girl. But I like turning it into a character

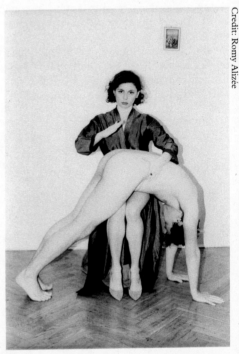

Credit: Romy Alizée

who's telling a story, and who has more going on than one might imagine. I think a pinup can reveal herself to be dominant and in control and playful; not at all submissive, silly, or nice. I'm drawn to that aesthetic, even though I know that it was part of a horrible time for women.

That's interesting, the reclamation and subversion of a visual aesthetic in the support of social progress.
There's also something about trying to understand another time period, which was that of my grandmother. My grandparents had a very complicated love story, and a very violent one. My grandmother was really the cliché of a neurotic woman, with five children and a house. She was harsh, very coquettish, always wearing earrings, a necklace, a blouse . . . a cliché. But she can't just have been this 1950s-style woman: a harsh, frustrated mother. She had a personal history too. Women from the fifties were relegated to the kitchen. They always had to suck it up, look pretty, and serve. There was this way of performing femininity, which at the time was surely crushing for plenty of women who didn't want to do that. There's that series, *Mad Men*, where everyone got all excited about the *Mad Men* aesthetic, but actually the story it tells is a hard one. The women who are in it pay dearly, and the stay-at-home wife is bored shitless and winds up getting divorced. These are life journeys that I find quite poignant.

So what do you think the pinup aesthetic means now, to you and to society?
I feel like there's this nostalgia about it. It's really weird, actually, because there are a lot of feminists who have a very pinup-esque style. I think it's very interesting to offer up this image that looks kind, that looks soft, but to show, with the eyes, that there's an explosion going on inside. I think that sometimes, in my pictures, that's also what you get. It has to be framed, clean, and pretty, to draw people in and to then get them to see, on the inside, things are a lot more complicated.

You speak often, in other interviews, about the idea of "trash." Pushing the boundary of what's considered trashy. The Internet has made it much easier to discover our kinks and has brought about the conversation of accepting and normalizing many unique sexual interests. So where's the boundary of trash currently?
It's kind of a strange word, because people might call different things "trashy." It really means something different from one person to the next. I don't really know if I'm pushing the boundaries of it, really. I feel that people are more accepting, but that at the same time, there remains a need to justify because there are plenty of people who might say these kinks mean we're all crazy. I think that with sex, you specifically don't have to be normal. Actually, it's a place where you may have things to deal with in terms of your history, that you can relive through your sexuality. Sex is specifically a playground where we can reclaim a bit of power over our hurt. So, when we describe certain practices or kinks as "abnormal," well . . . I think that the human psyche knows no limits, really. And so we must not judge people.

At a larger, social-acceptance level, what do you think differentiates a kink from a taboo?
There are some kinks that I'm, maybe, less comfortable with. For instance, stuff that has to do with blood, wounds, or with being hurt. For me, that might be my limit in terms of kink; being hit. That isn't a sexual pleasure at all, for me. I associate it with violence, and I associate it with other bad stuff. And yet that's a kink for some people, giving themselves bruises. That bruises-kink is all over the place. I can understand there's something one might find exciting about it, because with sex, we're always reenacting the plot of things we've been through. Sex can act as a kind of psychotherapy, really.

Violence is such an interesting example, sexual violence particularly. Something we're really trying to eradicate socially, and yet retain acceptance for as a kink.

There is consent, though, too. And that's important because, in life, when you're subjected to violence, you don't consent to it, you don't want it. If you decide to bring it into your sexuality, all of a sudden you're taking control over it. In so doing, you can derive pleasure from it, as well as a relief, a kind of blossoming. It seems strange that there are kinks people just don't understand. That make them say, "Oh boy, those people are whack jobs," whereas in fact, it's fairly healthy to say to yourself, "I have this thing that's present. If I make it into something that's exciting, sexually, then maybe I can reconcile myself with this thing that's inside of me."

In my research for this book, I ran into discussions on the idea of self-objectification: the idea that Internet-driven image culture is leading us to objectify ourselves. People who take more selfies and spend more time on Instagram and other apps are literally becoming objects. They speak less in social situations and are seeing reduced brain activity. I find it interesting that the act of your art, which results in clear positivity, is not altogether different—taking photos of yourself, I mean—from an action that's been shown to create such internal negativity when done for the purpose of social media. So, what are your thoughts on self-objectification? What do you think you've learned about yourself, by being your own subject?

For me, it's specifically not tied to being an object; it's about really being a subject. That's why I really don't make my images for social media. I make them separately, focusing on something that I have to say. I think something that stands out quite a bit, in terms of my work, is precisely this huge detachment when it comes to my own image. I'm not at all prudish about my own body, for instance.

I think selfies are associated with a lack of self-confidence, with narcissism, with superficiality. And there's this immediacy, of the self, of what we look like, and also of fake-

ness, because there are filters, because it isn't really a photo that represents you. I see it as this kind of frantic race. It's like running after an idealized self and after validation. It's as if every day, we wake up not believing in ourselves, and that through selfies, we're able to make ourselves exist, but only via Instagram. So, there's this need to "exist, exist, exist." It's this way of constantly performing the self. For me, you can't find yourself if you're always in contact with others. Solitary moments are really precious, but they also scare a lot of people.

So what do you see as the true difference between the two images, the self-portrait and the selfie?

Sometimes I take pictures that are only for Instagram. I often do that when I'm not feeling too great, when I want a bit of attention and reassurance. And that's it. It's as silly as that. It's just saying, "Hey, love me." Whereas when I take my pictures, my intentions aren't the same. My process, when I'm taking self-portraits, always has to have some significance that's connected to an idea or context.

Do you think sex is a remedy against loneliness?

Yes, that must be true for some people, but I think it's fairly fake. It has more of the opposite effect, especially when it's a lot of sex with lots of different people. Well, for me anyway, it's only ever brought me more loneliness. I think people can use sex as a desperate attempt to surround oneself with people.

How do you view technology's influence on sexuality, both through the image, but also more technically, through things like dating apps?

I think it's shed light on some fairly dark aspects of people, really, in terms of the fear of being alone. And also, sex is becoming a performance. We spend a lot of time developing our online image, our avatar, and that's real life now. But then, what's left of the physical person, you know? That's why there's this gap between hypersexuality and, with our generation, how we're realizing that

young people aren't having any more sex than generations past, and actually, maybe, we're having even less.

If sexuality is becoming more of a performance than it was in the past, what is love becoming?
I feel like there are two things that are emerging. There are some people who feel opposed to this sort of sex capitalism, and as a result, they're abstaining from it so they can have "real encounters." As in: "I just can't take the applications anymore, so I prefer not to have any more sex at all; it disgusts me." And there are people who don't want to weigh themselves down with feelings. And the Internet removes feelings. It's like becoming your avatar, a fake person, and I think some people are going to get even more into this feelingless sexuality. That's consumption, never being in the real moment, never logging off. It's like being with someone you met through a dating app, and when you're with them, you're still looking at your app. Making love to someone you don't know isn't very enriching, in my mind. I understand that there are people who will defend the opposite point of view though, and I don't have a problem with that.

Do you think it's becoming less possible to fall in love?
I think this trend is more in the big cities. In my own experience, I was single in Paris for seven years, and it was really hard. Nobody wants to commit, because there are too many people, too many options. Myself, I fell in love through Instagram, which is totally paradoxical. I wouldn't have imagined that happening at all.

Tell me about the experience. What did it teach you?
Well, at the beginning, he wrote to me. As a girl, I get loads of messages from dudes all the time, so I didn't pay it any special mind. I replied to him, but just kind of . . . to reply. I didn't notice what he looked like; he just made me laugh, and he suggested we cook together. So I went over. I wasn't at all in a "seduction" kind of mood. I had just

dumped a guy who was kind of a dumbass, so I really wasn't in that seduction mindset. Usually, when I'd go on a date, I'd really make sure to make myself look good. It was my first time going on a date without any makeup on, without any lipstick, without really doing anything extra. And maybe that's why it worked.

Before we finish, I want to talk about sexuality and love in Paris. It's a stereotype that Paris is extremely romantic, extremely sexual. How do you view Paris in those terms?
I do think it's a bit true. Even though I've been living here for nine years, I'm still very much in love with the image of the streets of Paris, the atmosphere, certain neighborhoods. And of course, if you meet someone and you go on a date in Paris, there are so many places that are just so beautiful. I understand people saying to themselves that it's the city of love and all that. Though, in terms of actual human relationships, no; it's not. There are plenty of assholes and loads of misogynist dudes. I mean that; it's not a nice city, and French-style romanticism doesn't exist at all. It's just misogyny in disguise. It's really very old-school. People defend this vision of French gallantry, which is really just a way to mask ordinary sexism. But in terms of the visuals, yes, I think there's something going on. I love wandering around Paris. So, you might as well do it with someone you love. At the time when I was dating boys outside of France, I would make them come to Paris, and I would make them wander around. But for me it's solely a visual thing.

So we've got the Parisian romantic thing all wrong?
In literature, and even in films, we've always associated Paris with being the city of libertines and of love, to the point where it's entered our unconscious. But I imagine that you can find that anywhere. It's really just the history of a city and a country. But I mean it isn't especially romantic. It's just pretty. There are some beautiful walks. There are some beautiful things to see. ◊

Wendy Huynh

about eyebrows, skin, and the beauty of the suburbs.

"I wanted to represent my town and where I grew up. I'd never seen pictures of Bussy, or Lognes, or Torcy."

Suburbs carry stereotypes and stigmas. I like them because they mean such different things to such different people. They can be fancy or not. Boring or not. Far or not. To me, suburbs mean the cul-de-sacs made of my friends' houses, playing basketball in quiet circles of my youth, not having to yell "Car!" at constantly passing motorists, the cars constantly interrupting my hot shooting streaks in sweaty games of asphalt hoops. I learned about the photographer Wendy Huynh through the magazine she runs, *Arcades*. The magazine is a beautiful mix of pictures, interviews, and stories documenting and honoring suburban life. Wendy comes from the suburbs of Paris, the ring of life encircling central Paris, collectively referred to as *la banlieue*. In Paris, the old inner-Paris of both foreign imaginations and high French society, *la banlieue* gets a bad rap. It is often viewed as "outside," not just physically, but also socially and politically. What I loved about Wendy's magazine, and her photography in it, was how it made me wonder. The photo series showed me buildings I'd never seen, faces I'd never crossed, nearby lives lived under stresses and joys that felt simultaneously foreign and familiar. Suburbs are fascinating in that way, as transition spaces, more similar to one another than they are indicative of the cities they surround or the countries they are found in. They remind me of moments I can't pin down in memory, experienced at home and far from it. When I met Wendy, she'd already made three issues of *Arcades* showing off the suburbs of Paris, London, and Berlin. She was splitting her life as a professional photographer between London and Paris. She was residing in a multiplication table of places that were the same but different, different but the same, helping us all to see. I wanted to hear how she felt about all that gorgeous in all that math.

Instagram: @wendyhuynh and @arcadesmagazine
www.wendyhuynh.com

When you left Paris to study in London, what was the first thing you found yourself missing from home?

I felt very lost. I missed the comfort of home, in the way that at home I knew the exact places I needed to go to get certain things. I had my routine that I was bored of, but my routine was the first thing I missed.

Were there cafes or bars or shops that you found yourself missing, the places you used to spend a lot of time at?

In my town there's not much. They just opened a bar. The cafes are not the cafes you want to sit and read in. But there's a big shopping mall toward Disneyland. Not that I love that place, but I think it was the easiest place to go, to have a walk, wander around, do stuff. So I miss that routine of going to the shopping mall and at night you go to the cinema near Disneyland. But it was only shit movies. A certain kind of comfort.

In a few sentences, can you describe for me the scene you see in your head when you think of home, the Parisian suburbs?

I mean, the long street where my house is. It just always seems long, because when I come back from the RER, it's straight and just looks so long. This scene with that street covered in leaves when it's fall, and the parks, faces of neighbors. Some that I've talked to, some that I never talk to but recognize.

Can you walk from the RER station to your house?

Yeah, it's nine minutes.

What were the most exciting visuals when you first moved to London?

When I moved to London, my first year was in New Cross Gate. I think I just have nighttime visuals. When I was in Paris, Bussy, I wasn't really going out that much at night because if I would go out I would have to find a friend who would let me stay the night at theirs, in Paris. So I didn't really know the nighttime; going to clubs, bars. So those are the first visuals I have of London, the busses, pubs, their lights.

Can you compare the Paris Métro to the London Tube or Overground stations?

The first thing I'd think is the Tube is so much cleaner. I tell everyone, "You'll see; it's on time, it's clean." The Métro has more life, in a way. You can see it, dirtier, older, less modern. The Tube is the total opposite. People in the Tube are more calm.

It's wild. Tube etiquette scares me. How proper people are on the Tube.

I was already surprised, the first time in London, when no one was complaining on the Tube [*laughs*]. No one was pushing. You know, when you're in Paris, even I did it. Pushing people to get the seats. In London, you don't know why people don't want to sit. I get quite suspicious. I wonder why these people don't want to sit.

Are there places when you've had a good day, or a bad day, that you go to sit?

London Fields, the park itself. I have lots of memories of going there at night to sit. I cycle now, everywhere, and I always cycle through London Fields. I love the path, cycling to my studio, from Bethnal Green to Lower Clapton. That's the general place, cause I always take the same route, my comfort route.

What's the comfort route? What streets do you go down?

Broadway Market, then London Fields, and then I go parallel to Mare Street, then the weird bit of Hackney Central, where you have the Burberry Outlets.

You've moved back and forth since graduating Central Saint Martins in London. Tell me about the movement decisions since finishing school.

When I left Paris, I felt Paris was boring and I just wanted to do photography, so I moved to London. Then, for a while, there was a time where I didn't really know where I lived, Paris or London. Because there was also my ex-boyfriend who was in Paris. You know, you have your personal life. And I guess I thought my personal life was in Paris, and then in London I had my work.

Creteil. Credit: Wendy Huynh

I've felt in between both of them. But then I stayed in London because I just had more opportunities. When I was doing *Arcades*, I was building a bit of a network through the magazine, and everything in London was just more attractive than being in Paris at that time.

Do you feel like you made the right decision?
Definitely. I just felt like I had to go back to do what I wanted to do. I felt like, in London, people would be more open to listening to what I wanted to do. Whereas Paris, I felt judged.

How would you describe the similarities and differences between the art communities in the two cities?
Similarities, hmm . . . I mean, differences

[*laughs*]. I feel like in London you have niche communities spread around, specific to certain fields, whereas Paris everything is centered. It doesn't feel like you have different groups and communities in Paris. It's more like one group and you're either out or you're in.

That's interesting. The question I was originally trying to ask was the physical sense. And it's interesting you say that, the out or in, in a conceptual way. Because in Paris you have the inner versus the outer, central versus *banlieue*. Whereas in London it's not that way. It's funny to think it would take on that same sense, in the cultural scene.
London is so vast. If you compare to Paris, everything in London is happening outside the center. What even is the center of

London? Soho could be the center. Things are happening there, sure, but with people I know, no one lives there, no one goes there, no one works there. You have some agencies there, but . . .

Coming from a Paris suburban background, how does "outside" feel? Was it something you noticed when you were younger? Or was it something you could see when you returned from a different place? Do you have any idea why that happens, why, beyond the physical divide, there's a social divide?

When I was in high school, and my foundation year—art preparatory school—after, I really did feel this divide. That people would see you differently. Maybe it's the way you talk when you live in the suburbs versus when you're in the center: expressions. It's not that obvious but it's there. I did feel the divide, the fact you come from outside. It was hard to be part of something. But at the same time, now, I feel that because people are more interested in the suburbs and people talk about it and brands are more and more interested, I feel like that now; maybe it's something exotic.

Paris used to have a much stronger weight in the global art community, in the sense of being the center for new ideas. There is research to show how New York took a lot of its power in the fifties and sixties. But, more recently, it feels like Paris has lost out a bit to cities like London, Berlin, Barcelona, and smaller cities like Leipzig, Hamburg, Marseille, etc. Sometimes I feel like Paris lost its artistic freshness compared to other cities. Why do you think this might have happened? Is there more to the reason than simply cost of living, because London is much more expensive than Paris for example?

I feel the same; that's why I left. I feel that Paris didn't really evolve. People didn't trust younger generations. I thought it was a bit of a cliché in Paris, but when you're there, you feel it. People don't seem to let younger generations say what they want to say.

I think you're right. It's something about younger people in Paris that's not as respected. So trying to move it a step further . . . why don't they get as many opportunities? London is more

Waltham Cross. Credit: Wendy Huynh

expensive than Paris to live in, so it should be hard for young people to figure out London. But there seem to be more opportunities for young people in London. You can make the money you need to survive there more easily.

It's a matter of trust. I think Paris might be a bit afraid of new things, of fresh things. And I think London is hard because it's expensive; rent is expensive. But maybe that's also what feeds people's creativity and their need to be heard. French people, especially younger generations, have always complained that "our generation is not heard by the government." If you come from the suburbs, you feel even less heard by society.

Do you think it has anything to do with the administration and cultural formalities added to the French art culture in the last fifty years, like the massive social subsidies for the arts?

If we talk about administration in France, it's so complicated, even just to be self-employed. It's a pain. I was self-employed in France, the paperwork, everything. It made me want to leave. Whereas in London there are so many self-employed people, so many people creating their own business. In France, I don't think we encourage people to create their own business. My dad has always had his own business and he was always telling me, "Don't do this in France; they take all your money, there's so much tax to pay." I think it stops people.

That's cool; I've never thought of that. I'll tell you my theory. You have these cultural institutions; France has major cultural institutions supported by the government distributing large sums of money. To me, that means it brings in bureaucracy. People who are older have more developed networks, have friends as decision-makers giving out the money. It's not as tied to capitalism. Whether or not that's a good thing, it allows people, if they're good enough, to get market attention, to get paid. Whereas in France, after the war, the whole country became a big bureaucracy. That's interesting,

the idea that to be an artist is basically to be an entrepreneur. And if you make it difficult to be an entrepreneur, you make it difficult to be an artist.

I think so. I think in France, if you say you're working for yourself, people have a judgment about you. Whereas in London it feels like everyone else is an entrepreneur too. Even if they are employed, they also do some freelance on the side. People in France wouldn't encourage you to be an entrepreneur, to start your own business. In France, people expect you to do your studies and then work for someone. In London, people encourage. Even at school, something the tutors always repeated was, "You're not gonna find jobs after uni, so you have to create your own."

I wanted to know your thoughts about the Grand Paris plan, related to suburban life and the change Paris is about to go through in the next five to ten years. The development is supposed to incorporate suburbs, including yours, into a new idea of the city. What do you think of it?

Of course it's a positive change because it's trying to incorporate the suburbs into Paris, which is a good thing. But I also think the words "Grand Paris" is just a nicer way to keep saying "the suburbs." I think there will still be division; even if geographically the suburbs will be incorporated into Paris, mentally it's still gonna be the same. It will still feel like they're not in Paris, that they're outside.

Do you think the suburbs will change?

I think there will still be a high demand for the central Paris. I don't hear people I know who grew up, and still live in Paris, saying they are going to move out to some suburban town because the Grand Paris is developing and it will be easier and cheaper. The only people who say that are people like my sister, who has always lived in my town, in the suburbs. I think people who are already far out, it's fine for them; they are already in the suburbs. In a way it will be good because it will just be more practical for them to get central. It's more a practicality thing. And I

think that's what I mean when I say that a mentality change will be hard.

Let's talk about your photography. What is your favorite part of the face? Or which part of a person's face do you notice first?
It's an interesting question. I've always been obsessed by people's eyebrows or the upper part of the eyes. They're the quick structure of your face. Not that I stare at people's eyebrows; it's just that . . .

When I was living in London, I found there to be something different with eyebrows in that city. Eyebrows had trends in London. The thick eyebrow . . .
The colorful eyebrow. Tie-dye eyebrows. Some weird stuff.

What happens to a person's face when they are in love?
Good skin. Glowing skin.

What happens to a person's face when they have been hurt by another human?
You can see when someone's face is *mort* [dead]. I'm not sure you can really see it physically, but it's the exchange of a feeling where you can tell the person has been hurt.

In photographing others, how do we assess ourselves?
When I take portraits, I really try to assess myself at the same level of the person I'm photographing. It's a bit like how I see documentary photography. When I photograph someone, I try to arrive at their understanding.

Were there any shoots where arriving at that understanding was particularly difficult?
For the first issue I photographed skaters who I didn't really arrange a meeting with. They were random interactions, then coming back to see them again. I don't skateboard; I've never really been surrounded by skaters, so it was harder for me to understand how they would react to certain things, how they would speak, what kind of answers they

would want to give. But it's just taking the time to talk to the person and get immersed in their environment.

I'd like to know about *Arcades* magazine and its aesthetic development. It has such a nice mix of architecture, portraiture, and quotidian images. What did you feel you needed to show to correctly represent "suburban" life?
When I first set up the project it was only on Paris suburbs. It was something so personal. I wanted to represent my town and where I grew up. I'd never seen pictures of Bussy, or Lognes, or Torcy; places like that. When people say suburbs, the first thought is that they are considered rough. When I set up the project, the aim was to show that I live in a suburb as well, but it's completely different. I just wanted to show the diversity of the suburbs. It felt organic. Around where I live there's very weird utopian buildings and that's what I wanted to show, the architecture. At the same time I also wanted to show faces that I see every day of my life. And it's this process I repeated in every issue.

You first did an issue on Paris suburbs: a place you grew up in. But now you've done London suburbs and Berlin suburbs as well. Could you tell me, both from an editorial and photographical sense, how you developed relationships with these places through the representation of them?
In London, when I went to Waltham Cross for example, I randomly went there. It's hard to describe, but I think it is a lot about chance. And feeling. I went to loads of different places, and in some I just felt like I wanted to go home directly. There wasn't much I wanted to document. But Waltham Cross was full of people and I just felt like following my instincts. That's how I work in documentary photography. In Waltham Cross, I met some people on my way, talked to them, photographed young bikers. It's a bit hard to tell beyond instinct, but I guess when you feel something is going to happen, it's about going and making it happen, creating the opportunity.

I love the mix of ages you show in the *Arcades* photo series. Often youth, but also people of all ages. There are constant discussions of generational divides, made more divided by technology now. How did you find the relationships with people in different age groups when studying and representing these places?

I remember when I was in Waltham Cross and I was talking to these young bikers, teenagers, biking everywhere, messing around, but not doing anything wrong. I remember hearing older people saying they were so annoyed by the kids. They were really scared of them. There's definitely conflict like this between generations. But, for example, I went to Canvey Island, photographing this guy called Rod. A guy taking care of the town. He's much older. I've always found it more difficult to approach older people than younger people. I feel like I can talk like a young person, say things they want to hear. But older generations are always much harder. I never know if I need to be a bit more formal. But it was fine. It was a good experience, and I felt like, maybe older generations are more interested in what younger people are doing than we think.

I find a lot of commercial photography to be adapting to the personal, natural styles of the Internet. Why do you think that is? Do you think that's a good thing?

When I worked with Veja [*a footwear brand*] for example, they were great because it was really carte blanche and I could do whatever I wanted, in an *Arcades* way, in a documentary way. It's not that they didn't care about the outcome, or the final images I made. It was more the process they were interested in. I've had a few clients that have given me total freedom.

I really loved how your personal style was so visible in the Veja. And I remember it making me wonder why brands want to blur the line between commercial and personal images. Why do you think that is?

People are more interested in other people now, and not just the work or the product.

If we take Veja, they've always been a brand that supports transparency. So it was the process, the work in progress that they were interested in.

Explain to me that idea a little more, the progress.

With Veja, the whole process of the shoot took so much time. They had pairs of shoes and they gave me a list of shoes to give to BRIT School students. So I asked each student which pair they wanted, and then sent them the pairs one or two months before the shoot so they could wear them, customize them. And then I documented the end result. I think that's what they were interested in, to see how the shoes were worn. The photos themselves were portraits of the students in their rooms, in their houses, nothing crazy, just documenting real life.

So if commercial brands are going the social media route to appear more natural, I wonder then, is it a good thing?

I think it's to appeal more easily and quickly to customers so they can easily see themselves in the editorial.

I'm not a staunch, flag-bearing anti-capitalist. So I'm not entirely thinking this act is bad for the state of our future. But at the same time I wonder . . . before, we could more clearly tell what was an advertisement and what wasn't. So what comes from the merge, when brands make themselves appear more natural?

It's a bit like the Grand Paris. In one way it's a positive thing, because it's showcasing people we don't usually see in the media, like different generations, and you can see yourself in the editorial. Anyone can be shot for a luxury brand nowadays. Which in a way is reassuring, that it can be anyone. But at the same time, it's to sell more. To attract more customers.

The bad with the good?

Yeah, maybe this is a nicer way to sell. ◊

Chefs

Talking with

Alcidia Vulbeau

about building a community out of a restaurant and eating well in a world of politics.

"Why do people refrain from appropriating certain cultural items, but not food? Sure, if a white person is good at cooking recipes from another culture, you might wonder how they learned to do it, but not whether they're allowed to. It's interesting to see that mouths, as this direct source of pleasure, allow us to move past that tension."

Restaurants, especially the new ones, are supposed to be a chaos of questions and potential failures. But when I went to Alcidia's restaurant opening for her first restaurant, Bonne Aventure, what I saw was a chaos of answers. Good answers. Answers to questions of the moment that don't have anything to do with food really. Answers to the hard questions today's society seems plagued with; questions today's society seems to struggle so hard with answering. At the opening were people of different ages, different backgrounds, different economies. They were collected in a neighborhood without pretension. They were sharing tables. Passing drinks. Seemingly infected with smiling. The food was affordable, so I ate it. And on the menu itself, there was an edible diversity. Flavors from the Caribbean. Flavors from Japan. Flavors from France. I know it was an opening, and as such, a party. But in the months since the opening, I've gone back to Bonne Aventure and found it the same. The tables are still shaped to be shared. The prices still affordable and absent of any gastronomic hierarchy. I originally wanted to interview Alcidia because she is one of those people who quit an unfulfilling day job to face the exciting terror of the restaurant industry. There are so many people dreaming to do what Alcidia has done; I felt she could advise us all on it. What I found instead, in her food and in the space Alcidia has created, is something so much more interesting; so much more delicious. What I found was a new community: the tasty cheap treat of our real souls. What I thought, and still think, is that Alcidia can probably advise us on bigger questions than our lonely careers or our underdeveloped palates.

Instagram: @alcidia_vulbeau
www.bonneaventure.fr
Translated from French by Christopher Seder

Let's start by talking about art. Are there representations of food in other art forms that you find inspiring?
I think that there's this very pictorial materiality to cooking. Food coloring, the colors and textures of food—you get all of those things in painting, too. The world of abstract art is a big influence for me. It helps me to structure a plate. Using a color palette can be a good guide. I like Rothko a lot. When I look at his paintings, they inspire me to do new things with dishes.

Are there any particular paintings that affect your cooking?
It's not a literal thing, but there are artists who speak to me. I like Cy Twombly a lot, the precision in his drawing. The elegance of his line, but also his use of white. For a drawing to exist, the white needs to exist, and it's the same with dishes. You have to decenter things. A dish should never be centered.

Before becoming a chef, you worked in the publishing world. Tell me about that part of your life. What were you doing there?
I studied to become a publisher because I love literature, writing, the whole "behind-the-scenes" aspect, how a book is constructed, how you help a writer along. At the time, I wanted to connect gastronomy and literature. I did a series of internships, but I couldn't find any work. So, I ended up working at a scientific publishing house. It was boring as hell, but on a commercial level, I learned a lot of things from it. Do you know the Omnivore festival?

No; what's that?
At the time, when I started wanting to cook, there was Le Fooding and Omnivore. Omnivore had been put together by Luc Dubanchet. He'd been through higher education and his thinking was that culinary journalism should be on par, in terms of quality, with news journalism. He helped elevate the way we approach gastronomy conceptually. For me, Omnivore is this festival that's really helped to structure how we think about food. So, I had all of these

leads in mind and at some point I said to myself that it wasn't enough to just fantasize about cooking, that being a journalist was interesting, but that I also wanted to tackle the technique. So, I became a cook. I didn't want to remain an observer; I wanted to do it, too, sort of like Bruno Verjus, who's this food-critic-turned-chef.

Where did this food path come from? Was it something you were teaching yourself? Did it come from your family?
Everyone cooked in my family, but not professionally. My grandmother was an incredible cook but the stuff she did was simple. It was "homemade" food, made using whatever was in the garden: redcurrants, raspberries, and so on. It was a precise kind of cooking, but also one that used very little: poor-people cooking, cooking that was based on what little we had. But I am very *gourmande* myself.

I've learned a sense of that word, *gourmande*, since living in France. But I've never fully understood it. What does it mean to be a *gourmande*?
Being *gourmande* means that food makes you light up, that it's really about pleasure, for you. Some people enjoy reading books or watching movies. That's what makes them happy. Well, eating and cooking are what really make me happy. I'm guided by pleasure. That's how you make sure things work out well.

When did you realize you were a *gourmande*?
You can be two and a half and already be a *gourmande*. I see kids sometimes, at restaurants, snarfing down a sausage, trying their parents' dishes—those are *gourmandes*. When I was a little girl, four and a half years old, if my parents didn't buy oysters at the market, I would cry. We love eating in my family. Taste is a familial and cultural construction, one that you develop as you go along and meet people, and through traveling. Going out into the world and encountering new people and cultures through food is the best. It eliminates the need to talk to one another in order to understand each other.

If a grandma in Vietnam or in Thailand has you taste her soup, you don't need to talk; it's all in the eyes and taste. Do you know Tomi Ungerer?

No. Who's that?
He's a children's book writer, a cartoonist and an artist. He's really part of French folklore. He died a few days ago. He wrote *Zeralda's Ogre*. It's the story of this young farmer girl who takes care of her father. One day, she takes her cart to the market and meets an ogre who tries to catch her, so he can eat her, but he falls down and sprains his ankle. So, she says, "How silly; I'll make you some food," and then she spends the day cooking for him. The ogre eats and, by the end of the day, he turns into a lovely guy, and he decides to stop eating children. And then they get married. I was raised with that story. I think my desire to cook can also be attributed to that.

So, you've had a love for food since you were young. But what inspired you to leave publishing and start cooking?
Le Fooding was launched in the aughts, as was Omnivore. I was too young at the time, but as soon as I started to have a little bit of money, I went to the restaurants. It quickly occurred to me that something was happening, particularly in terms of the *bistronomie* [gastropub] trend. In the aughts, suddenly, being a chef wasn't a road-to-nowhere job anymore. We're very snobby here in France; there's this relationship with the intellect. If you're gifted, you must pursue your studies. But that ignores a whole array of different intelligences, such as manual intelligence, the intelligence of know-how. That snobbery is beginning to disappear, thanks to cooking, among other things. This has to do with shows such as *Top Chef* and so on. Those are awful, because they're these canned programs for TV audiences, but they helped make occupational training and "road-to-nowhere" jobs more acceptable. The image of those changed, and so did that of chefs. There started to be more and more women chefs, for instance.

And then how did you go from the passion to actually getting in the kitchen?
After two years in the technical publishing house, I had set aside a little bit of money, and I applied for a chef training. What's cool, in France, is that when you're employed by a company, you pay contributions to finance

Fish Risotto with Fresh Peas

professional training. So, you can ask your employer to subsidize some professional training for you and take a gap year. That's how I was able to do a cooking CAP, a Certificate of Professional Aptitude. I knew it was what I needed to do. It spoke to me on the inside. There are times in life when you hesitate, but I didn't have any doubts, here. So, I started a blog with a friend. We teamed up; she did the pictures, and I wrote the text. And then we went out and met all of the people in the industry whose jobs seemed like the stuff of dreams to us. We went to see a guy who made sausages, and a baker called Thierry Breton. We asked them about what the job was like, to tell us about how hard it was. And as soon as I set foot in the kitchen, I realized it was what I wanted to do.

Did you start working directly after the cooking program?
Half the time I was at school, half the time I was at the restaurant, at Frenchie. It was hard but it wasn't brutal. The people were incredible, so I held on. It was very much an education. I was older than the chefs, but when you can sense someone is gifted, that

Burrata with Cucumbers

doesn't matter. François [Roche] was very impressive. He was very organized. I could mess things up six times in a row and he wouldn't get mad.

Let's fast-forward. I want to talk about your restaurant, Bonne Aventure. You just opened a few months ago here in Saint-Ouen, which is in the suburbs of Paris. Congratulations. Why did you decide to open a restaurant here and not in the more popular, more central, more trendy neighborhoods for "new" French cooking?
It's very connected to the place where I grew up, in the 93 [Saint-Ouen's postal code]. I mentioned snobbery in France, earlier. When we were teens, there was a split between Paris and the suburbs, this real divide, this snobbery. I refuse to perpetuate it. I don't want to be in Paris because I want to expand the circle of initiates. Gastronomy is a world of initiates; it's an expensive world. It needs to be made accessible. It's a wonderful world, but also a very simple one. Some educating needs to be done, both when it comes to children and to my friends who spend their days eating kebabs. A young couple came to the restaurant yesterday, and they were super-happy because they had Brussels sprouts. They were surprised because they were "so good." To me, there's no point in going and setting up shop in Paris, in the 11th, and selling a fixed-price menu to people who are already familiar with all that stuff. I'm not interested in that at all, and I wouldn't be able to do it. I wanted to open my place here.

I only know of the division between Paris and its suburbs through the urban studies lens and through living here. Do you find the same division in the food world?
My friend Julie, for instance, has a restaurant in Belleville, because she opened five years ago. The customers aren't the same. You can't live in Paris anymore. You need at least 3,000 euros a month, whereas the median salary in France is 1,700 euros. Parisian life is impossible. Staying in Paris and

perpetuating that is silly. It's living above one's means. We love doing that, in France, but it's dumb as hell.

There are coming urban development plans, the Grand Paris plan, that are meant as an attempt to reduce those divisions through new public transportation investments. Do you think they'll have an impact on those divisions? And on the neighborhood and your restaurant?
The division is certainly starting to collapse. But the coming together is still pretty tentative. I like being one of the pioneers, but that isn't why I'm doing it. I'm doing it because I grew up here. People talk about the idea of food being local, of it being from a place. Well, this is where I'm from; it's my locale. I belong here.

One of the new subway lines being built as part of the Grand Paris plan will stop near here, in Saint-Ouen. Do you think it will have some type of gentrifying effect?
You just need to belong to a place, to live somewhere and then to make do. You figure it out. I'm not all that conscious of it yet. It's too early on, here, still. I'm part of that change myself. There are people who will say, "All right, here come the hipsters." But I pay attention to pricing; I'm careful to explain where the products are from. That stuff is important to me. There's this neighborhood guy, a bit of a big-man type, who showed up and started saying stuff like that to me, and I replied: "Well, yeah, but you're finally going to have a place where you can bring your girl, instead of taking her to the gross kebab shop." I'm really hoping he'll come eat here. You don't always have to live badly; it's okay to give yourself a little bit of room to live freely, to do something that's good for you. Sure, it's going to cost him a bit more, but not that much, really, and he'll be treating himself; he'll get to have a nice time. Hipsters are not a threat. Because in the end, the hipsters of Montreuil, they're just like us; they make 1,000 euros a month. The words "hipsters" and "gentrification" always raise red flags. All we want is to live happily, to live in a way that's more connected to our space, to our place. It's not that big of a deal, really. They've managed to turn it into this negative thing, when really, people just aspire to lead a simpler life. Or maybe I'm just too naive. But my struggle, my focus, has to do with the cost of my food.

That's something I've always been fascinated by: how restaurant owners determine the prices they charge. Can you tell me your philosophy on price?
I picture myself, and how much I would be able to pay for a dinner. Sometimes, you have money, you can afford to spend a little, and other times, not so much. So, on a menu, you always need to have some less expensive dishes and some more expensive dishes. You need to have a range of prices on a menu. Some days, you're just going to get some hummus and have a drink, and you're going to have a great time. Other times, you're going to treat yourself to fish or some scallops. You have to have options. We try to make it so that nobody feels scorned. We pay attention to who you are. Then, granted, my own limits may not be the same as other people's limits, so all that is debatable. But the keys are expanding the circle of initiates, educating people, and explaining why things cost what they do. What you have to do is explain that the dish is worth such and such because the vegetables come from such and such a place. Most of the time, people get it. It's in keeping with this idea that I chose to have a tapas set menu in the evenings, so that anyone can come, and then, when the day comes when it's the start of the month and they have a couple more pennies in their pocket, they can come back and treat themselves to something a bit more significant [*on the lunch menu*].

What do you think of the idea that a restaurant can act as a vehicle for creating a community? Do you see restaurants creating new communities in the city?
Here, I want people to be able to share the space, to share a moment through food,

but certainly not to share it through price. The pricing must not exclude people. That's why I refuse to do a "starter, main, dessert" type menu, because those exclude people. You have to fight the fact that families with children can't sit down at restaurants. Everyone should feel like they have a place there. And for that to be the case, we need shifting, free spaces, where things are not governed by structure and timing. There's no such thing as a service hour; people shouldn't worry because they're showing up an hour late. That's how I imagine a social space working, today. It isn't an easy goal, but it's mine.

When I came to the restaurant opening a few months ago, I noticed how diverse of a community showed up. Not just racially or ethnically. There were families with little kids. Old people. Cool kids. Professionals. It was really cool to see. It wasn't like the crowds I normally see through the windows of the "hype" restaurants in the 11th arrondissement.
Having grown up in the 93, I can be in any environment and feel at ease. I have this ability to bring people together. But we'll also have to withstand the test of time. I think this restaurant should allow anyone to sit down in it, to come in and out of it. You see that table there? We never put table settings on it, and the idea is that it belongs to everyone, that its function changes depending on the uses people put it to. That's the idea behind "tapas"—I don't like that word because it's Spanish and refers to a specific tradition—but it's to have this format, in the evenings, that allows everyone to be able to come and dine here. You can come whenever you want, as you are. That's freedom.

When we talked before, you used the term *métissage culturel*—cultural miscegenation, cultural mixing—to describe your cooking. Does this have a link to "fusion" cuisine?
The word "fusion" in cooking is a bit dated, in French. Also, we only talk about fusion when it comes to food. When it comes to individuals, we use the term miscegenation.

Fusion cuisine was trendy in the aughts, and the word has lost a bit of its meaning. I use the word miscegenation to talk about my cooking because I think it's important to discover the culinary cultures of others. Miscegenation is already anchored within me. The mix is there. That also means that there's something to be reclaimed from each culture, something to be valued, and that there is no hierarchy. We French people have this tendency to say that we're the best in the world, to blow things out of proportion. Our last president said that the French-style menu should be made a part of world heritage—the arrogance! I think that with miscegenation, there's no hierarchy between cultures. In France, we're still stuck in this post-colonial mindset. Hence, my need to mix things up! And that can be a draw for people, too, and give you a chance to have them taste different things, things they aren't familiar with.

What cultural cuisines are inspiring you right now? Are there flavors or dishes you're pulling from at the moment?
I'm really impressed with Lebanese cuisine. They know how to use lemons, whereas we tend to do things with vinegar. The same goes for Thailand; the way they use acidity is very different, it's fascinating. Lately, I've been especially inspired by Japanese food, which I blend with my own personal history. I went to Japan three years ago; I really wanted to discover Japanese flavors, and in particular, the one that people refer to as "umami."

In our political dialogue, we often hear of the concept "cultural appropriation" used as a negative in relation to the mistreatment of minority cultures. But I never hear that concept discussed as a negative in relation to food. Why do you think that is?
I think I like the idea of miscegenation because I come from the West Indies, but without having grown up there. I don't know what things taste like over there. My face tells one story, but my food says something else. I try to explain to people that you can have the culture you want, that it's possible to

communicate across all cultures. I think that people live in a little box, that they don't want to leave their own worlds. Miscegenation means pushing boundaries, going to check out what other people are up to. It's curiosity. Nobody goes around saying that Japanese-Mexican fusion restaurants are a problem. It's funny how racist we are in France, when French people's favorite dish is couscous. It has to do with our colonial past and our way of dealing with things. We're the fruit of a country that has exploited other countries.

If people are uncomfortable, it's because we haven't figured out how to move past that yet . . . why do people refrain from appropriating certain cultural items, but not food? Sure, if a white person is good at cooking recipes from another culture, you might wonder how they learned to do it, but not whether they're allowed to. It's interesting to see that mouths, as this direct source of pleasure, allow us to move past that tension. ◊

Talking with

Luis Miguel Tavares Andrade

about becoming a chef by accident and learning to love food that scares you.

"That's really the magic of cooking: to make people like something they don't know they like. To share something new with others."

When I met Luis to talk, at Au Passage where he's chef, we opened the doors to the restaurant and found pooled blood on the floor. Tuna blood. A mess left carelessly by a small distributor of excellent tuna. We immediately began speaking of respect and how it's intertwined, sometimes positively, sometimes negatively, with the pursuit of quality in the restaurant industry. We talked as Luis used paper towels to mop up the blood. Now, whenever I enter Au Passage for a little food, Luis reaches his arm out from the kitchen through a little window in a little door. We touch the backs of our wrists: a sign of respect to one another, a show of respect to other customers so as not to put too many of my germs on his cooking hands. Out of respect, those cooking hands hide challenges throughout Luis's menu in recipes that push customers to try flavors and textures they've been fearfully avoiding. There's his *ris de veau*, sweetbreads, thymus gland: an often discarded body part crucial in the production of white blood cells for the immune system, a body part full of respect. By cooking the gland hot, in butter, then hiding it among spinach leaves and raisins and date sauce, Luis turns thymus into the story of his cooking education. There's the cockles, little clams cooked the Portuguese way in lemon and diced onions: a respectfully hidden reference to Luis's personal history. And then there's the chocolate mousse: a soft chocolate custard hiding an unbelievably smooth chocolate fudge, as a reward for the customer's bravery. Cooking is hard. Cooking well, with respect for a customer's money and time, with respect for the cooks spending their lives learning how, with the hidden tact of subtle respect . . . well, that's its own echelon of difficulty.

Instagram: @luisandrade.la23 and @aupassage
www.restaurant-aupassage.fr
Translated from French by Madeleine Rothery

Chefs often get asked what their death-row meal would be, as an eater. But I was wondering: what is the last meal you would want to cook?
When I was six years old, I was already coming home from school alone. My school was only two minutes away and my neighborhood was very open. Everyone knew each other. Everyone's doors were always open. There were no worries. My mother and father were both working, so at the age of six I learned to cook for myself. The dish I made all the time was pasta and tuna, with a fried egg on top. And that has really been my dish, since I was six years old. We had an hour and a half lunch break at school, so I would come home, boil the water, cook the pasta. Sometimes I added a little bit of ketchup. It's something that I still make today. The last dish I would cook would be that; to cook and to eat. It's really made a mark on my life. I love eating, but never in my life would I have imagined that I would be a chef.

My childhood was a little like that. I started cooking for myself at a very young age. My dish was angel hair pasta with butter and Parmesan, the kind you shake from the plastic bottle.
Yes, it's these simple things that we continue to make. Simple but gourmet, done well.

You're Portuguese but your family originally comes from the Cape Verde islands. What flavors represent Cape Verde to you?
For me, it's corn. We have a traditional dish called *cachupa*, which is basically just corn. It's always very dry in Cap Vert. I was there last February and everything was as dry as a desert. Because of that, we eat corn in all kinds of ways: we eat it fresh, we eat it grilled, but mainly we eat it dried. Just like beans. We dry the corn, then have to soak it. It's a way to preserve the grain.

What flavors represent Portugal for you?
Olive oil, because we have a huge culture around olive oil in Portugal. We don't use butter for cooking so it's really olive oil that

best represents Portugal.

Is there a difference between say, Portuguese olive oil and Italian olive oil? Does Portuguese olive oil have a particular taste?
It's just like our wine. Portuguese wine is very rich. It's full-bodied. Because there is so much sun, there are a lot of tannins. It's the same for Portuguese olive oil. What comes to mind is a simple grilled fish with just a touch of olive oil. It's really warmth that defines our olive oil.

And France?
Butter. It's a taste that I've always loved: toast and butter, fried eggs with butter. Butter adds a touch of indulgence to a dish. Everything is about butter here.

Was learning to cook with butter instead of olive oil difficult, when you were starting to cook French cuisine?
No, the most difficult thing for me was raw meat: tartare. Where I come from, we don't usually eat tartare. Tartare was really the most difficult thing, both to prepare and to eat. But now I love it. It's a very delicate dish.

Why is it so difficult?
When I arrived in France, I wasn't a chef. I'd never eaten tartare before in my life. So when I started working in kitchens, I would see my colleagues preparing this seasoned raw meat and people would love it. I said to myself, this is not possible. It absolutely disgusted me. Oysters as well; I couldn't eat them. In fact, there were a lot of foods that were difficult for me to eat. Up until the age of twenty-eight, I barely ate anything.

Until twenty-eight!?
Yeah, until I arrived in France. I only ate what I liked. I wouldn't eat avocado. I wouldn't eat oysters. I just wasn't used to eating them. In fact, there are a lot of things that I only learned to enjoy eating when I started working kitchens in France.

But when you're cooking, you have to try the foods. How did you manage that

when you barely ate anything?
That's why cooking is magic. Most people don't realize, but it all comes down to the seasoning. It's all about how you make someone eat something they don't like. It's how I learned how to eat a lot of things. For example, I had to prepare raw salmon. At first, I said to myself, "How am I ever going to eat this?"

That's a really interesting point: how do you get people to eat something they don't like?
At the time, I was working with the chef Thierry Breton. He wasn't the first chef I worked with but he taught me a lot. I said to myself, "How on earth has he managed to season and marinate salmon in a way that I, who had previously refused to eat it raw, loved it?" He managed to make me love foods that I thought I hated. And it's really through that, seasoning, that I learned. That made me understand cooking. Now I can eat anything, I taste everything. There isn't really anything that I don't like anymore. Of course there are things I like less. But now, foods that I like less I work with the most. Like celery. I'm not a huge fan of celery, but I love working with it. You can easily change its taste so that it becomes fine, delicate, balanced. Now I even eat it raw.

That reminds me of my favorite dishes on your menu, sweetbreads. They are this very gross-looking cut of meat. But when prepared simply, with lots of butter and lots of garlic, they can be incredible.
I felt the same way about sweetbreads. Now it's a dish I really appreciate. I think that I'll always have it on my menu. But it was a real challenge at first because I hated sweetbreads. Well, I didn't really hate them, I just didn't know them. I couldn't understand how anyone could eat them, yet I would see people eating sweetbreads and loving it. I learned to eat sweetbreads at Palais Royal. Philip Chronopoulos made magnificent sweetbreads and when I became the butcher there, it was me in charge of preparing and cooking them. I was obliged to taste a little

bit. Having to taste them made me realize that they're really interesting. The texture is obscure, but after you cook them—and you cook it well—they become gourmet. That's really the magic of cooking: to make people like something they don't know they like. To share something new with others.

To share the experience of being brave enough to try something new . . . that's really cool. What has cooking taught you about humanity?
Respect.

Why?
Because each job is different. In a kitchen, in a restaurant, every job is essential. There are some incredible stories. Sometimes, when you talk with a dishwasher, you fail to see past the fact that he's a dishwasher. You forget that, yes, here in France he's a dishwasher. But back in his home country, he was a well-respected doctor. Now he washes dishes with a smile on his face because he's happy to learn new things. We often forget that the dishwasher has a life. We forget that the chef has a life.

So that's what I learned from cooking: to respect everything and everyone. You respect your colleagues, you respect the food, you respect the customer. It's the basis of everything. Look at my kitchen . . . it's tiny! My team and I work in there together for eight hours a day. We bump into each other. We touch each other. It's a dance. If there's a lack of respect, you couldn't successfully work together in a kitchen like that. Imagine: it's two a.m. and there are four of you, all stuck in the kitchen together. It's like putting four lions in a small cage. So yes, for me it's really respect that I learned.

I worked as a waiter in New York for about a year. The stories of the people who worked in the kitchen were incredible. Lots of people busting their ass to make a better life for themselves and their families.
So why don't we show them that same respect? I'm always trying to find out what

Chocolate Ganache with Olive Oil and Sea Salt

someone did before, and what they like now, to show the ultimate respect. It helps me at the end of the day. Once you understand that, you are able to build a strong team.

I want to speak a little of your journey: when you arrived in France, and the first work you found in the restaurant world.
It was January 21, 2013. I arrived with no specific dreams. I just said I was going to France and I would work it out. I would do whatever. At first, I was a builder. I installed drywall. Everything I do in life I give my all. And I learned to love it. I spent one year doing plastering. I made some amazing friends. In fact, one of my best friends, Pedro Andrade, who I'm still friends with now. Both of us arrived here in France, from Portugal, and worked in construction.

Then I met Cris [*Luis's wife*]. She already worked in restaurants. I loved the idea of being a sommelier. Originally, that's what I wanted to do. So I started working in restaurants with the aim of being a sommelier. I

didn't have the necessary qualifications, but you can work your way up to becoming a sommelier without a diploma.

My first experience working in restaurants in France was in a Cape Verdean-Portuguese-Brazilian restaurant. It was magical. I would arrive in the 5th arrondissement and I would serve French clients these traditional dishes from my country. I worked there for three weeks and it did me a lot of good. I worked a little in the restaurant, a little in the kitchen, a little as a dishwasher.

When you started working in the kitchen, what position did you have first? And how did that turn into becoming a chef?
Really, I was looking for a job on the floor. I said to my friends Luca and Manu, who were also waiters, "Look guys, I need a job. I'm up for anything." Manu said Thierry Breton was looking for someone to work in his kitchen at Chez Casimir, but only to work the brunch. I arrived and he asked me if I knew how to cook and I said, "Yeah, a little," which was a lie.

I was hired and I worked with a Sri Lankan guy named Aranan. He's the one who trained me, who taught me the basics. I was doing *mise en place* [plating] and *patisserie* [pastry]. I wasn't doing a lot of cooking though, except on the weekends. After a year, I was on top of all of the recipes but I still wasn't a chef. I didn't really want to be a chef. I wanted to work the floor.

How do you feel about your education as chef? Learning on the job in comparison to people who go to cooking school?
I mean, it was pretty funny. People would come straight from school, working as an intern. And then there I was, working as a line cook without any official training. I learned a lot from those who had actually studied cooking. I learned their way of working, because at school you learn how to cook but you're not actually in a restaurant. I know less about the actual theory of cooking, but I have experience. The students are more theoretical. I'm more practical. There was

149

the opportunity for sharing. It was mutual.

Respect.
Exactly. I learned a lot from the chefs who went to cooking school. They're very passionate: they graduate, they know a lot about the produce, they teach you how to prepare carrots correctly, etc. And I taught them how to work in a kitchen. I've always had student interns and I've always learned so much from them.

So how did you go from a brunch cook to head chef at one of the most respected restaurants in Paris?
I started at the Palais Royal restaurant as a line cook. By the end I was basically souschef. I had a different vision of the world in comparison to most people who worked in restaurants. Working in kitchens was hard to begin with. There's so much hierarchy. It's sort of militaristic. I always said there would be no hierarchy in my kitchen, just respect. And that's what pushed me to work harder, to rise up the ranks, to become head chef, so that I could have my own kitchen.

Then I moved to Au Passage as an extra. I saw the potential of the kitchen and that was really what I was looking for. It's cool; there's good produce, it's simple. Dave, the previous chef, was leaving and I ran the idea by Audrey [*the owner*] of taking the role of head chef. Audrey said, "Are you joking, Luis?" I said, "I guess a little, but also why not?" So she said, "Okay, let's try it." I wasn't really scared, but I also felt the pressure of taking over a successful restaurant. They produced good things and I had to maintain that. I said to myself, "All right, let's give it a shot because it'll be a huge challenge for me."

When I was looking for chefs to interview for this book, Au Passage came up several times. It seems like a restaurant that's produced some of the most wellknown, well-respected chefs in the city. How do you think the owners [*Audrey and Jean-Charles*] succeeded in creating this space that nurtures young chefs?
It's natural and normal. We do simple things. Well-done, but simple. There's no specific training. I do the same type of cuisine here that I did at Palais Royal, but without the same pressure. It's more chill. You can do your own thing with no pressure. And that's what allows you to grow. That's what makes you want to learn. It's every chef's dream.

So now that you're running a kitchen, making the bigger decisions, how does your unique path to becoming a head chef affect the team you lead? Is there a certain kind of person you look to hire for your kitchen?
I'm focused on energy. I look for good vibes. It's not about strength or talent. Then, it's respect. These are the most important qualities. After that, it's their work ethic. Sometimes people have a crazy résumé but their actual work ethic doesn't correspond. Then there are people who don't have a résumé at all but are very impressive. Before Au Passage, I'd already worked with tons of people. The cooks who were the most impressive to me were those who actually hadn't worked for a long time in the kitchen. They have the motivation. They have the respect. And that's what I'm looking for, alongside efficiency and organization.

So it's not necessarily "skills"?

Yes of course, I look for that as well, but you can always teach someone those things. Au Passage taught me that it's not easy to be a chef. It's not easy when people consider you to be *the chef*. I need people to work with me, to help me, so I can continue learning too. So that's what I'm looking for: It's the drive and the respect. Everything else will come when you work well together.

Do you want to open your own restaurant someday?

Yeah.

How do you imagine it? The style, the concept, etc.

To be honest, I don't really have an idea in mind. If I were to open a restaurant tomorrow, I have no idea what it would be like. I know I want to have my own business, but I can't tell you what style it would be.

Is there a particular motivation behind opening a restaurant, something you want to try out?

I'd like to take old, forgotten recipes and to modernize them. I mean, that's what we do with everything in life right now. Think of vintage clothing stores: we buy old clothes to update our wardrobes. I'd like to do the same thing with cooking.

Is there a recipe in mind that fits the idea?

Yes, there's a Portuguese dish called *bacalhau à brás*. It's salt cod with shoestring fried potatoes that you cook with a little bit of onion, some olive oil, then you mix it with egg yolks. You cook your fish, you filet it, you mix it with your fried potatoes, and you bind it all together with egg yolks. Then you can add some black olives, a splash more of olive oil. It's really simple. It's just one of these dishes we forget about, but that we like a lot. I want to have *bacalhau à brás* on my menu. I wouldn't change it much; I'd just make it more elegant.

I find that every profession, every art form, has a slightly different vision of the world. From your place as a chef, what do you find people struggle with most in today's society?

Given the time and the effort we put into our work, the love that we put into each dish we create, each wine we sell, the struggle for the chef is really to make our customers come with an open mind and leave with a full heart.

And for the customer?

When people leave saying, "Oh, it wasn't very good," well . . . we have to remember that we're all just human at the end of the day. And the dish being "good" isn't really what we're looking for anyway. We're looking to share joyous moments together. I understand that the customers are spending money, but we want people to realize that it's more than just the food. It's about the moment. And it's about sharing these moments with others. That's the battle that we're always fighting for.

So open-mindedness. Is that what you see as missing from our lives? Why do you think this is important?

Even if you're a foodie and like to eat well, that doesn't mean you will necessarily show respect toward the restaurant staff. I have a window in my kitchen and I can see all the clients who are lacking this respect, who come to the restaurant and still click their fingers to catch the waiter's attention. It's as though they think, "I'm the one paying, therefore you are my slave." No, those days are over. You have to show the same respect to everyone. The struggle really is encouraging everyone to show the respect we all are due. ◊

Talking with

John Denison

*about the technicalities of treating meat,
and yourself, with respect.*

**"Bushel of blue crabs and cheap beer has a place
in my heart. That's where I grew up: Maryland, the
Chesapeake Bay, known for dirty sea creatures . . . It's
got a mercury feel to it. The whole time you're like,
'This is bad, this is really bad.' But I love it."**

I met John in his apartment, which was wild. John lives in the Palais Royal, with windows onto the gardens of the palace where, I'd heard it rumored, Napoleon lost his virginity. John is a Portland boy (by way of Maryland), or at least he was for the last six years. I'm a Portland boy too, or at least I was until I was eighteen. So we were two Portland boys, together in Paris, sitting in a palace with twenty-foot ceilings, crown molding, the distant echoes of Napoleon's moaning, and the dead skin dust of dead aristocrats. It's something I love about the city, how people like the two of us, from the new of America, can often find ourselves in the cast-off apartments of history. John was given a cheap room in the Palais through a benevolent connection at his new job, as a chef at the restaurant Verjus (and its sibling restaurant, Ellsworth). He'd been in Paris for six weeks when we spoke and that's why I wanted to talk: he was going through something I'd gone through years before, moving to Paris to improve on a craft in a place with unimaginable aura and unthinkable age for someone like a Portland boy. John is good at cooking meat with respect; a stance in the great vegetarian debate of society I wanted to hear from. He knows how to cook pigs without wasting any of their life's parts. He's worked in room-service kitchens cooking chicken fingers and gourmet kitchens cooking duck. He's touched the bad and good of the food industry with his hands. And he'd come to Paris to better himself and better his cooking, two improvements, that of happiness and skill, that I find holy.

Instagram: @cultured_pig
www.verjusparis.com and www.ellsworthparis.com

Verjus and Ellsworth are very international, with chefs coming from all over to work there. How does that affect the kitchen and the food you cook?

We lean almost 100 percent French; 80 percent modern, 20 percent classic. But we get to riff on things with other ingredients. For example, we have a Portuguese girl working with us right now. All of our snacks need to be gluten-free, so we needed to find an alternative flour that would expand and hold in the way gluten holds an expanding bread. Cassava flour and taro does that. And that came from her knowing gluten structures and protein structures in flours, which she knows from Portugal. We would have never gotten there without her knowing what expands in the same way. There is a lot of influence like that. But at the end of the day, we keep it very French.

You recently moved to Paris to be a chef, a "chef in Paris." You've been to Paris before, and other parts of France before with your work, but what was the first thing you noticed when arriving here to "stay"?

Pâté en Croûte

It's definitely been a milestone. Paris has always been a hotbed of culinary creativity. Always steeped in tradition. You read all these chefs' biographies. Basically every great chef had some time where they said, "To do this right, I need to go to France." Even after the last couple years of coming to France, working down south, I never felt like I was checking that desire off completely. It was working in really cool food and I was learning a lot, but it wasn't the experience of coming to Paris to cook. It was always something in my head where I said, "I gotta fucking do it."

It's been super-intimidating, getting here and getting in the flow. Kitchens are high-paced. Your first week or so, no one expects you to be good at your job. You're just learning what's going on, in the shit the whole time. The first week I was just thinking, "What am I doing here?" Then that calmed down as it always does. It's important to have a humble nature about it. To know I have a lot to learn. To tell myself I'm here to learn. It's super-easy to second-guess yourself and to think you shouldn't have done this. But after six weeks now, things have taken a turn and I'm feeling like this is great. Where I'm so happy I've gotten through that first two-week period and I'm loving it now.

What are you trying to learn from the French cooking community?

I think I'm here to learn true French technique. The average Parisian has a much better idea of what is "good." You can't really slide by with putting something on the plate here that might fly back at home. Here technique takes such a forward stance. There's just not a lot of places here that do pretty presentation and shitty technique to make it acceptable. Here the technique needs to be perfect, the sauce needs to be perfect, the flavors need to be perfect.

You told me you're from the mid-Atlantic, that you passed through Colorado before settling a while in Portland. Tell me about those moves and when food started playing a part in that movement.

I left DC when I was eighteen to move to Colorado for college. All my friends had worked in restaurants but I'd worked landscaping growing up. I got into cooking when I was nineteen because I needed a snowboard pass for the mountain. They were $1,200 a year. So I got a job at the hotel in Steamboat, at the base of the mountain. I was doing room service for them. The graveyard shift, working ten at night till eight in the morning.

Brutal.
I kind of sought it out actually because the mountain opened at eight a.m. Not that many people are ordering room service at four in the morning. I might cook a burger or something. I could basically hang out and do most of my homework there. At eight a.m., I'd get off work. The mountain would open. I'd snowboard for a few hours. Get to class at noon. Then I'd go pass out for six or seven hours, and go back to work.

How was cooking there? Did they not require any cooking experience?
It was basic, cook by numbers. Chicken tenders. Burgers. It was whatever. For the first few years of cooking I was doing bar food and hotel food. Super uninspiring. I basically worked to get out of kitchens. My whole goal was to get away from cooking because that life was my idea of cooking.

My degree was in sustainability studies. The reason I moved to Portland originally was to stop cooking and work at this solar energy nonprofit. And I just fucking hated it. I couldn't do the office job with the water cooler. I realized, "I think I'm really unhappy." I wasn't making much money anyway. So I got a second job back in cooking and ended up at a nice little restaurant and fell back in love with it. I had a great chef at the time who mentored me. And eventually I quit my office job and got back into cooking full time.

What are a few flavors you love?
Bushel of blue crabs and cheap beer has a place in my heart. That's where I grew up: Maryland, the Chesapeake Bay, known for dirty sea creatures. They're from brackish waters. So it's not fresh water, it's not salt water, it's literally muddy water. It's got a mercury feel to it. The whole time you're like, "This is bad, this is really bad." But I love it. My earliest memory of food is my whole family gathered around a picnic table outside, in the sun, eating blue crabs.

Is it one of those scenes, tables covered in newspaper?
Exactly. Newspaper, cracking them open with crab mallets and dumping them on the table and going for it.

What flavors represent Colorado to you?
It's basically a high alpine desert through most of the Rockies. So you don't get a lot of access to produce, but the thing that is so significant is game, wild game. Elk, venison, bear. Wild game with berries. Whenever I think of Colorado food, I think of elk and blueberries.

And Portland?
Portland is vegetables. It has the best produce, the Pacific Northwest, in the entire US. I think of the Oregon farmers' markets, like the Portland State University market. I'd go every week and find something I hadn't cooked before. Oregon does such a good job of reaching out to small farms and bringing them into the light. And people support it. That's the most important thing, pulling out your wallet and spending money on small farms.

Any vegetable specifically?
The artichokes from DeNoble Farms. You can get baby artichokes in the middle of winter from them, then you can get these huge, beautiful heirloom artichokes that are amazing all year round.

I ate a lot of artichokes growing up. But I had no idea until you just said that that artichokes in Portland are a thing.
Artichokes are such a West Coast thing. I didn't have my first artichoke until I got to Colorado. I talked to my mom about them recently and she was like, "I've probably only

155

had five artichokes my whole life."

If I told you how we cooked artichokes growing up, I think you'd be offended. We cooked them in a microwave, wrapped in cellophane, and then we dipped the leaves in mayonnaise.
That's funny; I grew up the same way. It was a sign of the time, our mother's microwave cooking. Microwave potatoes, microwave everything. My mom used to microwave eggs for our sandwiches.

My dad does that every single morning of his life.
Yeah she'd microwave it, put it on a sandwich for us. It's so weird.

My mom can make a peppermint ice cream chocolate cake in the microwave. It's one of her things.
That's crazy [*laughs*]. That's fucking wild.

And how about Paris?
The biggest thing I love about France, Paris especially, is the seasonality of meat. It's something I never experienced in the US. Like, lamb shouldn't be available all year long. Lamb should be birthed once a year, in springtime. Then you have three to four months before they turn into mutton. Working your way through the year, when you birth, when you milk feed, when you have your fresh cheeses, when you have your hard cheeses. Things like that are very European still. And that signifies France for me.

You told me before about your ecological interests as they relate to food. As a butcher, you practice whole-animal butchery, meaning you have to use every part of the body. No waste. To start, can you tell me how your relationship with the environment has been changed by cooking?
I grew up on farms. My dad was a botanist-horticulturalist. A tree farmer more or less. I grew up doing beekeeping with him. Always half city, half farm. I think that's what brought me back to working with farmers and that side of sustainability. It's so

fascinating, watching people take a product from its birth to a useable product. It's so easy to forget how important that is.

What are the things that concern you most regarding environmental practices related to the food industry?
Meat is such a controversial topic. Production of meat in the USA has become crazy. There are no seasons of meat. Not even a thought of it. The meat world and the lack of support for the small meat farmers is crazy. The USDA requires you to buy whole and half animals from small farms. It's really daunting for a family to buy half a cow. Where do you put it? How do you use it? What do you do with the odd parts? The amount of stuff that gets thrown away is concerning. It's something I've always felt passionate about.

What are some easy ways a person can treat the world a little better through changing certain aspects of their food consumption?
Buying smarter with your meat. It's always the fallback. Going to the farmers' markets and supporting local farmers is the easiest way. It's something that's talked about, and is a proud taboo for the people that do it, but it's not widespread enough.

My perception is to consume like that is a lot more expensive. Maybe it should be. But are there any ways an average family going to the local grocery can do better?
Especially in America, the portion thing is our biggest downfall. People are like, "How would I eat a twelve-ounce steak every night if I was buying from small farms?" Well you shouldn't eat a twelve-ounce steak every night. You need to consider responsible consumption. The thought that it's too expensive to buy organic, or that the world wouldn't be able to transition to that, is just a myth that's proliferated by the large companies and the USDA. If you spend more of your money on small farmers, things do become cheaper; you build a relationship with farmers, and you support that sustainable food system. There's so much pushback in

the States by lobbyists and big business to keep those small farms from succeeding.

Let's talk about whole-animal butchery. How does the math work, planning and consuming in that way, making sure you use the whole animal?
There's two sides to it. Buying at home is much more feasible than people think. Buying half a pig at a time seems daunting. But by the time it's cut up and packaged, it only takes up three square feet of your freezer. It really does condense down.

From a technical chef's side it's really hard. You decide you're gonna do a pork chop but you only have one loin on the back of a pig with sixteen chops. Say you sell sixteen pork chops in one day; then you're through the chops. You just have a short rib or a belly, two trotters and offal. You either need a menu big enough to spread an animal out through it, or you need a menu fluid enough to suit what you have left every day. That's a drain creatively. It becomes a constant grind to change your menu every day, which is why a lot of people don't do it. But that's changing. People are becoming more interested in eating weird parts.

What parts of the animal are hardest to use? How do you use those weirder parts?
Kidneys. Nobody buys kidneys. And I get it; they're weird.

What do you do with them?
I usually blend them into a mousse or a pâté just to sneak them into something to bulk it up. But you can braise them. You can grill them. Heads are still hard. People are still put off by seeing a half a pig head that's been fried and put on their plate. They don't want to have that association. At a past restaurant we did head roulades, deboning the heads, shaping the meat into rolls, taking the snout off. We'd braise and fry the snout separately with chickpeas. It's delicious, but putting a snout on a plate and giving it to somebody... 90 percent of people won't touch it. And I'm like, "Just try it; it's really good." But nah, not

Fish in Tomato Dashi

happening. There's still such a disconnect, though more in America.

I learned butchery on a farm in the south of France. The coolest thing down there, working with the whole-animal idea, was selling directly at market and seeing consumers buy your stuff. We would be left with pork chops at the end of the day, whereas brains would be the first to go. Then ears, kidneys, trotters. All the fatty flavorful parts would fly off the shelf in the south of France to the old French ladies. And pork chops would be left at the end of the day. Nobody wanted them. They'd be like, "Yeahhhh, they're dry. It's not my thing."

I only heard about whole-animal butchery through making charcuterie. What are some of the things you've learned to make that work well with the whole-animal philosophy?
You have different styles of charcuterie. You have your ready-to-eat, dried, whole muscle. You have your fresh sausage. You have your fermented sausage. You have your pâté. Then you have rillettes. So you have five different styles of charcuterie that you can put on

157

a board that completely vary in textures, mouthfeel, flavors. You can play with spices.

I've gotten into the highly emulsified, technical charcuterie. Like your mortadelas. Your *pâté en croute*, pie-crusted pâté. To make a *pâté en croute* is a three- to four-day process of cooking, setting, filling, setting. Almost everything in charcuterie is at least a two-day process. You cook it, you set it, and you come back the next day. The story of my life in charcuterie is leaving something and having to come back the next day, waiting to find out if it worked. You go home like, "Ughhhhhh, tomorrow I find out if that thing set, if it actually bound." So it's very stressful in its own way, doing all the cooking and not having a real guarantee it worked.

What are some things that prevent people from doing that sort of work?
To make half those things in America you need a HACCP plan, and that's fucking daunting.

What's that mean?
It's a weird rabbit hole. As I said that, I realized it would be hard to explain. HACCP is hazard analysis of critical control points. It's a NASA-written program originally, which they developed in order to take food into space. They can't just take food into space and hope everything goes well. It's a way of completely controlling your supply line, creating checks and balances to build safety in high-risk foods. The government took that over the years and decided any sort of high-risk food program has to do HACCP. Any sort of fermentation. Any sort of charcuterie. Because charcuterie is technically fermented meat.

That's the sort of thing that stops people from doing a whole-animal program, the amount of restrictions on getting whole animals, breaking them down, having fresh blood in your restaurant. It's super-weird. A lot of health inspectors come in, and they're not foodies, they just know the rules. They come in like, "That seems scary, that seems weird, no no no no no." Especially in America. Here it's really easy to sell boudin. You can sell blood sausage no problem. People buy it and I fucking love it. But it's still taboo in America.

That sounds stressful. I've been wanting to ask a chef about stress and mental health in the food world. Are there stressors you think are unique to the life of a chef?
What I got burned out on is everybody serving the exact same thing at the exact same time. If it's green garlic season for example, you're like, "Fuuuuck, what's this person doing with green garlic right now? What's that person doing? Am I doing better than them? Or are they way more creative?" It's a tough subject because the job is very mentally draining, physically draining. And at the end of the day you have nothing but your thoughts about how bad of a job you might have done. Working in kitchens is an art of failing and recovering. All day long is just problems and recovering from problems. It's so easy to leave at the end of the night and feel like you did a terrible job, that you need to do better. And it's just you and that for the rest of the night. Then you go back the next day and have to do it again for another fifteen hours.

Flank Steak with Radishes and Mustard

So there's a lot of self-comparison in a cooking job?
Very much so. Lots of self-comparison. Lots of self-doubt. Lots of anxiety. And that's magnified by the amount of hours you're there.

Is there a lot of loneliness in the industry?
It's really easy to turn to substances in the restaurant industry. I mean, you're getting off at bar hours. If you're hungry, you're going to a bar to eat. And then you're gonna drink as well. I think it's really easy to go down that road, into a self-deprecating, lonely state. It's weird; you get off work at twelve or one in the morning. For most of the week, the streets are empty. You're kind of just alone, walking home. And you feel like you're not even part of this society. But with that being said, in this industry it's so easy to find a community within that, because you're all sectioned off from the rest of society in a way. You have your own community within that.

How have you learned to overcome it?
Taking care of yourself on your days off. Simple things like hydrating and not taking the job home. It's key to everything. You're going to mess up constantly. You can't take that home and let it haunt you. I always tell young cooks when they start working for us, "Hey, do a really good job but don't take this home. Seriously let it go. Don't let it haunt you. It's not that big a deal." At the end of the day we cook people dinner. And I think it's easy to forget that in the egotistical rat race of "Is your restaurant good enough," "Is your food good enough."

I'd never really thought about it as a performance. Like if you're an actor, you might be the best you could possibly be through 99 percent of it, but if you screw up 1 percent that's all you think about?
Totally. You cook fifty fish in the matter of three hours, over and over and over again. One comes back and it's not perfect, or somebody didn't like it, that will haunt you. At the same time, no one is going to get those fifty right every fucking time. The ability to mentally recover is everything. The stability to say, "Hey, it's fine, let it go." That was the most important thing someone told me when I was twenty-two. I was stressed out, running around, wasn't ready, all over the place. My boss stopped me and asked if I was all right, and I just had this, this, and this to do, and he was like, "Hey man, it's just fucking dinner. It's fine. Take it easy."

Is mental health something that is discussed in the industry?
It's become much more. I think cooking over the years has always been this pirate lifestyle where you push and push and you don't ever stop pushing. My hands are constantly chopped and burned to shit. Half the time you have an artichoke spine up your thumb, so you can't use your thumb. And you have a huge cut on the other hand. It gets really draining. For a long time it was the attitude, "I don't care how hurt you are; if you cut yourself then you cauterize it on the fucking stove and keep going." I used to dip my finger in salt when I cut it really bad, to stop the bleeding.

At the end of the day, in a restaurant, you give what you're willing to give. I always tell cooks, this will consume you. If you allow this to take over your life, it will. This restaurant will eat you alive if you let it. You need to be upfront with yourself, and with us as your employers, with how much you're willing to give. And that's fine. Because if you keep dipping, you'll never stop dipping. I think that's the most important aspect of people staying stable in kitchens.

Do you have any emotions that are specifically linked to certain foods? Foods that you find you gravitate to when in certain moods?
If I've had a long week and I don't want to be in public for my weekend, if I want to hermit at home, then it's gonna be a cathartic rolling of pasta. I can do it by myself, in a kitchen, with a rolling pin, playing music and I can zone out. I love that. ◊

Thanks

First, I'd like to thank you, the artists in this book, for giving your thoughts and emotions and time. Then I'd like to thank you, Lauren, for your all-encompassing help. Then I'd like to thank you, Dallas, for giving me this opportunity to talk with all these interesting people. Then I'd like to thank you, Nikki and Jules and Zach and the rest of the Relegation team, for helping me make this book. Then I'd like to thank you, Gretchen and Sean, for making sure this book came out pretty. Then I'd like to thank you, Mahaut, for all your help getting started. Then I'd like to thank you, Maxime, for all your endless ideas. Then I'd like to thank you, Candice, for helping me with the text messages and the phone calls and finding the patterns. Then I'd like to thank you, Dale, for always telling me like it is. Then I'd like to thank you, Christopher and Madeleine and Jennifer, for the beautiful translations. Then I'd like to thank you, Nina and Lily and Ambre and Christopher (again) and Jennifer (again), for the brutal transcriptions. Then I'd like to thank you, Rauwanne, for helping me make this prettier. Then I'd like to thank you, Roma and Raphaël and Frédérique, for your constant support while I was making this, making sure everything else was okay. Then I'd like to thank you, Francie and Jeb, for giving me a place to sleep while I wrote. Then I'd like to thank you, Luke and Jess and Alice and Maxime, for also making sure I had places to sleep. Last, I'd like to thank you, my parents, for making me.

About the Author

Will Mountain Cox is an American-born writer living in Paris; he serves on the Artistic Committee of the Mona Bismarck American Center there. His work has been published in *The Bohemyth*, *For Every Year*, and the *aleï journal*. In 2013, Will founded the *Belleville Park Pages*, which published more than 300 writers from 35 countries in three years and was described by *Monocle* as "the perfect, intelligent way to distribute new writing." He holds degrees from Boston University and from Sciences Po in Paris, where he was named Graduate of Honor in 2017 for his research on the sociology of technology and urban life. Will is from Portland, Oregon.